Christian Church
Women
SHAPERS OF A MOVEMENT

Christian Church
Women
SHAPERS OF A MOVEMENT

Debra B. Hull

Chalice Press
St. Louis, Missouri

Biblical quotations, unless otherwise noted, are from the *New Revised Standard Version Bible*, copyright 1989, Division of Christian Education of the National Council of the Churches of Christ in the USA and are used by permission.

Cover artist: Kris Vculek
Art Director: Michael Dominguez

10 9 8 7 6 5 4 3 2 1

Library of Congress Cataloging–in–Publication Data

Hull, Debra.
 Christian church women / by Debra Hull.
 Includes bibliographical references.
 ISBN 0-8272-0463-9
 1. Ordination of women—Christian Church (Disciples of Christ)
2. Women in church work—Christian Church (Disciples of Christ) I. Title.
BV4415.H75 1994 262'.1466'082 93-23431

Preface

This book is dedicated to two groups of women whose names do not appear in it. The first group is made up of women who heard the call to be preachers and evangelists, college students and authors, missionaries, reformers, ecumenists, and leaders and administrators in the church, but who were prevented from responding fully to their call. Perhaps they were subtly discouraged from living as the Spirit directed them, the sort of oppression that results from years of cultural conditioning. Perhaps the opposition was more intentional and vocal, the direct kind that makes one howl with rage and hurts all the more when it comes from the church. So in partial retribution, this book is dedicated to those thousands of women whose yearning to serve the church was stifled, to those whose stories should have been recorded but were not.

This book is also dedicated to another group of forgotten women who have not received proper credit for the significant contributions they made to the founding and shaping of the church. Because the service these women rendered was humble and traditionally feminine, it was not deemed worthy of recognition. So this book is also dedicated to all women who inspired love for the church and faithful living among the children they taught in Sunday school; to all women who cooked meals for the bereaved; to all women who witnessed in the name of God to those who were ill, poor, uneducated, and oppressed; and to all women who kept the faith alive in their homes. In short, this book is also dedicated to those women whose names are not written in our books, but in our hearts.

I am profoundly grateful to John Hull, not only for writing the chapter on leaders and philanthropists in church-related colleges, but also for encouraging me in every step of the preparation of this book. Throughout our life together he has

unselfishly affirmed me and my work. At the same time, he has been a true partner, sharing equitably in the care and nurture of our children.

James Seale and May Reed of the Disciples of Christ Historical Society have been most gracious in responding to my inquiries and in providing photographs. The Society maintains an extensive collection of Stone-Campbell historical resources and is intentional in its efforts to preserve information about women.

I appreciate being allowed access to the wealth of materials held in the Bethany College Library, another excellent repository for historical material related to the Campbells and to Bethany College.

The faculty and administrators at Wheeling Jesuit College have been exceptionally supportive and encouraging. Not only do they value the scholarship necessary for such an undertaking as this book, but they also urge their colleagues to find an authentic spiritual path, and they seek actively the stimulation of religious diversity on campus.

Finally, Bonnie Bowman Thurston has been my pastor for the past several years, not because of the formal position she holds, but because of the personal relationship we share. She provides thoughtful and careful criticism of my ideas, always framed in the context of faith. I am most grateful to her.

Debra Beery Hull
Bethany, West Virginia
Summer 1993

Contents

Taking Our Place on the Church Family Tree[1]

Introduction

Others...express the simple but for the time unfulfilled desire to share the life of the community.[2]

The nineteenth-century restoration movement that today finds expression in the Disciples of Christ, the independent Christian Churches, and the Churches of Christ is an indigenous American religious tradition that was undeniably shaped in its early years, at least in part, by women. In addition to their roles as preachers, pastors, and evangelists, women (some ordained, most not) have also served with distinction in church-related higher education, domestic and foreign missions, ecumenical work, Christian education, ministry with children, and as authors and editors. Often their work coincided with active participation in social reform efforts, especially in the suffrage, abolitionist, peace, and prohibition movements.

The contributions of early church women usually were not made through the traditional church organizational structure, to which women had only limited access. Rather, their efforts, born of personal conviction, were often nurtured in

1

low-budget, grassroots organizations that existed apart from established church structures. In several cases, though, women's efforts led to the development of independent organizations that became so successful that they were recognized by and subsequently merged into officially recognized manifestations of the church.

The story of women's increasing participation in the life of the church is, of course, intertwined with the development of their roles in society at large. Many women, unable to gain meaningful employment or pursue educational opportunities, turned their considerable talents and energy to church work, where their loyalty was cultivated by pastors eager for their support and for the support of their husbands. Women's church work both mirrored and shaped their participation in the larger public culture, giving them the organizational, management, public relations, fund-raising, and leadership skills that qualified them for and gave them access to paid positions outside the church.

Historical Factors in Women's Church Roles

When European settlers came to America during the colonial period, they brought with them certain assumptions about the place of religion in their daily lives. The Virginia colony was particularly influenced by English custom in which church, governmental, and educational leaders were one in the same (and all male). And even though northern colonies tended to be settled by those escaping religious persecution, religious and civil authority often were indistinguishable in the community. Men possessed power and authority and occupied the public leadership roles in the government and in the church. Women were not full participants in either area of life.

Revolution and the subsequent establishment of a Constitution brought at least partial separation of church and state. One's religious obligations were separate from one's obligations to the state, and became more a matter of personal conscience. Because of this, participation in a community of faith became truly voluntary and religious institutions came to depend on freewill contributions from their members, both in terms of money and time. Even so, the conditions for women in the church, and in the culture at large, changed very little.

While widows sometimes were allowed to control their husband's property and unmarried women could conduct busi-

ness without male assistance, married women did not have legal control over their children or their property. Abigail Adams is reported to have pointedly criticized her husband, John, when she said,

> I cannot say, that I think you are very generous to the ladies; for whilst you are proclaiming peace and goodwill to men, emancipating all nations, you insist upon retaining an absolute power over all wives.[3]

And while some well-to-do colonial women had time for church work, few had access to their own money, even if they had inherited it. The financial resources over which less well-to-do church women had control were limited to the proceeds they realized from selling spare butter, eggs, and rags. Even these meager earnings were usually given to church men to spend.[4] Without control over their own money, women's decision-making power in the church was limited. Virtually no women held formal church leadership positions during this time.

Any voice, power, or prestige women enjoyed in the church came because of their positions as daughters and wives. And while these early women certainly helped to shape the direction of the church indirectly, many must have longed for independent authority and recognition instead of the status accrued to them because of the power of the men in their lives.

In the years immediately following the Revolution, women continued to have limited access to educational opportunities. As Ida Withers Harrison, speaking of the early 1800s, noted in 1920,

> Less than a century ago the most rudimentary education was considered all that was necessary for a woman. Anything beyond that was considered indelicate and unwomanly, and was supposed to unfit her for the sphere to which God had assigned her.[5]

The ideal woman of the time possessed such traditionally feminine characteristics as domesticity, purity, interest in the arts, modesty, submissiveness, and piety—virtues that did not lead directly into educational or church leadership opportunities.

In many ways the Civil War was a turning point for women. Before the Civil War, women were virtually silent in the

public arenas of their churches and communities. Generally they could not vote or hold leadership positions, attend seminary, preach, or be missionaries, except by accompanying their husbands.[6] But in the period following the Civil War opportunities for women outside the home increased enormously.

This increase was due in large part to the self-confidence women gained and the practical skills they learned as they cared for their homes, farms, businesses, and communities in the absence of their husbands and fathers during the war. In addition, as the country industrialized and health standards improved, the need for large families decreased, the birth rate declined, and women lived longer and had the energy and time to look beyond the family. Perhaps most importantly, women felt a faith-born "surge of self-affirmation" against the prevailing church and community traditions that so clearly devalued them and their gifts.[7]

Women Assert Themselves in the Life of the Church

Unable fully to participate in the organizations of male-dominated public life, women established their own organizations, beginning in their churches. Most post-Civil War church women, especially in the South, had their first experiences in public life in a church missionary society.[8] The typical pattern played out in many Protestant denominations about the same time was for a group of women in a congregation to meet twice a month for prayer, Bible study, raising money for benevolent activities, and offering mutual support for one another. While pastors often encouraged these groups, the authority to which the women answered was beyond the church and civic worlds controlled by men. Soon leaders of local women's organizations realized that they could have a greater impact if they combined their groups into a statewide or denominationwide organization.

Almost simultaneously, in a sixteen-year period following the Civil War, congregational women's organizations joined to form national women's organizations in all the major Protestant denominations.

Congregational—1868
Methodist Episcopal (foreign missions)—1869

Presbyterian (foreign missions)—1870
Protestant Episcopal—1871
Baptist (foreign missions)—1871
Episcopal Church—1874
African Methodist Episcopal Church—1874
Disciples of Christ—1874
Reformed Church in America—1875
Baptist (home missions)—1877
Presbyterian (home missions)—1878
Evangelical Lutheran—1879
Methodist Episcopal (home missions)—1884[9]

Ironically, the politically disadvantaged position in which women found themselves had its positive side as it gave impetus and shape to women's church work. Self-abnegation and submission gave rise to self-assertion in the name of the gospel.

Perhaps because of their experiences of marginality [women] were better able to live up to some of American Protestantism's professed ideals—toleration for divergent religious and political views, empathy for the oppressed and victimized, belief in the value of the laity, responsiveness to the church people at the grass roots. Sometimes, because they had less to lose they seemed braver, more outspoken, more activist than their brethren. The women may, in fact, have helped sway the establishment in a more liberal direction.[10]

Related Reform Efforts

But still, in order for their leadership efforts to be accepted, women had to maintain their femininity. Time and again tributes to powerful church women assure the reader that while the woman may have had a masculine mind, she never lost her femininity. And although there are clear and powerful examples of church women who overstepped the bounds of female propriety, many early church women began by extending what was considered to be their natural sphere— living the gospel through caring for children and upholding moral virtue—from their homes to their churches in a non-threatening manner.

While maintaining their feminine attributes, these women went on to extend their influence from the home to the com-

munity, and then to the world, improving the lot of the disadvantaged and unchurched as they went. By using a feminine style of relating, women were able to wield considerable power without arousing too much opposition to their efforts and without being accused of being unfeminine, and thus dismissed as unnatural.

Church women were active in reform efforts outside the church as well. For instance, the Woman's Christian Temperance Union formed in 1873 was led by an ecumenical group of church women. In addition to temperance goals, the Woman's Christian Temperance Union also worked for prison reform, international peace, child labor laws, and public kindergartens. Other women's reform organizations formed about this time in history include the YWCA and the American Red Cross. Because of their experience in church and civic groups, women were learning that they could organize themselves, raise substantial sums of money, and work cooperatively for social justice.

The next stumbling block women faced was garnering support for reform legislation (especially temperance laws) from all-male governmental bodies. Their lack of success in persuading male voters of the rightness of their positions led women into suffrage work. And while there was significant opposition to women-led social reform efforts, particularly to temperance and suffrage, the popularly presumed moral superiority of women (due to the "natural" links between benevolence, feminine traits, and moral virtue), did give some validity to the social criticism and religious prophecy underlying women's reform efforts.

Women's Church Work Gains Acceptance

Even though seen by some as morally superior—possessing tenderness, sympathy, meek and merciful hearts, and being freed from worldly concerns—and therefore especially well suited for bringing the gospel to bear on the problems of the world, women and their organizations were seen as "other"—qualitatively different from the male norm. That is, the leadership styles males exhibited and the structures they designed in the church were seen as the standard—as the way things should be done. Women's styles of leadership and organizations were evaluated in light of the male norm. Early in their church work, women were outsiders. For this reason

women's organizations such as the Christian Woman's Board of Missions were prohibited from competing for funds with other officially recognized church organizations through established channels. Instead, for their organizations to survive and prosper, women had to solicit many small gifts through direct appeals. Effective communication with women in local churches was critical in this effort.

Even after the Civil War women generally were not allowed the same opportunities in higher education as were men. Women seeking higher education often studied in separate institutions that existed close to male institutions. And while these women students often followed a curriculum patterned after that of their male counterparts, women's seminaries did not enjoy the status or financial support of all-male schools. Women also were denied access to seminary education, or when allowed to matriculate, were discouraged from preparing for the pastoral ministry. Beginning in the 1880s, church women from several denominations did something about that too. They established mission training schools to train women (and men) teachers, preachers, and domestic and foreign missionaries.

It was only after women's organizations and mission schools began to thrive, in the 1920s, that they were incorporated into official church structures. In many denominations, as in the Christian Church, women's missionary societies were merged with general missionary societies. Training schools were taken over by seminaries. Some female colleges were merged with male schools or closed when women were admitted to previously all-male colleges. The United Church Women (now Church Women United), an ecumenical organization, became part of the National Council of Churches.

Women agreed to these mergers in a spirit of cooperation largely out of loyalty to the church. Mergers were not necessarily in the best interests of women or their organizations. Even though women leaders did become members of the resulting merged boards, their power and influence declined. The number of women board members was small and they were not experienced in the male style of conducting business. Commonly, the top leadership positions previously filled by women were taken over by men. In many denominations, when the first women on the merged boards retired, they were replaced by men.[11]

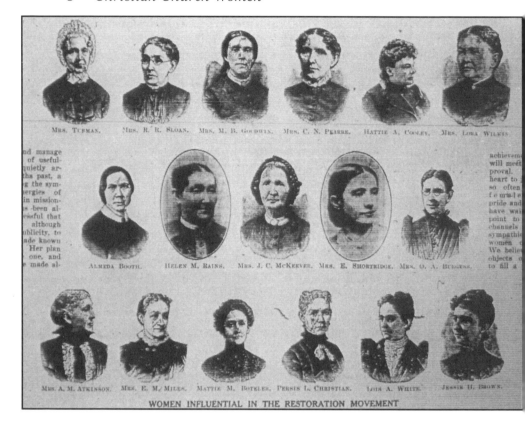

WOMEN INFLUENTIAL IN THE RESTORATION MOVEMENT

At these moments of involuntary incorporation many women had to face the fact of powerlessness. Although their public rhetoric was usually muted, their private letters to each other often expressed great outrage and bitterness.[12]

Even after the mergers, women were not allowed the same easy access to seminaries that they had enjoyed in mission schools, nor did those who completed seminary have the same support network as women trained in the mission schools.[13]

Unlike women in the mission movement or the diaconates, they [women seminary students] did not benefit from the buffer of supportive organizations. Unlike male seminarians, they could not receive scholarship aid or free room and board in those seminaries which did accept them. Moreover, the academic

credentials which they painstakingly earned—and which were not considered essential for most male ministerial candidates of the day—were insufficient to assure either ordination or a parish position.[14]

Finding the Stories of Influential Women Disciples

Despite these very real and long-lasting obstacles faced by women in all denominations, many women did make major contributions to the development of the Stone-Campbell movement in its early years. Although far too many of their contributions have been lost or ignored, some women were recognized by male leaders of the church. In the supplement to the *Christian Standard* published in 1916, editor Isaac Errett printed a composite picture of seventeen women he considered to be influential in the restoration movement. They included authors, editors, and women involved in education, philanthropy, and Christian Woman's Board of Missions work. Errett's picture provided a starting point for this book; sixteen of those women are included in it.[15]

In addition to the names of women in the picture Isaac Errett printed, several authors have provided helpful accounts of women's participation in certain aspects of the church's life—especially Ida Withers Harrison's history of the Christian Woman's Board of Missions, Lorraine Lollis' book on church women (concentrating on women's work in the Christian Woman's Board of Missions and the Christian Women's Fellowship), and Marjorie and Hiram Lester's book on the history of the National Benevolent Association.[16] Over the years there have been shorter articles on women and their work (especially as pastors), and histories of female seminaries, regions, and churches that provided additional information. The women included in this volume are clearly the ones for whom there is the greatest amount of publicly accessible material available.

Undoubtedly there are many important women who were not included, not because their work was less significant, but because it was less well recorded. It is my hope that this book will lead to greater interest in the discovery and preservation of materials related to women and that it will encourage us intentionally to preserve a more complete record of women's thoughts, words, and deeds. I am planning a second volume

(in a somewhat different format) that will allow for the inclusion of women whose stories are not recorded here. I would appreciate suggestions and information from readers.

Researching the lives of church women of the eighteenth, nineteenth, and early twentieth centuries often feels like trying to put together a giant jigsaw puzzle with half the pieces missing. Piecing together the factual parts of women's lives from snippets of information is difficult enough, but trying to recreate their hopes and fears, how they felt about their work and their families, and how their faith compelled them forward depends on intuitive skill as well as on the availability of objective fact. Often the official record doesn't quite square with the words of the women themselves. When discrepancies arose, I chose to be as faithful to the voices of women as I could. The words of the women themselves took precedence over those of reporters, editors, and biographers.

African-American Women

The contributions of white, European-American women from both the United States and Canada are best represented in this book because nonwhite women faced the double burden of gender and race in seeking acceptance for their work in the church. Among nonwhite women, African-Americans are the best represented because they were active in the Christian Church from its beginning, and particularly after the Civil War. The major difficulty in being faithful to the contributions of African-American women is finding written records of their work in the church. Even after the Civil War their contributions were less likely than those of white women to be recorded in the official church periodicals that were edited and published mostly by white, European-American males. Regrettably, the number of African-American women whose stories are recorded here still does not accurately represent their contributions in shaping the Christian Church.

The Christian Woman's Board of Missions assumed responsibility for "Negro educational and evangelistic work" in 1900. In the late nineteenth century and early twentieth century educational institutes were established in Mississippi (the Southern Christian Institute), Kentucky, Alabama, Virginia, Tennessee, and Texas (Jarvis Christian Institute). Evangelistic efforts among African-Americans were centered in those states and in Arkansas, Georgia, Missouri, Oklahoma, and

South Carolina as well.[17] Initially black and white Christian Church women worked in separate arenas, and in many cases white women tended to be rather maternalistic in their dealings with black women. Gradually, though, black and white women working together came to understand the importance of shared leadership in a multicultural and multiethnic church.

Hispanic Women

There are very few Hispanic women whose lives are recorded in this book. Because there were very few Hispanic people in the United States before the twentieth century, Hispanic women did not play a major role in shaping the early Christian Church in the United States and Canada. Also, until recent times, the major leadership roles in Hispanic churches have been held by men and few Hispanic women have been ordained.[18] In addition, Spanish-speaking people in North America, while united by a common language, represent diverse cultures—including people of Puerto Rican, Spanish, Mexican, and Cuban descent. Disciples women, again through the work of the Christian Woman's Board of Missions, did reach out to their Hispanic sisters and brothers, establishing small ministries in Mexico toward the end of the nineteenth century. Ida Withers Harrison lists pre-twentieth-century Mexican missions in Juarez (1895) and Monterey (1897) and early twentieth-century mission efforts in fifteen other Mexican villages.

The Christian Woman's Board of Missions also established mission stations in other Hispanic areas—in Puerto Rico in 1900 (at Bayamon), in Argentina in 1906 (at Belgrano and Buenos Aires), and in Paraguay about 1920. While the Christian Woman's Board of Missions missionaries to Latin America, the Caribbean, and South America were Americans of European descent, missionaries were assisted in all these efforts by local people.[19]

Asian-Americans

Because there were also relatively few Asian-Americans in areas where the Christian Church was growing before the twentieth century, they did not have a prominent role in shaping the early church in America either. The Christian Woman's Board of Missions did sponsor an Oriental mission program in the United States beginning in 1891, with minis-

tries to Japanese- and Chinese-American men in California and Oregon, adding ministries to women and children in 1908. Asian-Americans assisted Christian Woman's Board of Missions home missionaries in these efforts—establishing a training school, a night school, a YWCA, churches, medical facilities, and industrial training classes.[20]

Women's organizations, especially the Christian Woman's Board of Missions and the Christian Women's Fellowship, were the first manifestations of the church not only to be sensitive to the special needs of minority women, but also to recognize and affirm their unique gifts and talents. In particular, the members of the Christian Women's Fellowship and the International Christian Women's Fellowship intentionally and progressively led the way in learning from and serving with nonwhite church women.[21]

There are contemporary efforts to preserve the stories of nonwhite church women whose role in transforming the church has really come in the twentieth century.[22] Those who come after us and record the history of the church in this century and beyond will write a more colorful and diverse history, including the large and growing number of African-American, Native American, Hispanic-American, and Asian-American women who are providing leadership today and shaping the church of the twenty-first century.

Some Questions

In addition to the very real problem of who to include is the question of how to address the women whose lives are recorded here. One of the peculiar difficulties in researching the lives of women is tracing name changes. The first names of married women are sometimes lost if they are referred to by their husband's first names or initials. If referred to by their own names, sometimes middle initials are from their own birth surnames, sometimes from their middle names. Spelling variations occur. Multiple marriages and the resulting name changes pose particular problems in tracing women.

For this book, it seemed to me rather too formal to refer to women by last name only. The title Ms. that we use today seemed too modern for women of the eighteenth and nineteenth centuries. And first names alone did not always connote the respect I intended to show them. Therefore, you will not see

total consistency in the way in which women are addressed. In general I tried to use the forms of address most often used for a particular woman or to address her as she might have been addressed at a certain point in her life. It is not a perfect solution, but one that seemed to reflect the variety of life situations in which church women found themselves.

The purpose of this book is to examine the part played by women in shaping the development of the early church. Consequently, almost all the women whose contributions are remembered here are deceased. There are a few women who, although deceased, are more contemporary. They were specifically included because they gave leadership in more recently emerging priorities of the church—particularly in ministry with nondominant ethnic groups.

One Woman's Story

The inspiration for this book is very personal. Some years ago I, a young woman nurtured in the church, was having a hard time reconciling my recently identified feminism with the oppression I saw around me. To me, an obvious place to turn for reconciling answers and for support was to the Christian Women's Fellowship. I might easily have found rejection of what were then rather radical views, and consequently might have left the church. Many of my friends were doing just that.

Instead I found a rather traditional Christian Women's Fellowship woman who sensed what I needed and responded by suggesting that I get to know the Christian Woman's Board of Missions. This suggestion led to Ida Withers Harrison's chronicle of the Christian Woman's Board of Missions and to a turning point in my adult faith journey. The strength of our foremothers in the faith reached out over the years to claim my wavering commitment to the church as I learned that a flame of the Lord's kindling cannot be extinguished by human actions, even oppressive actions committed in the name of the church. My experience resonated with Annie Dillard's when she wrote that nothing so much convinces her of the mercy of God than the continued existence of the church (in all its ungodliness).[23]

On many occasions since then I have hesitatingly expressed my views on justice and faith issues, fully expecting

not to find support. And sometimes there is not support at the time. But I can no longer count the number of times women, often older, apparently traditional women, have encouraged me, at the time or later, to keep raising the issues. The loving support of my sisters in the faith provides direction for my current efforts.

Ultimately I found the roots for Christian feminism in the lives of the church women who preceded me. Struggle for affirmation of the gifts, talents, and rights of women in the church is not a twentieth century phenomenon, but goes back to the beginning of the church and has its origin in God. Our mothers in the faith give me my sense of rootedness and constancy.

And our daughters in the faith energize me to work to preserve the unbroken and eternal chain of women until they link arms with us—daughters, mothers, sisters, and grand-mothers—forward and backward in the circle of faithful women.

Our Heritage

We are justifiably proud of our great women philanthro-pists, preachers, and scholars. Yet few of our foremothers—those we can name here, and countless others—have left us the legacy of great endowments, fancy cathedrals, or theologi-cal treatises. More often their heirs are poor orphans and small, struggling churches. Their legacy is found in the work of the National Benevolent Association, the Christian Woman's Board of Missions (now evolved into the Divisions of Home-land and Overseas Ministries), the Christian Women's Fel-lowship, and Church Women United. The record of their lives is mostly not found in histories of the church or in legislative activities, but found rather in the quilts they made, the stu-dents they taught, and the spiritual meditations they wrote.

Across from my desk, lined up, facing out, are pictures of six Disciples women who have been my constant companions over the past months. Although none has lived during the time I have lived, I feel I know them all, for their very pres-ence is in the room as I work. I hear them chuckle as I struggle with the problems that so dominate daily life but become utterly inconsequential over the decades. I see their furrowed brows when I misinterpret their lives, allowing twentieth century eyes to cloud the vision of their work. I feel their

tender touch when we make connection across the years and I manage to get it right. In their eyes I sense our kinship in the faith.

These women represent only a small number of the countless Disciples women who have generously shared their stories with me. Some have emerged as sisters and mothers. Others remain distant cousins and crazy aunts. Together with us they weave a rich and varied tapestry of faith that warms the body and the soul and expands every time we look at it. Some of the strands are a delicate golden; some are a strong, rich brown. Some are distinct, running the entire length; others are fragile, hard to see, and still emerging. The entire tapestry is supported by strands that will never be seen, never named. Yet the part we can see, if only dimly, depends for its very existence on those unnamed strands that support it.

The rational, hierarchical, patriarchal church in which I grew up challenges the mind as it calls for study and action. But the circle of church women I have come to know claims my heart. When I set out to write this book, I had objective goals about recording the lives of the historical women who shaped the Stone-Campbell movement. In the end, I finished it because I could not escape the power of our foremothers. As you read it, may the fire of the spirit that lit their lives burn within you.

An Opportunity to Respond:
Creative Arts and the Faith Journey

If you or your group have abilities in one of the arts or crafts, use your talent and skills to create a tribute to the women who have guided you on your faith journey—in your family or in your church. Consider the following ideas.

1. Get together with other women in your church through the Christian Women's Fellowship, a Sunday school class, or some other organization and piece a quilt. Each member could make a square or two in tribute to the women who have been her foremothers in the faith. The fabric, types of stitches used, and symbols in the square could all reflect something important about the woman being honored. When the group meets together to piece, stitch, or tie the quilt, encourage each woman to share the story of the women represented in the square she contributed to the project.

2. Identify the women who have had a prominent role to play in the history of your church. Assign each historical woman to a current member of a women's organization in your church. Ask her to find out all she can about her foremother and to develop a quilt square to commemorate her life. When the group gathers to piece, stitch, or tie the quilt, ask each woman to tell the story of the foremother she was assigned.

3. Adapt the second suggestion to another artistic medium. For example, on one of the walls of the church paint a mural commemorating the lives of your church's foremothers. Find, reproduce, and hang on one of the walls photographs of historical women important in the life of the church. Ask one or more women in your church to develop a longer presentation on the historical women in your church. Consider dressing as the historical women might have dressed. Try to use some of the words of historical women, if possible, in telling their stories. Offer to repeat the program for the Sunday school classes or for a youth group meeting.

4. If you are working alone, without the support of a church group, downsize the project. Make a pieced pillow or lap robe instead of a quilt. Become an expert on the life of one of the historical women in your church.

5. When you have completed your project, plan a service of dedication. Before the service, ask each one present to think of the name of a woman important in her personal faith journey. During the service, thank God for each woman by name. The following prayer litany based on and inspired by the Christmas program "Gifts of Wise Women," written by Susan Shank Mix for the Christian Women's Fellowship and available from the Division of Homeland Ministries, could serve as a guide for the service.

Litany for Women

Leader: Biblical women heard the good news from Jesus and followed him. We remember with grateful hearts the lives of Mary, Mary Magdalene, Joanna, Priscilla, Phoebe, and others.

People: WE CELEBRATE WOMEN WHO RECOGNIZE CHRIST IN OTHERS.

Leader: Over the years Disciples women have preached the gospel, supported financially the mission of the church, educated young women missionaries and preachers, ministered to those in need in their communities and around the world, and written with passion and conviction.

People: WE CELEBRATE DISCIPLES WOMEN WHO HAVE CONTINUED JESUS' MINISTRY OF TEACHING, PREACHING, AND HEALING.

Leader: The women in our families and among our friends have brought us to this. We celebrate the tender ties that bind us to the family of women by naming those dear to us.

People: (EACH WOMAN PRESENT IS INVITED TO SAY ALOUD THE NAME OF A WOMAN IN HER FAMILY WHO HAS BEEN IMPORTANT IN HER LIFE.)

Leader: Women in this church have influenced and inspired us. We celebrate women who have brought courage, vision, love, and commitment to the church in this place by naming them.

People: (EACH WOMAN PRESENT IS INVITED TO SAY ALOUD THE NAME OF A WOMAN FROM THIS CHURCH WHO HAS BEEN IMPORTANT IN HER LIFE.)

Leader: We celebrate and honor the lives of women in this room who are growing together in Christian faith and action by naming them.

People: (EACH WOMAN PRESENT IS INVITED TO SAY ALOUD THE NAME
OF THE WOMAN TO HER RIGHT.)

Leader: Our God, nurture our gifts and talents, we pray.
Guide us to ever deeper understanding of the holy scrip-
tures. Make us faithful to the call to be your instruments
in the world. Give us the courage to insist on justice for our
sisters. Have mercy on us when we stray from the path
you have laid for us. Walk with us in this life until we are
able to look on your face in eternity. Amen.

Notes

[1]The inspiration for the title of this chapter comes from a church history
membership class curriculum written by Vicky Fuqua and Karen Nolan and
available from Historic Bethany, Bethany, WV 26032.

[2]Sophonisba P. Breckinridge, *Women in the Twentieth Century: A Study
of Their Political, Social, and Economic Activities.* (New York: Ayer Press,
1972), p. 4.

[3]Jean E. Friedman and William G. Shade, *Our American Sisters: Women
in American Life and Thought.* (Lexington, Massachusetts: D. C. Heath,
1982), p. 13.

[4]Ida Withers Harrison, *The Christian Woman's Board of Missions,
1874-1919.* (no city: Mayfield, no date). See also Debra B. Hull, "CWBM: A
Flame of the Lord's Kindling," *Discipliana* 48 (3) (Fall, 1988), pp. 39-42.

[5]Harrison, *CWBM*, p. 19.

[6]Virginia Lieson Brereton and Christa Ressmeyer Klein, "American
Women in Ministry: A History of Protestant Beginning Points," in Janet
Wilson James, *Women in American Religion.* (Philadelphia: University of
Pennsylvania Press, 1980), pp. 171-190.

[7]Elizabeth A. Johnson, *She Who Is: The Mystery of God in a Feminist
Theological Perspective.* (New York: Crossroad, 1992), p. 66.

[8]Lois W. Banner, *Women in Modern America: A Brief History.* (San
Diego: Harcourt, Brace, Jovanovich, 1984), pp. 18-21.

[9]Brereton and Klein, "American Women," p. 174.

[10]Virginia Lieson Brereton, "United and Slighted: Women as Subordinated
Insiders." In William R. Hutchison (ed.), *Between the Times: The Travail of
the Protestant Establishment in America, 1900-1960.* (New York: Cambridge
University Press, 1989), p. 163.

[11]Brereton, "United and Slighted," pp. 146-147.

[12]*Ibid.*, p. 147.

[13]Brereton and Klein, "American Women," pp. 180-182.

[14]*Ibid.*, p. 180.

[15]"Women Influential in the Restoration Movement," *Christian Standard* 51 (April 16, 1916), p. 1011. I could find no further references to Mrs. E. M. Miles in Disciples periodicals. She was identified by Isaac Errett as a writer of prose and poetry. There is an Emma Bell Miles who was a noted Southern author of about the same period, but I am not at all sure these two women are the same.

[16]See Harrison, *CWBM*, Lorraine Lollis, *The Shape of Adam's Rib: A Lively History of Women's Work in the Christian Church.* (St. Louis: Bethany Press, 1970), and Hiram J. and Marjorie Lee Lester, *Inasmuch...The Saga of the NBA.* (St. Louis: National Benevolent Association, 1987).

[17]Harrison, *CWBM*, pp. 131-132.

[18]Several people have been particularly generous in helping me research the lives of nonwhite women active in the early church. Among them are Janice Newborn, Daisy L. Machado, and Conchita Delgado. T. J. Liggett also provided comprehensive information concerning Hispanic involvement in the early Disciples church in the United States and South and Central America. I thank them all.

[19]Harrison, *CWBM*, pp. 126-130.

[20]*Ibid.*, p. 131.

[21]Janice Newborn and Martha Faw, "Forty Years of Choices and Changes," *Discipliana* 51 (1) (Spring, 1991), pp. 3-6.

[22]See Carol Coffey (ed.), *Christian Women Share Their Faith.* (no city: Department of Church Women, Division of Homeland Ministries, Christian Church [Disciples of Christ], no date) and Melvia Fields, *Women on a Mission.* (Paris, Kentucky: Bourbon Graphics, 1990).

[23]In Annie Dillard, *Holy the Firm.* (San Francisco: Harper & Row, 1977).

Daughters of Priscilla

Pastors and Evangelists

Many women are distinctly the "Martha type."...They are worth their weight in gold to their families....Not so numerous, but more noticeable are the "Marys" of life....Their contribution to civilization is beyond computation.[1]

Nineteenth-century restoration churches of the Stone-Campbell movement trace their roots to the church of the New Testament. To those of us living today, it may seem that recognition of women ministers and evangelists is a recent phenomenon, a product of modern-day changes in gender roles. In reality, early Disciples discussed in detail the role of women in ministry, endlessly and passionately debating the seemingly contradictory biblical passages related to women's roles in the church.

Those who favored ordination of women found ample evidence that New Testament women were active in ministry at a time when they did not have social or political equality with men. For example, in Romans 16 the work of Phoebe, one of several New Testament deacons, is described. Her ministry included supporting the church financially and delivering Paul's letter to the church at Rome, as well as serving in her home church. It is obvious from the text that she had a

significant leadership position in the community, legitimate authority in the early church, and Paul's admiration as a Christian sister.[2] Indeed, the *New Revised Standard Version Bible* suggests that "deacon" might also be rendered "minister."

Another New Testament figure, Priscilla, is clearly recognized as Paul's coworker in evangelistic ministry. Prisca (as Paul calls her) and her husband Aquila traveled throughout the Mediterranean with Paul, establishing churches in Corinth and Ephesus. In so doing, Prisca acted in direct opposition to the Roman emperor Claudius, literally risking her life for the church.[3]

Those who opposed ordaining women focused on 1 Corinthians 14:34–35: "women should be silent in the churches. For they are not permitted to speak, but should be subordinate, as the law also says. If there is anything they desire to know, let them ask their husbands at home. For it is shameful for a woman to speak in church." This passage, which was presumed to ban women from preaching for all time and in all places, was not seen as banning women from all church participation. They could teach (children), sing, and comfort the sick and bereaved.

Though in most quarters women ministers were not as readily received as their male counterparts, some women were ordained early in Disciples history. These courageous Disciples women, pioneers though they were to us, really only continued the long line of women preachers, as Priscilla and Phoebe's daughters in the faith, and as our faithful grandmothers.

Denominational Patterns in the Recognition of Women

In several major Protestant denominations in America, women as a group first proved their capabilities and commitment through significant lay leadership roles, then were, as something of a natural outcome, allowed to be ordained. In the Disciples tradition, the pattern is different. Women were ordained relatively early in the church's history but wide recognition for laywomen's leadership (especially in the eldership) occurred later. Most observers of the Disciples pattern believe

it occurred because elders rather than pastor-evangelists performed the liturgical functions in the church.[4]

Historically, presiding at the Table and other sacramental roles are considered to be "priestly" functions reserved for males. In denominations where such functions are performed by ordained ministers, ordination of women generally came late. In denominations where such "priestly" functions are performed by elders, ordination of women came earlier, but the acceptance of women as elders was delayed.[5]

In addition, as this list illustrates, the four denominations that began ordination of women in the latter half of the nineteenth century are congregationally organized and highly value local church power and autonomy. The six that began ordination of women in the latter half of the twentieth century have a strong hierarchical, ecclesiastical structure of power and authority.

United Brethren in Christ—1851
Congregational—1853
Disciples of Christ—1888
Cumberland Presbyterian—1889
Methodist—1956 (full conference privileges to
 ordained women)
Presbyterian Church in the U.S.A. (Northern)—1956
Presbyterian Church, U.S. (Southern)—1964
Lutheran Church in America—1970
Episcopal—1976
Anglican—1992

With the exception of the Congregational church, early ordaining churches were also frontier churches, developing in sparsely populated regions where there were few seminary-trained preachers. The hierarchically organized churches, true to their European roots, developed in more urban areas of the country, often near educational centers where access to well-trained male ministers was greater.

Early Disciples Women Evangelists: The Three Marys

After their baptism as adults in the several years on either side of 1816, Mary T. Graft, her husband, Jacob, Mary Morrison, and Mary Ogle, all living in Somerset, Pennsylva-

nia, "resolved to make the Word of God their rule of life and faith."[6] Even though none of them was trained as a pastor, the little group met regularly for prayer, singing, and study of scripture. Although at different times loosely associated with the Baptists and with the Redstone Association, their refusal to accept humanly created creeds and confessions made it impossible for the three Marys to unite with any of the local churches. Following a visit from Thomas Campbell in 1828, the group assumed the name Disciples of Christ.

The three Marys set about evangelizing their neighbors, visiting from house to house, writing letters explaining the gospel message, and distributing Alexander Campbell's publications in their community. Because of the sustained efforts of the three Marys, the church at Somerset began to prosper and grow until there were more than five hundred members in the 1840s.[7]

Mary Graft, Mary Morrison, and Mary Ogle were the mainstays of the church for nearly forty years, "taking the lead at prayer meetings, [and] sometimes conducting them altogether."[8] Because of their dedication to the work of their Lord, the three Marys came to be known in the wider church community with a title that denoted the profound respect in which they were held—Our Mothers in Israel. All three were blessed with long years of service. Mary Morrison died April 29, 1851; Mary T. Graft on August 5, 1862, at age eighty-nine; and Mary Ogle on January 1, 1863, at seventy-nine years of age.[9]

New England Christian Evangelists
Nancy Gove Cram

Nancy Gove was born in Weare, New Hampshire, in March 1776. Despite a disappointing marriage to Mr. Cram, who left her for another woman, Nancy Cram remained faithful to her calling to spread the gospel. And although she maintained a lifelong membership with the Free Will Baptist Church, her sympathies were always with the Christian Church.

About 1812 Nancy Cram began her evangelistic work in upstate New York. Her prayers are reported to have given worshipers such a profound glimpse of eternal life that weeping members of the audience regularly converted. Nancy Cram had no luck finding a Baptist minister who would come to

baptize her converts and establish a church, so she turned instead to the Christians. Three ministers responded, opening the way for Nancy Cram to establish the churches of Four Corners and Galway in Charleston, New York. Unfortunately, Mrs. Cram died at the age of forty after only four years of ministry.[10]

Abigail Hoag Roberts

Abigail Hoag was born in Greenbush, Rensselaer County, New York, on February 17, 1791, and raised in the Quaker faith (where she became accustomed to hearing women speak in church). She married Nathan Roberts in 1809, a man known for his support of his wife's evangelistic work. About Abigail's beliefs and motivation for service it was said:

> She may not have been a theologian—few women are—but she had in her the stuff of martyrs, and would have died for her cause. It is religion, and not theology, that forms the spiritual life of woman. She cares nothing for dogmas. It has been said that in the whole history of the world's opinion, no dogma of any weight has ever originated with woman. Wherein, if the statement be true, she shows points of superiority in intellect, as well as religion.[11]

Abigail Roberts was converted to the Christian Church by Nancy Cram. Although she encountered stiff opposition at every turn, both because she was a woman daring to preach and because she spoke out in opposition to the creeds and formulas of faith imposed by other churches, Abigail Roberts remained a loyal and courageous servant of the word. After a full life, Abigail Roberts died on July 7, 1841. Part of the legacy she left was in the work of her son Philetus, who followed in his mother's footsteps to become a pastor himself.[12]

Mary Stogdill

Mary Stogdill was baptized in the Greenville, New York, Christian Church and left shortly after that for upper Canada. There she converted hundreds of people who were then baptized and received by the Christian pastors from the New York Conference she could persuade to come to Canada. The Ontario Christian Conference dates its beginning to the work of Mary Stogdill in 1821.[13]

Singing Evangelists:
Edith Pelley and Princess Clark Long

In his 1904 history of the Churches of Christ, John T. Brown identifies Edith Pelley as a singing evangelist. She was born on November 7, 1883, baptized at age fourteen, and began her evangelistic work at age seventeen in Brandon, Iowa.[14]

Better known is Princess Clark, born in Van Wert, Ontario, on February 17, 1862, and raised as a Methodist. She married Disciple Edward Clarence Long in November 1887 and began her career as a soprano soloist. Mrs. Long was featured frequently at state conventions and served as a soloist at the Pittsburgh Centennial Convention of 1909.[15] J. W. McGarvey, writing in *The Christian-Evangelist*, reported that hundreds had been converted to the church after hearing Mrs. Long's gospel music.[16]

Mrs. Long credited her Methodist roots with giving her enthusiasm and the Christian Church (to which she converted as a young woman, shortly before her marriage) with giving her the substance of her faith. Particularly appealing to her was the Christian Church's refusal to adopt human creeds, and what she found to be the greater emphasis on the love and mercy of God rather than on the wrath of God.[17] Mrs. Long died March 7, 1950.

Sunday School Evangelist Turned Pastor:
Sadie McCoy Crank

Frontier churches during the revival period were less burdened by tradition than were the more established city churches. Women participated in revival services, praying and witnessing alongside men. Because of the shortage of ordained ministers in rural areas, churches often held teaching services and revival meetings using lay evangelists. Often participants in these services were moved by the Spirit to come forward and confess Jesus as Lord and Savior, and sometimes the evangelist who received them was a woman. This somewhat awkward situation led directly to the ordination of Christian Church women. For most early Disciples, ordaining women was probably more a matter of necessity than theological conviction.

The clearest example of theological and cultural misgivings about the ordination of women giving way to practical need began when the Illinois State Sunday School Society, under the leadership of James Rawser Crank, hired Sadie McCoy as a Sunday school evangelist.

> At Marceline, Illinois, she was holding an institute and answering Bible questions. One night as a closing hymn was sung a person came forward to make the good confession. Sadie asked herself, What shall I do? Then she remembered what her pastor had asked her a few years previous. She asked the same question. The next night others came to make the good confession of faith— 96 came before the institute closed. The revival was unplanned. Sadie sent for a preacher to do the baptizing.[18]

The church was faced either with denying the confession of these ninety-six people or with recognizing a woman's authority to receive them.

The decision was made when Sadie McCoy was ordained in Marceline, Illinois, on March 17, 1892, and no longer had to send for a man to do the baptizing. During her illustrious career Sadie baptized between five thousand and seven thousand people (sources differ), officiated at 361 weddings and more than one thousand funerals,[19] organized or reorganized fifty churches, and assisted in eighteen church building programs in Illinois and Missouri—outstanding achievements.[20]

Sadie McCoy was born in a log house near Breckenridge, Illinois, on August 15, 1863. She remembered her mother as generous, kind, used to gracious living, and acquainted with notables (having been entertained before her marriage in the home of Daniel Boone), but as burdened with the care of twelve children, ten of whom survived infancy. Sadie's father was her mother's frequently drunk second husband. Although a charmer in some ways, he failed to support his family, lost their inheritance through gambling, abused his daughters, and drove away two of his potentially income-producing sons.

When Sadie was sixteen, her mother arranged for her to work in the home of the county school superintendent in return for room, board, a small salary, and the opportunity to continue her education to become a teacher. Sadie's father opposed the plan and almost prevented her from realizing her

dream. But Sadie was a determined young woman, and with the help of her mother, siblings, and a few good friends, escaped from her father.

The story went like this. On the Sunday before school was to start, Sadie's father, accurately fearing she would try to leave, pastured the horses and mules more than a mile away from the house, then left, taking the wagon, bridles, and lines with him. Later in the day, Sadie headed off alone, captured a blind mare and a crippled mule, and led them both to a neighbor's house, intending to borrow a wagon. But before she could use the wagon Sadie had to empty it of a full load of apples. Then with clothesline ropes and the sack strings and bits of cloth she and her mother had resourcefully gathered, Sadie devised a hitch and lines for the animals and set off for a girlfriend's house. The friend agreed to take Sadie's belongings to school for her, and Sadie returned home intending to walk the twenty-three miles to school on Monday. Once established in the superintendent's home, Sadie became the sole support of her mother and siblings.[21]

In one of her father's last contacts with the family, Sadie records this event.

> My father returned home from one of his drunks and tried to impose a drunken companion on my sister, two years younger that I, who had just come into womanhood. She escaped and ran three quarters of a mile barefoot in a muslin gown that cold winter night to a neighbor. The exposure brought on finally epilepsy that weakened her mind to suicide.[22]

After his final desertion of the family, James McCoy, "spent his last days near the Kansas-Nebraska line serving the community as Indian doctor when sober, preaching the Primitive Baptist doctrine when drinking."[23]

During her early years, besides the Primitive Baptist faith of her parents, Sadie was exposed to pioneer preachers and evangelists. Their emotionalism and adherence to strict Calvinistic creeds (and surely her father's behavior as well) almost turned her into an atheist. Fortunately, when she was twenty-four, "a Christian Church preacher, Elder Wilson, presented the Gospel in a new light and placed the responsibility of accepting or rejecting [it] upon her."[24] Sadie was baptized in Bear Creek, Illinois, in May 1887. Along with her school

teaching, then, Sadie began to organize Sunday schools and to set, inadvertently, the stage for her ordination in 1892.

A year later in 1893, Sadie was married to J. R. Crank. Despite not infrequent opposition from church leaders and local congregational boards, J. R. always encouraged his wife to continue to live a life true to her call. Together they developed an impressive library and Sadie McCoy Crank continued her study of scripture. Although Sadie received numerous requests to move to big city churches during her years in the ministry, she believed her call to be among the rural folk of her roots.

As many of her sisters today, Sadie McCoy Crank balanced well the public and private spheres of her life, calling her significant temperance work with the Illinois Woman's Christian Temperance Union and her service with the Christian Woman's Board of Missions her "side line," and her three daughters and one son (all college graduates) her "big task."[25] At her death, a male pastor likened her to Mary; to her family she was surely their Martha. Perhaps for us she was one of the earliest Disciples women to combine successfully the two roles.

> Many women are distinctly the "Martha" type. They are doers rather than dreamers....They are worth their weight in gold to their families. Their price is far above rubies. Not so numerous, but more noticeable are the "Marys" of life. They are capable of the deepest devotion and severest sacrifice. Their contribution to civilization is beyond computation.[26]

Who Was the First? Some Possibilities

Because pastors were ordained by congregations or conferences, it is difficult to determine with certainty who was the first ordained woman in the Stone-Campbell tradition. The earliest woman ordained in the Christian Church that I have found is Ellen Grant Gustin, who was ordained by the Miami Christian Conference in Newton, Ohio, in October 1873. She spent most of her ministry in the New Bedford, Massachusetts, area. Emi B. Frank of Indianapolis may have been ordained about the same time. These two ordinations were reported in the *Woman's Journal* before 1882. Apparently the

men present approved the ordination without dissent and urged the conference to encourage young women to enter the ministry.[27]

Melissa Garrett was born in Adams County, Ohio, in 1834. She was married to Reverend W. H. H. Timmons, and after that, to Mr. Terrell. Melissa Terrell was ordained by the elders of the Ebenezer Church, Clark County, Ohio, on March 7, 1867. Later that year the Deer Creek Conference met and determined that, by virtue of the action and authority of her local church, Melissa Terrell was an ordained minister in good standing in the conference. However, in their official statement the officers of the conference remained opposed to the ordination of women.[28] Melissa Terrell served pastorates in Ohio, Iowa, and Missouri.

In a sermon preached before the Southern Ohio Conference in 1877 and later printed and widely distributed, Melissa Terrell spoke on the importance of the prophecy of handmaidens on whom the Spirit has been poured. Melissa Terrell's ability as a preacher and her humility in service led to her acceptance as an ordained minister in the Christian Church, at least among those who knew her as a pastor and preacher.[29]

Three couples were ordained for missionary service by the General Missionary Society in a controversial service in 1883. Isaac Errett, as editor of the *Christian Standard*, supported the ordination of the three women involved: Laura D. Garst, Mary L. Adams, and Josephine W. Smith.[30]

The First: Clara Hale Babcock

Although she followed the lesser-known ministries of her sisters Ellen G. Gustin, Emi B. Frank, Melissa Terrell, Laura D. Garst, Mary L. Adams, and Josephine W. Smith, Clara Celestea Hale Babcock is commonly credited with being the first woman ordained for preaching in the Disciples tradition. She was born on May 31, 1850, in Fitchville, Ohio, married Israel R. Babcock in 1865, and was the mother of six children. Clara was an active Methodist who was converted to the Christian Church at the age of twenty-five after attending a series of meetings conducted by evangelist George F. Adams. In particular, Clara valued the teaching of the Christian Church regarding baptism.

Clara Hale Babcock

Several obituary notices report that Mrs. Babcock was ordained in 1888. However, Glenn Zuber found more convincing evidence to suggest that she began preaching at Erie (Illinois) Christian Church in 1888 but was not ordained and installed as its pastor until August 2, 1889. Andrew Scott, pastor of the Sterling (Illinois) Christian Church, conducted the ordination service.[31] So, at the age of thirty-nine, Mrs. Babcock was ordained and went to work primarily as an evangelistic preacher in northwestern Illinois and eastern Iowa.

In the twenty-eight successful revival meetings Mrs. Babcock conducted during the first twenty-nine years of her ministry, she converted fourteen hundred people.[32] Mrs. Babcock also held fairly long pastorates in at least four churches and was responsible for organizing the congregation at Rapid City, Illinois. At her death in 1925, Mrs. Babcock was pastor of the Savanna, Illinois, church and had just baptized her 1052nd convert. Like Sadie McCoy Crank, she was active in the Illinois Woman's Christian Temperance Union and was remembered in her obituary by those who knew her for her "strong intellect, clear presentation of the Scriptures, and effective appeal on behalf of Christ."[33]

A Pastor to Pastors: Jessie Coleman Monser

Another early Disciples woman minister, Jessie Coleman Monser, was ordained in 1891 and continued in the ministry until her retirement in 1944. Jessie was known as a lecturer for the Christian Woman's Board of Missions, a coauthor with her husband of a cross-referenced Bible, and as pastor of

several churches in Illinois. Mrs. Monser's first pastorate was in Malden, Missouri, a post she assumed when her husband was forced to give it up during a long illness. As with many other women pastors, Jessie found easier acceptance when she followed her husband into the pulpit.

In 1931, Mrs. Monser spoke to a national meeting of ministers' wives. She spoke first of the church's mandate to embrace women ministers:

> Only as men and women seek truth together and together build for a complete humanity can either come to the fullness of life. Both men and women are needed to make the Church full-orbed and complete.[34]

Mrs. Monser went on to quote from letters she had received from other women ministers. The joy they experienced in response to their call to the ministry was tempered by the heartache of discrimination—subsistence wages, no pensions, difficult journeys on mule-back to small mountain churches, long hours caring for both family and parish, and the struggle for academic training. Mrs. Monser closed her remarks with these words,

> For a full 40 years I have been exalting, eulogizing, praising, dramatizing, memorializing and holding, almost as saints, the women who have gone to the foreign field. Now my heart burns within me and bleeds in sympathetic pity as I read replies to letters written to our women preachers. There is praise, pathos, suffering, privation, humor and physical endurance that is almost unthinkable.[35]

Opposition to Women Preachers

Full and enthusiastic acceptance of ordained women was sorely lacking in the early Disciples church, undoubtedly discouraging many who did not have the self-confidence to pursue their dream in a sometimes hostile church. Courageous women who found a voice with which to speak and respond to their call did not find widespread sympathy among the men who controlled access to theological education, church boards, and periodicals.

Alexander Campbell, for instance, while espousing the concept of the priesthood of all believers, dismissed the question of women speaking and praying in church by saying, "I submit to Paul, and teach the same lesson."[36] The periodicals of the time (especially the *Christian Standard, Millennial Harbinger*, and *The Christian-Evangelist*) contain articles opposing women who presumed to speak the gospel and those who supported their efforts.

One of the most intense debates occurred in the pages of the *Christian Standard* from 1892-1893 when twenty-nine different authors discussed the issue, with twenty-one clearly in favor of ordaining women and six clearly opposed. The chief opponents were John B. Briney, a church leader known for his debating skill in opposition to Darwinism, and Morgan P. Hayden, a noted Midwestern preacher. Advocates included Persis Lemon Christian, a regular contributor to the *Christian Standard;* Clara Babcock; three nineteen-year-old girls; missionaries Oliver A. Carr (husband of Mattie Forbes Myers Carr) and George T. Smith; and many others. The debate centered around the proper interpretation and application of scripture, the role of culture in church polity, the critical need for evangelists in the church, the inherent status of women, and the authoritative function of preachers and evangelists.[37]

Disciples women were not alone. Early American women preachers from other traditions were also discouraged in their attempts to become ordained. The contributions of women who might well have become the Fred Craddocks, K. David Coles, C. William Nichols, or Joan Brown Campbells of their time were lost to us as women turned their considerable talents instead to social activism. Mary Ellen LaRue argues that abolitionist Harriet Beecher Stowe, pacifist Julia Ward Howe, feminist Susan B. Anthony, and temperance advocate Frances Willard, all active church women, would have become ministers had they lived in a different time. Indeed, Frances Willard once wrote, "If I had been a man the pulpit and politics would have been my field."[38]

Despite lack of education and financial support, and considerable opposition, numerous women felt an inescapable call to ministry. For them the power of the Holy Spirit was stronger than what they perceived to be discriminatory church custom and misinterpretation of scripture. Barbara Kellison was one of the first Disciples women to call to the public's

attention the question of the church's position on women ministers, presenting her views on the rights of women in the church in a pamphlet published in 1862. Kellison, a member of the Iowa Conference, carefully documented specific biblical references highlighting the various ministries of women in the New Testament church, concluding that, "You might as well try to convince me that I have no soul as to persuade me that God never called me to preach his Gospel."[39]

In Defense of Her Call: Marinda R. Lemert

Disciple Marinda R. (usually known as M. R.) Lemert of Hebron, Ohio, is probably the best known early Disciple spokeswoman for the rights of women ministers. After nearly a lifetime of frustrated attempts to get church leaders to take the question of women's ordination seriously and to give it sound theological study, Marinda Lemert set about through her own study to force the issue. Mrs. Lemert reported the results of her study in a series of articles written for *The Apostolic Guide* in 1888. In them she took on the likes of J. W. McGarvey and others, addressing one by one the arguments used by those who advocated silencing women in the church. In her conclusions, she writes:

> The doctrine that seals woman's lips in the church assembled...is a heresy....It impeaches the wisdom of God. It accuses him of acting in bad faith with woman— of mocking her. It also impeaches Paul—accuses him of transcending his mission; of contradicting himself— pulling down what he has built up—in short, of committing moral suicide. Further, it deranges or destroys the divinely constituted relation of the sexes, in that it exalts the man above God, in demanding supreme honors of woman; it rejects woman as helper, and brings her, as a religious being down on a level with traditional animals.[40]

Further, she writes that her conclusions were,

> reached by nine years' careful and prayerful study of God's Holy Word upon this subject, and of nine years' combat with the...self-appointed guardians of female modesty, who have had their dreams so disturbed lest the sisters should tarnish their modesty by speaking of

Jesus as the Savior of the lost [and] who had better bestir themselves.[41]

Women such as Marinda Lemert and Barbara Kellison were willing to follow Priscilla and risk at least their reputations and standing in the community, if not their lives, for the right of women to preach the gospel. Unfortunately, many of those who led the fight for a woman's right to be ordained never saw the full fruition of their life's work. Marinda Lemert was seventy-eight years old when she wrote her stirring words in 1888, and died a few years later.

An African-American Pastor: Sarah Lue Bostick

Despite the failure of many of the guardians of tradition to bestir themselves, the ministry of courageous women developed in a number of different arenas. Sarah Lue Bostick, an African-American woman, overcame both the bias against women and the prejudice against blacks during the last half of the nineteenth century by becoming a noted preacher in both black and white churches, primarily in Arkansas. Mrs. Bostick had an insatiable thirst for knowledge, working her way through the equivalent of the eleventh grade at age thirty-five, and embarking on a lifelong study of the Bible. Mrs. Bostick was instrumental in organizing black women in a number of Arkansas Christian churches, probably without ever holding a pastorate. She went on to became a national worker for the Christian Woman's Board of Missions in 1901, working primarily in Texas.[42] Mrs. Bostick represents African-American women who were recognized by and functioned admirably as preachers and evangelists in the church.

Pastor to the Struggling Churches: Bertha Mason Fuller

Bertha Mason Fuller, Mrs. Bostick's biographer, was herself a minister, ordained August 26, 1896, in Houston. Her first pastorate began when she assumed leadership in her home church after illness incapacitated her pastor husband. Like many women ministers of the time, Mrs. Mason devoted herself to small, struggling churches, writing in a letter to the Pension Board, "I have held many pastorates in both Texas and Arkansas, usually churches no one else would have."[43] In

addition to her work as a minister, Mrs. Fuller served the Christian Woman's Board of Missions faithfully for twenty years as Arkansas secretary.

Clara Espy Hazelrigg: Convertor of Jesse Bader

Clara H. Espy Hazelrigg was ordained in 1897 at the age of thirty-seven, after service as a public school teacher, a superintendent of schools, an author of some repute, an active member of the Kansas Woman's Christian Temperance Union, and the Kansas secretary for the Christian Woman's Board of Missions. Mrs. Hazelrigg served as an evangelist in an eight-state area of the

Clara Hazelrigg

Midwest and West and raised the money needed to build the West Side Christian Church in Topeka, where she served for eighteen years. She is probably best remembered as the pastor who converted Jesse Bader, one of the most outstanding male evangelists of the Christian Church.

As part of his evangelistic ministry, Jesse Bader was a broadcaster, world traveler, and the General Secretary of the World Convention of the Churches of Christ. He combined evangelical and ecumenical work in his position as the first Director of the Department of Evangelism of the National Council of Churches of Christ. Jesse Bader's foremother in the faith, Clara Hazelrigg, argued persuasively in an address to the Minneapolis Evangelistic Convention titled, "Help Those Men,"[44] that the work of the church in spreading the gospel cannot be accomplished without the assistance of women.

Preparation, consecration, inclination, make up a call to the ministry, not sex or previous condition of

servitude....The roughest and surliest men treat women in the ministry with chivalric courtesy. All classes of women lay bare their souls to a minister of their own sex. Young people meet her frankly. Let fitness be the requisite.[45]

First Woman with a Divinity Degree: Ellen Moore Warren

It was well into the twentieth century before women were accepted as full-time, degree-seeking students in divinity schools. Mrs. Gustine Courson Weaver, one of the first women to attend classes at the College of the Bible (now Lexington Theological Seminary) recorded her experiences as one of J. W. McGarvey's students in 1895.

> The doors of the College of the Bible were opened wide enough for the slender Miss to squeeze through, that is, if, demanded Brother McGarvey, she sit on the back seat, next to the door, and if at the close of each session— when I nod my head to her, she arises at once and leaves the room before I dismiss my class—also if on days when I decide our text is questionable and she finds a note written by me on her desk—she quietly withdraws, before the class begins—yes—if—also she always arrives—after the men students are all seated and we have started well in the lesson—and if—she speaks to none of the men students.[46]

Ellen Moore Warren (married to Louis A. Warren) was the first ordained Disciples woman to hold a divinity degree. She graduated from Transylvania College in 1914, from the College of the Bible in 1916, and was ordained on June 10, 1923. At the beginning of her career, Mrs. Warren gained acceptance by serving as a guest preacher in area churches (both Disciple and others) and by filling in for her husband once a month when he preached elsewhere. At her ordination, she was recognized for her "unusual ability, excellent training, and unbounded enthusiasm."[47]

Many Others

In 1918, the International Women Preachers' Association was founded in St. Louis. In 1920, Disciples minister Lulu

Hunter of Chicago became the vice president of the group. Disciples pastor Mary Lyons of Cleveland later became president. The stories of these and the many other women ministers in the Disciples tradition are less well known, but their memory lives on in the work they were able to do in proclaiming the gospel.[48]

Today's Ministers

Early Disciples women ministers, particularly those who tried to follow the traditional male path to ordination, faced almost insurmountable problems. They were denied access to higher education and training in divinity schools. Those who did receive training were encouraged or obliged to enter nonpastoral positions. If called to pastorates, they were asked to serve struggling churches no one else wanted. Their salaries were lower than those of men and they received no guaranteed pensions. Women who established themselves first as pastors' wives, then took over churches after their husbands died or became ill, fared somewhat better, being more readily accepted by their congregations. And as always, there was a place for a few exceptional women who found acceptance because of their undeniable gifts. Sadie McCoy Crank was one of those whose life was infused with a spirit that refused to die to the tribulations of the flesh.

> In 1910 the Crank family moved to Mt. Vernon, Missouri. J. R. Crank preached there first. There was prejudice against women preachers. Some of the members refused to shake hands with Mrs. Crank when she first preached there but were soon won over by her forceful preaching. By the close of the year, Mrs. Crank was the pastor.[49]

Jessie Monser reported that in 1931 there were 365 women ministers, eighty-five of whom were pastors.[50] In 1952, a United Church Women survey showed 298 ordained Disciples women, thirty-nine in pastorates.[51] Following that report and at the request of the National Council of Churches, a committee was convened to consider prayerfully the status of women in the Christian Church. This committee, made up of women leaders in the church as well as four men—A. Dale Fiers, W. E. Garrison, Perry Gresham, and Howard Short—called for "the

recruiting of women for the ministry with full opportunities for service."[52] Still, almost twenty years later, in 1972, fewer than 1 percent of ordained Disciples were women.[53]

In recent times women have made some gains. In June 1990, 15 percent of ordained Disciples ministers were women; 8.6 percent of those serving churches as senior or solo pastors and 38.8 percent of associate pastors were women; and 43 percent of Disciples divinity students were women.[54] Yet the average woman serving a parish earned only 77 percent of the salary earned by her male counterpart.[55]

> Everywhere women ministers face longer periods of unemployment, lower salaries, less opportunity to shoulder the full responsibility for parishes—especially larger ones—and less likelihood of appointment or election to leadership positions within ecclesiastical structures.[56]

Many of the women of today can relate directly to the experiences of early women ministers. Many continue to feel the urgency of the call and the hesitancy of the church community to support the call.

> What women in ministry want is no different than what men in ministry want; that is a place to exercise the variety of gifts given to them by the God who has created each of us to be divine image bearers.[57]

In Memory of the Daughters of Priscilla

Jesus gave many gifts to the women of his time and encouraged them to use these gifts in service to the gospel. He first revealed his Messiahship to the woman at Jacob's well. He spoke again with Martha of Bethany of his power to lead the way to eternal life. And Jesus' resurrection was first discovered by Mary Magdalene and her women friends, who spread their good news to the male disciples. In remembrance of these gifts, in memorial to Disciples women ministers of old who paved the way for us, and in solidarity with the daughters of Priscilla of today, the following short pageant is reprinted. It was published in 1943 in the *Christian Standard*[58] for use by the Christian Women's Fellowship and could easily be adapted, updated, and performed today as part of a Christian Women's Fellowship program.

An Opportunity to Respond:
Jesus Speaks to Women

A Short Pageant

This service is designed to use five women: One as *Narrator*, three *Readers*—reading the accounts of the Samaritan woman, Martha, and Mary Magdalene—and a *Soloist*; or, if the committee desires, a *Chorus* may be used instead.

The platform should be beautiful, with Easter decorations. If possible, arrange a cross at the center-back. This cross should be dark as the *First Reader* reads, then dimly lighted as the *Second Reader* nears the end of her scripture, and fully lighted as the *Third Reader* finishes her reading.

The pianist plays a medley of Easter hymns, and as she nears the end of the score the *Narrator* and *Soloist* take their places at either side of the platform. Both should know their lines so well it should only be necessary for them to merely glance at their scrolls.

Narrator: (holding scroll in her hand and speaking in a clear, distinct manner) Our Lord used every opportunity to show men and women the way to eternal life. He braved the sneers and threats of the Pharisees many times, but He continued going about and doing good. And so it is that we find Him one noonday sitting at Jacob's well in the beautiful Valley of Sheehem in the country of Samaria. The Jews despised the Samaritans so much that they would go many miles out of their way to avoid setting foot on Samaritan ground. But when Jesus decided in that first year of His ministry to leave Judea and return to Galilee, He chose the short route, which would take Him through Samaria, and when they came to Jacob's well he sent His disciples into the city of Sychar to buy food, while He, weary with the journey, sat by the well to rest. A Samaritan woman came to the well to draw water, and Jesus, knowing that she needed spiritual food, brushed aside the Jewish tradition that a rabbi might not converse with a woman on the street, not even his wife, and asked her to give Him a drink.

First Reader: (if dressed in biblical costume should read the scripture from a scroll, but if not, reads it from the Bible— John 4:7–27). {Takes place at the left of cross.}

Soloist: (sings first verse of "The Old Fountain")

Narrator: Yes, the first time that Jesus revealed his Messiahship was on that day by Jacob's well in the beautiful valley of Sheehem, when he said to the Samaritan woman, "I am he, the one that is speaking to you."

And now we see Jesus in the last days of his earthly ministry receiving word from Martha and Mary, of Bethany, that their brother and his beloved friend was sick. And because our Lord recognized that the opportunity was at hand to show the glory of God and to glorify his Son, he tarried two days before he started for Bethany. His disciples, knowing the Jews meant to harm him if he came into Judea, urged him to forgo the journey, but Jesus, knowing all things, steadfastly turned his face toward Bethany, and his disciples went with him.

Second Reader: (reads slowly and distinctly John 11:20–28). {After reading, takes place at right of cross.}

Soloist: (to the tune of "The Old Fountain")

Martha met him that sad day.
Heard his dear voice gently say
Words that brought her hope and comfort,
long ago;
Heard him call her brother's name,
And from out the tomb he came,
For they trusted in that Fountain, long ago.

Narrator: This was the first time he had spoken the greatest message in the world, "I am the resurrection and the life, those who believe in me, even though they die, will live"; and it was given to a woman—Martha of Bethany.

It has been said that in life woman was Christ's comforter, in death his chief mourner, and in the resurrection his herald. And now we see Mary Magdalene and her group of faithful women who stood at the cross carrying spices to the tomb to anoint the body of their Lord. Perhaps the birds were singing to each other in that early dawn as the women went on their way; but if they were singing, the melody was not heard, for the entire attention and thoughts of the women were on the huge rock at the door of the tomb and how they could roll it away. They went on, never dreaming that the stone on their hearts would soon be

rolled away just as that which closed the tomb had been rolled from its place when they arrived.

Third Reader: (reads in a clear, sympathetic voice John 20:1–19 or John 20:11–19). {If the cross is elevated as it should be this speaker stands in front of it.}

Soloist: (to the tune of "The Old Fountain")

Through the early morning gloom,
Mary hastened to the tomb,
And her eyes were opened there long ago:
Saw and heard her risen Lord,
Carried the first gospel word,
Of that Fountain that was opened, long ago.

Narrator: The women of long ago were privileged to minister personally unto their Lord; and he, looking down through the ages, has made it possible for us to minister unto him. He must have been speaking to the women of today when he said, "Inasmuch as you have done it unto me." Yes, if we are worthy to follow the Master, as those women of long ago, he speaks to us in his gentle voice and we can be privileged to carry the spices of the gospel to those in the tomb of sin and ignorance and see them rise to a new life in Christ Jesus.

Soloist: (sings the last verse of "The Old Fountain")

Note: Those taking part may wear robes; but if robes are not worn then care should be taken that the colors of the clothing harmonize.

Notes

[1] Written after Mrs. Crank's death by an anonymous pastor who had known her for twenty-five years. Earl Truman Sechler, *Sadie McCoy Crank (1863-1948): Pioneer Woman Preacher in the Christian Church (Disciples)* (Hermitage, Missouri: The Index, 1950), p. 49.

[2] I am grateful to Bonnie Bowman Thurston for sharing her work on New Testament deacons with me.

[3] Charles M. Laymon, (ed.), *The Interpreter's One-Volume Commentary on the Bible* (Nashville: Abingdon, 1971), pp. 753ff.

[4] Barbara Brown Zikmund, "The Struggle for the Right to Preach." In Rosemary Radford Ruether and Rosemary Skinner Keller, (eds.), *Women and Religion in America, Volume I: The Nineteenth Century, a Documentary History* (San Francisco: Harper & Row, 1981), pp. 193-241.

[5]*Ibid.*, pp. 193-194.

[6]Charles L. Loos, "Obituary Notices," *Millennial Harbinger* series 5, vol. 6 (January, 1863), p. 45.

[7]Hiram J. Lester, "Three Marys," in Peter M. Morgan, (ed.), *Disciples Family Album: 200 Years of Christian Church Leaders* (St. Louis: Chalice Press, 1990), p. 31.

[8]Jonathan J. Schell, "Obituary Notices," *Millennial Harbinger* series 5, vol. 6 (February, 1863), p. 95.

[9]See also, Alexander Campbell, "Obituary," *Millennial Harbinger* series 4, vol. 1 (June, 1851), p. 358.

[10]J. F. Burnett, *Early Women of the Christian Church: Heroines All* (Dayton Ohio: Christian Publishing Association, 1921), pp. 9-13.

[11]*Ibid.*, p. 17.

[12]*Ibid.*, pp. 15-24.

[13]*Ibid.*, pp. 31-40.

[14]John T. Brown, *Churches of Christ: A Historical, Biographical, and Pictorial History of Churches of Christ in the United States, Australasia, England, and Canada* (Louisville: John P. Morton & Co., 1904), p. 547.

[15]"Obituary," *The Christian-Evangelist* 88 (May 17, 1950), p. 497.

[16]J. W. McGarvey, "Mrs. Princess Long," *The Christian-Evangelist* 61 (April 14, 1904), p. 485.

[17]Princess Long, "How I Became a Christian," *Christian Standard* 61 (April 22, 1905), p. 636.

[18]Sechler, *Sadie*, p. 6.

[19]Mary Ellen LaRue, "Women Have Not Been Silent: A Study of Women Preachers Among the Disciples," *Discipliana* 22 (6) (1963), pp. 88.

[20]"Crank, Sadie McCoy," *Christian Standard* 84 (November 6, 1948), p. 737.

[21]Sechler, *Sadie*.

[22]*Ibid.*, pp. 4-5.

[23]*Ibid.*, p. 1.

[24]*Ibid.*, p. 6.

[25]*Ibid.*, p. 43.

[26]*Ibid.*, p. 49.

[27]Phoebe A. Hanaford, *Daughters of America; or Women of the Century*. (Augusta, Maine: True and Company, 1882), pp. 468-469.

[28]Burnett, "Early Women," p. 26.

[29]*Ibid.*, pp. 25-30.

[30]See Mary Ellen Lantzer, *An Examination of the 1892-1893 Christian Standard Controversy Concerning Women's Preaching* (Johnson City, Tennessee: Emmanuel School of Religion, 1990).

[31]Glenn Zuber, "'The Gospel of Temperance': Early Disciple Women Preachers and the WCTU 1887-1912," *Discipliana* 53 (2) (Summer, 1993), pp. 47-60.

[32]Bea Smith, "Clara Hale Babcock," in Morgan, *Disciples Family*, p. 68.

[33]B. H. Cleaver, "Mrs. C. C. Babcock: Effective Preacher Thirty-Seven

Years," *The Christian-Evangelist* 62 (December 31, 1925), p. 1703.

[34]Jessie C. Monser, "Women in the Ministry," *The Christian-Evangelist* 68 (November 19, 1931), p. 1530.

[35]*Ibid.*, p. 1530.

[36]LaRue, "Women," p. 87.

[37]Lantzer, *An Examination.*

[38]LaRue, "Women," p. 86.

[39]Zikmund, *Women*, p. 223.

[40]Reprinted from *The Apostolic Guide* (May 14, 1886) by Elizabeth Hartsfield, *Women in the Church: A Symposium on the Service and Status of Women Among the Disciples of Christ* (Lexington, Kentucky: College of the Bible, 1953), pp. 14-15.

[41]M. R. Lemert, "Universal Equality of the Sexes in Christ," *Christian Standard* 23 (June 16, 1888), p. 374.

[42]LaRue, "Women."

[43]*Ibid.*, p. 89.

[44]J. H. Garrison wrote an article entitled "Help Those Women" in support of the fledgling Christian Woman's Board of Missions. Mrs. Hazelrigg's title was probably a take-off on Garrison's.

[45]Clara Hazelrigg, "Help Those Men," *Christian Standard* 38 (January 18, 1902), p. 83.

[46]Hartsfield, *Women*, p. 12.

[47]"Mrs. L. A. Warren Ordained," *The Christian-Evangelist*, 60 (June 28, 1923), p. 818.

[48]LaRue, "Women," p. 89, provides a partial list of early ordained Disciples women: Miss Foster, Alice West Cole, Mrs. Bishop M. Hopkins, Mrs. Samuel B. Waggoner, Marjorie T. Haines. Lantzer, *An Examination*, lists 15 women who entered the (not necessarily ordained) ministry from Illinois.

[49]Sechler, *Sadie*, p. 18.

[50]Monser, "Women," p. 1530.

[51]LaRue, "Women," p. 89.

[52]Howard Elmo Short, "The Service and Status of Women Among the Disciples of Christ," in Hartsfield, *Women*, p. 25.

[53]Brereton and Klein, "American Women," p. 189.

[54]LaTaunya Bynum, "The Situation and Trends in the Ministry of Disciples Clergywomen Six Years Later," *Discipliana* 51 (Fall, 1991), pp. 35-37.

[55]Information provided by the Pension Fund of the Christian Church (Disciples of Christ).

[56]Brereton and Klein, "American Women," p. 172.

[57]Bynum, "The Situation," p. 37.

[58]Louise Miller Novotny, "Jesus Speaks to Women," *Christian Standard* 78 (March 20, 1943), p. 258. Copyright 1943. The Standard Publishing Company, division of Standex International Corp., Cincinnati, Ohio. Used by permission.

Gifts of Prophecy

Social Reformers and Ecumenists

There is no use in saying what people are ready to hear![1]

*I*n some senses it is rather superfluous to have a separate chapter for social reformers. All of the women who are subjects of this book are reformers in some way. Certainly women who founded the Christian Woman's Board of Missions and National Benevolent Association and those who insisted on their right to preach courageously risked ostracism as they sought to be loyal to what they saw as their scriptural imperative. These women were also among modern-day prophets, those who continue to speak for God on earth. Speaking the truth as it is revealed to you is often difficult. Frequently prophets are rejected in their own villages and in their churches. And yet, the women of this chapter felt it their special obligation, even in the face of opposition, to call into question and seek redress for the evils of their time.

Many of the names in this book recur. Leaders of the Christian Woman's Board of Missions were especially likely to be involved in other reform movements. The conditions of

nineteenth-century America and American women in particular brought about an inescapable call to prophesy that found voice in a variety of interrelated areas.

Christian Church women were united in their motivation for service. The God they knew through daily prayer and Bible study spoke to them of their obligation as Christians. Although rarely in possession of formal theological education, the service these women performed was rooted in the soundest understanding of the biblical call to a works-oriented faith. The combination of the all-too-obvious secular needs of the time, and the strong biblical conviction of church women, led them to make substantial contributions in temperance, suffrage, the abolition of slavery and education of freed blacks, better treatment for working women and children, care for immigrant families, and the early peace and ecumenical movements.

> Moral reformations...blend with each other like the colors of the rainbow; they are the parts only of our glorious whole and that whole is Christianity, pure practical Christianity.[2]

Motivations for Service

A number of events converged to activate church women for reform work. One important factor was their access to greater educational opportunities. Female-only seminaries, many sponsored by Disciples, opened around the country. No longer were women trained purely for domestic work. Curricula were increasingly patterned after male-only schools. Many of the specifically church-related female seminaries had as their purpose training women for missionary service. In foreign mission fields, women who were not allowed to preach, teach, administer, or doctor at home found opportunities for expression of their talents and faith.

The Civil War, so detrimental to our country in so many ways, had the positive outcome of empowering women. Women learned skills needed for nursing and other support services on the battlefield, and for administering farms and businesses at home, including making independent financial decisions. Once the war was over, newly confident and skilled women had a basis for transition to peacetime work.

Reform movements often do not begin among the most oppressed, but among those with the eyes to see oppression and the time, money, and energy to do something about it. Such was the case with the reform movements led by American church women. Middle- and upper-class women with sufficient family resources—able to hire others to care for their children, accomplish the work necessary to maintain a home, and manage the household workers—ran the risk of succumbing to idleness. The thought of spending one's days adorning oneself for the appreciation of others and dying without accomplishing anything important beyond the self was another part of the impetus that drove some women to church and charitable work.

> Can woman be content with this aimless, frivolous life? Is she satisfied to lead a mere butterfly existence, to stifle and crush all aspirations for a nobler destiny, to dwarf the intellect...and desecrate all the faculties which the Almighty Father has given her and which He requires her to put to good use and give an account thereof to Him?[3]

The dawning realization that women were accountable to God rather than to men for their earthly behavior was another key to their independent activity. A rereading of scripture through the clear eyes of equality led to a new understanding of the role of women in creation.

> Woman was not exempt from the demand for righteousness on the grounds of her supposed inferior mental and moral faculties. Nor was she to bear the exclusive burden of being the virtuous, pious sex, while man went about his business unencumbered by morality....The reformers insisted that both sexes were called to righteousness. Both were intellectually equipped to choose the just course of action.[4]

Women Speaking: Prophets of the Pulpit

Women who sought and fought for the right to preach in churches were among the earliest Disciple prophets and reformers. A member of the Christian Conference in Des Moines, Iowa, in 1862, Barbara Kellison, has left us a remarkable

statement of the biblical justification for the right of women to preach.[5] Her view was that the practice of Christianity should follow from its theology and that any question could be best answered with reference to scripture. In 1862 she published a forty-four-page pamphlet in which she systematically addressed various objections to women's rights in the church, citing scriptural references and pointing out inconsistencies in the arguments of those who opposed women speaking in church.

Interestingly, at one point she compares unfavorably the rights granted to women in the church in the mid-1800s to those granted to slaves. She argues that (male) slaves are considered equal to (male) masters in worthiness before God. Women, however, had to seek their salvation through their husbands. Barbara Kellison muses on the resulting strange sight in heaven, with women admitted only long enough to sing, or segregated in a corner by themselves. Kellison's words give voice to the depth of commitment felt by Disciples prophets more than one hundred years ago:

> [The word of God says that] she has a right to preach if God has called her to the work by his spirit. You might as well try to convince me that I have no soul as to persuade me that God never called me to preach his Gospel.[6]

A Rainbow of Reform

Commitment in one area of reform often demanded attention to other needs for reform. For example, Christian women who attempted to improve the living conditions of poor women and children living in bare subsistence found that these women frequently had habitually drunk husbands who not only failed to support them, but beat and abused them as well. Such realization led reformers into the temperance movement. When temperance workers found they could not count on male government leaders and policy makers to pass temperance legislation, they realized that women needed the vote, leading them into the suffrage movement. And the recognition of the financial and organizational power they possessed led church women to make more aggressive demands for changes in church polity and policy.

A Case of Dawning Awareness: Eliza Davies

There are numerous examples of church women whose consciousness was raised during the nineteenth century. Eliza Davies stands out as a woman who slowly and painfully came to realize that she was oppressed by her husband, found the courage to leave him, and went on to make wonderful contributions in reforming education for young women here and abroad.

Eliza Davies was born in Paisley, Scotland, in 1819. Her father died when she was just two years old and her only real memory of him was at his funeral. Eliza Davies described her mother as a cold and aloof woman who required absolute obedience from her daughter. Eliza remembers a time as a young child when her mother told her to dress in black even though she wanted to wear her pretty white dress. Although she obeyed, Eliza was confused by what seemed to her to be her mother's capricious behavior. It turned out that one of the members of the royal family had died and the black dress was a way of showing respect. Eliza's mother's explanation for why she didn't tell Eliza of the royal death was that she wanted to teach Eliza to obey without question. This early training (so unlike current advice on parenting) may have made it more difficult for Eliza later to leave an abusive husband.

Unfortunately, Eliza's mother's authoritarianism was accompanied by emotional coldness. Eliza remembered a number of times when she longed for her mother's embrace or for a compassionate, understanding ear, only to be literally pushed away by her mother.[7]

Eliza sought solace and direction for her life from the Presbyterian church, for which she was ridiculed by her mother. Finally, Eliza's unhappiness at home led her on a journey around the world ending in Australia. Eliza did not have the skills or education to support herself, so for a good part of her life she was beholden to families who took her under their care. Some of them were kind and acted in her best interests; some were not. After a time with one of the latter families, Eliza married Mr. Davies, an abusive tyrant. When he was drunk (which was often) he subjected her to unbelievable abuse. When sober, particularly in the presence of others, as is so often the case with spouse abusers, he was manipulatively gentle and thoughtful.

Eliza was trapped in this marriage—caught between what she believed was God's will for her life (to obey her husband and accomplish her wifely duties) and the horrors of the degrading treatment from her husband, caught in a cycle of alcohol-induced abuse and remorse, caught without resources to act independently, and isolated from her friends. In one particular incident Mr. Davies forbade Eliza from going to church.

> He swore at me, and I went to church with a heavy heart, and found, on my return, that I was locked out....I was stupefied with grief. I could not pray, and I wondered if God had forsaken me....Just then a rough hand was laid on my shoulder, and I was dragged unresistingly to the house, my bonnet and dress torn off me, and a thick rope, knotted and twisted, was whirled about my head and bare shoulders till I had no strength left to stand up under the blows....Meanwhile Mr. Davies went out and locked me in, all unconscious as I was.[8]

Finally Eliza was able to escape from her husband and return to Scotland where she met and was converted to the Disciples movement by Alexander Campbell. Eventually she went back to Bethany with him where she helped nurse ill Campbell relatives, shared their happy family life, and befriended Bethany College professors. Later Eliza became a faculty member at the newly opened Kentucky Female Orphan School (now Midway College) where she endowed two scholarships out of very limited income. Still later she opened several schools for poor children in Australia where she taught them about the Bible as well as to read and write. In her will, Eliza Davies stipulated that any woman's signature was sufficient to carry out the intentions of her will (in a time when a woman's signature had no legal value unless countersigned by a man).[9]

Although Eliza Davies hesitated for many years to write her autobiography, Bethany professor and friend of Alexander Campbell, Robert Richardson, finally convinced her to do so. Her book, painful to read, is a triumph of the spirit over human adversity, and a tribute to Alexander Campbell and others who recognized Eliza's significant gifts. The book is dedicated to the young women she loved, the pupils of the Kentucky Female Orphan School.[10]

Temperance Agitator: Carry Nation

Many Disciples women were active in the temperance movement in the second half of the nineteenth century. Among them are two women who took very different approaches to their reform work. Both saw that many of the social ills they were attempting to address could be traced directly to the abuse of alcohol. Their methods for redressing the evil they saw around them reflect their different life experiences.

Carry Amelia Moore was born on November 25, 1846, in rural Garrand County, Kentucky. Her father, George Moore, was a prosperous, slave-owning farmer with a restless nature who, by moving his family from state to state on speculative ventures, ended up losing his fortune. Her mother, Mary Campbell Caldwell (a distant relative of Alexander Campbell), along with many of her relatives, suffered from mental illness. For much of her life, Mary Moore believed herself to be a queen. Eccentricity, intense religiosity, and haphazard parenting characterized Carry's early family life.[11]

In 1855 Carry was baptized and united with Hickman's Mill Christian Church. At the age of twenty-one she married physician Charles Gloyd, the love of her life, who turned out to be an irresponsible drunk who died about six months after the birth of their only child, daughter Charlien. Charlien suffered from a facial deformity (which Carry thought was the mark of her ill-fated father) and spent much of her life in and out of mental institutions. Through Carry's experiences in her marriage to Dr. Gloyd she first became aware of the evils brought on by the abuse of alcohol.

After an unsuccessful stint as a schoolteacher, the young widow determined to find herself another husband. One almost has the sense that she decided to marry the next available man she came upon. For better or worse, that person turned out to be a lawyer named David Nation, a wandering farmer much like Carry's father, and a sometime preacher in the Christian Church, who was nineteen years older than Carry. David so thoroughly squandered their meager resources in poor management and speculation that Carry was forced to begin long and arduous hours as the keeper of a boardinghouse. Finally in 1889, financially destitute, Carry and David moved to Medicine Lodge, Kansas, where he became pastor of the Christian Church.

Throughout her life Carry heard voices and saw visions directing her work, but they became more pronounced in Medicine Lodge. She saw herself as an agent from God sent to destroy evil forces in the world. Indeed, her piety was so obnoxious to other members of the Medicine Lodge Christian Church that they withdrew from fellowship with her.[12]

The chief evil that caught her attention, of course, was alcohol abuse. Although the use of alcohol was illegal in Kansas by 1880, joints (as bars were called) flourished. Carry, a member of the Woman's Christian Temperance Union, began a campaign of passive resistance by praying outside the joints. When this, in combination with direct appeals to law enforcement officials to shut down the illegal joints, failed to produce results, Carry took more aggressive action. She began herself to shut down joints, using bricks, billiard balls, and rocks to smash liquor bottles and furnishings.

As might be expected, Carry's activities made many Woman's Christian Temperance Union members (who were by and large conservative women) and other church leaders uncomfortable. A number of articles in 1901 editions of *The Christian-Evangelist* criticized her methods, comparing them to lynchings, and advocated the use of prayer rather than hatchets in attempts to right social wrongs.[13]

Despite the opposition, Carry began to see her name and initials (carry a nation or can) as a sign of her calling. This insight (or delusion, depending on your perspective) fed the fire burning within her and propelled her to move her campaign to other Kansas cities.

> While Carry was quite outside the law, she was dealing with a lawless business. As a result of her activities arrests were made, officials made convictions, and Carry Nation accomplished in six months what other means and agencies had failed to accomplish in many years.[14]

In one of the most famous incidents, Carry Nation destroyed an elegant saloon and the picture that hung above its bar in the (ironically named) Carey Hotel in Wichita. The picture, which Carry thought was degrading to women, depicted Cleopatra at her bath with her attendants. After being arrested, Carry told her jailer, "You put me in here a cub; I'll come out a roaring lion."[15] And roar she did, through Kansas and then through the United States on a speaking tour.

Carry Nation had personal experience with the results of alcohol abuse in the death of her soul mate, Charles Gloyd. Combined with this jolting experience were her religious zeal and dominant personality. Regular means of public policy change were too slow for her. Today, some analysts see her actions with respect to temperance as comparable to those of John Brown with respect to the issue of abolition.

Eventually Carry Nation was divorced by her husband David Nation because of desertion (due to her being away from home so often). She died in Leavenworth, Kansas, on June 9, 1911, reportedly from paresis, the last stage of a mental illness caused by the syphilis bacteria.[16]

Following her death, and with the advantage of hindsight, an editorial in the *Christian Standard* praised Carry Nation for awakening a public consciousness and goading public officials to their duty.

> Opinions differ concerning Carry Nation. Her enemies insisted that she was insane. Some of her friends believed her to be mentally unstable, to which condition was added extravagant religious zeal....But she said that, with her Bible in her hand, she thus carried her message to millions of deluded souls who greatly needed it. She believed God called her to this task.[17]

Reluctant Reformer: Zerelda Wallace

Zerelda Wallace was as gentle, refined, and traditional as Carry Nation was coarse, strident, and outspoken. Zerelda Wallace had the benefits of a loving family and a secure social and financial position in the community. Carry Nation was frequently on the edge of financial ruin and social ostracism. But both of these women spent their adult lives working for the prohibition of alcohol, teaching us that reform activists have many faces and that different kinds of persons can use their gifts effectively in bringing about social change.

Zerelda Gray Sanders was born on August 6, 1817, in Millersburg, Bourbon County, Kentucky, to John H. Sanders and Polly C. Gray. As is turns out, Zerelda was probably lucky to be the oldest of five daughters. Having no son, her physician father spent time conversing with Zerelda and taking her with him as he practiced medicine. Although Zerelda did not have the benefits of much formal education, she read widely

and studied a number of scientific, political, and literary subjects with her father—a pattern of learning that would continue her whole life. After the family moved to Indianapolis in 1830, Zerelda became a charter member of the Central Christian Church in Indianapolis at the age of fourteen. She was a serious Bible student her entire life.

It was because she loved Christ that she...prayed beside the dying, preached against intemperance, besieged the halls of legislation, and finally turned to equal suffrage as a last means for bringing the laws to bear against the great evil.[18]

Zerelda Wallace

When she was just nineteen years old, Zerelda married David Wallace (the lieutenant governor of Indiana), a thirty-seven-year-old widower with three children. He went on to become governor of Indiana and then a member of the United States House of Representatives.[19] Frances Willard, founder of the Woman's Christian Temperance Union and Zerelda Wallace's good friend, remembers David and Zerelda:

How delightful were their evenings at home, when the babies were put to bed, and she sat with her foot on the rocker of the cradle and listened to Mr. Wallace read the latest political speech or newest book, which they discussed with the zest of professional critics. Everything Governor Wallace wrote, speech, essay, or argument, was submitted to her for criticism or approval.[20]

Zerelda also advised David on his congressional votes, including urging him to vote against the Fugitive Slave Law.[21]

When David died in 1859, Zerelda was left to raise his three children and the three of theirs who survived infancy. Although Zerelda had to take in boarders after her husband's death, she eventually had a secure income due to a rise in property values. Her best-known child was Civil War General Lewis Wallace, who wrote *Ben-Hur*, patterning the appealing mother character after his own stepmother, Zerelda.

As late as 1870, Zerelda told her friend Maria Jameson (the first president of the Christian Woman's Board of Missions) that she had no experience in public speaking, that she had never even spoken aloud in a prayer meeting. Yet something was burning within her. When she was fifty-seven years old, at a church service in 1874, after refusing the communion wine for several Sundays, Mrs. Wallace began her career as a reformer.

> Mrs. Wallace rose in her seat and gave her reasons for declining the wine in a speech that was the death knell to the use of spirituous liquor in churches. A meeting of the church's official board, of which Mrs. Wallace was a member, was called at once. The energetic woman renewed her warfare on spirits with a vigor that carried everything before it, and she won the day.[22]

Soon alcoholic communion wine was prohibited in all Christian Churches and in most other Protestant denominations as well.

Zerelda Wallace attended the organizational meeting of the Woman's Christian Temperance Union in Cleveland in 1874, then went back to organize Indiana women in the state chapter, serving as Indiana president until 1877, then again from 1879-1883.[23] At the same time, Zerelda was active in her church. It was in her home in July 1874 that the Christian Woman's Board of Missions was organized, and she served on the executive board of that group for many years.

Despite her lack of experience, Mrs. Wallace soon came to be recognized as an effective speaker on behalf of temperance. She traveled widely and gave stirring speeches for up to two hours without notes. Lacking formal training and possessing stereotypic feminine traits, Zerelda Wallace was an unlikely public speaker. Her method of speaking, however, is partially representative of a phenomenon characteristic of orators in the 1850s and 1860s—trance speaking.

Obviously led by the Spirit, but still possessing feminine qualities of self-submission and modesty, powerful women trance speakers could garner credibility for their words without risking ridicule as "unnatural" women or as representatives of a "third sex." Spirit possession so legitimized women's words that public speaking was considered acceptable behavior for women by the end of the 1860s. And as more women gained credibility as public speakers, trance speaking declined, suggesting that this manifestation of charisma initially occurred in a group (women) that did not have ready access to the institutionalized church and that trance speaking declined as that group's acceptance increased.[24]

It was before the Indiana legislature that Zerelda Wallace became a suffragist as well as a temperance advocate. Mrs. Wallace was speaking against the repeal of a temperance law. So compelling and sincere were her arguments that a representative who was a Presbyterian elder rose to urge his colleagues to vote not their consciences (which were being swayed by Zerelda's words), but for their constituents (male voters mostly opposed to temperance laws). This man's statement was a turning point for Mrs. Wallace.

> Instantly, there flashed into my mind the question: Why am I not one of this constituency? You are against our cause [she told the senator], but I am grateful to you, because you have made me a woman-suffragist. You have proved to me how trifling a cipher an unfranchised person is in the eyes of a Legislature.[25]

From this point Zerelda Wallace organized the Indianapolis Equal Suffrage Society (affiliated with Lucy Stone's group) in 1878 and served as its first president, organized the Indiana Woman Suffrage Association (affiliated with Susan B. Anthony's group) in 1887, and served as the head of the suffrage division of the Woman's Christian Temperance Union from 1883-1888.[26]

Rather late in life, after raising two families of children and caring for four grandchildren, Zerelda Wallace overcame her reticence about speaking in public. The power of the Holy Spirit, apparent in her convictions and earnestness, made it possible for her to grow from "saying a few words in the meeting, choking and sitting down"[27] to captivating audiences in at least twenty-seven states. "As she became accustomed to

the sound of her own voice the pent-up thoughts of forty years burst forth in a torrent."[28] And the gentlewoman from Indianapolis made major contributions to the work of the Christian Woman's Board of Missions, the temperance movement, and women's suffrage, all in her later years.

Zerelda Wallace was not alone in her multifaceted involvement in reform movements. Church women from many denominations were active in cooperative reform efforts, including the Woman's Christian Temperance Union. This interdenominational cooperation led naturally to other ecumenical activities (discussed later in the chapter).

Other Women Active in the
Woman's Christian Temperance Union

Silena Moore is an example of one of the many Disciples women active in the Woman's Christian Temperance Union. She was singled out by John T. Brown for inclusion in his volume on notable Disciples, published in 1904. Silena was born on July 9, 1850, near Decherd, Tennessee. From the age of fourteen until she married Dr. T. P. Holman at the age of twenty-four, she worked as a teacher. Later, under her Woman's Christian Temperance Union presidency, which began in 1899, the Tennessee chapter quadrupled its membership.[29]

Clara Hale Babcock, credited with being the first ordained woman in the Christian Church, was also active in the Illinois Woman's Christian Temperance Union. In addition to being well known as a temperance speaker and organizer, she served for a time as president of the Whiteside and Sterling County chapters.

Many times temperance speeches were made from church pulpits. Glen Zuber believes that the acceptance of women speaking for the temperance cause from a religious perspective in church pulpits paved the way for the ordination of women by those same churches. In addition to Mrs. Babcock (ordained in 1889), Sadie McCoy Crank (ordained in 1892), and Clara Hazelrigg (ordained in 1897), Emma Gates Moxley, Ella P. McConnell, and Birdie Farrar Omer all had extensive experience as temperance "preachers" and organizers.[30]

Emma Gates, born on February 19, 1865, and married to Pastor J. H. E. Moxley on July 2, 1884, was known for her

work as a preacher and with the Christian Woman's Board of Missions and the Woman's Christian Temperance Union— primarily in Ohio, West Virginia, and Pennsylvania. Although she probably was not ordained, Mrs. Moxley preached regularly at the Manchester Christian Church in Summit County, Ohio, and is credited with inspiring many of the thirteen hundred people who joined the church during her husband's ministry. She died March 17, 1919, in Canal Fulton, Ohio.[31]

Ella Poppy McConnell served as a pastor with her husband Levi J. McConnell. A graduate of the ministerial department at Hiram College, Mrs. McConnell served her first church before her marriage. Later, the McConnells served churches in Ohio and California. Mrs. McConnell first was active in the Woman's Christian Temperance Union in childhood. In adulthood she was Ohio state president of the Christian Woman's Board of Missions and worked to organize auxiliaries in California, Nevada, and Arizona. After the death of her husband in 1940, Mrs. McConnell established a scholarship for ministers at Hiram College. She died in 1952.[32]

Frances "Birdie" Farrar Omer (born in 1874, died in 1970) was a minister's wife who traveled seven miles on horseback to preach to the struggling church at Palestine, West Virginia. There she helped double the membership and revitalize stewardship offerings. On Sunday evenings she also preached in the Proctor, West Virginia, church. Her involvement in the Woman's Christian Temperance Union began at age fourteen.[33]

Civil Rights Leader: Osceola Aleese Dawson

The life and work of Osceola Aleese Dawson in the area of civil rights was highlighted when, after being named one of ten Kentucky black women of achievement in 1958, she was described as "a symbol of orderly, progressive hope for her people" and "a solid rock of hope for the Negroes who are plodding toward a better way of life."[34] Because her father died when she was only two, Osceola Dawson was raised by her paternal grandfather, Peter Dawson (a former slave), grandmother, and mother, in Christian County, Kentucky. Osceola learned easily despite the poor quality of the segregated schools she attended, which she described as "incredibly poor little hovels with battered desks, smoking wood stoves, broken windows and

teachers who knew little more than their pupils."[35]

After graduating from high school at age sixteen and attending college, she began her long years of service as registrar at West Kentucky Vocational School. Osceola Dawson was also a member of Clay Street Christian Church in Paducah and the Social Action Commission of the National Christian Missionary Convention.

An article in *The Christian-Evangelist* on Osceola Dawson focuses on her respect for and ability to make changes within the system. Phrases such as these are sprinkled in the account of her award, "She approaches race matters quietly but firmly. She has no compla-

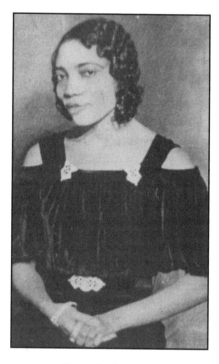

Osceola Dawson

cency but at the same time doesn't tear into discrimination and prejudice recklessly or with malice."[36] She also urged students not to use color as an excuse for mediocrity.

As we have seen, reformers are of all sorts. English philosopher Mary Midgley says that extremist reformers (such as Carry Nation) energize social change movements but that the gentler souls among us (such as Osceola Dawson and Zerelda Wallace) work out the slower details that result in lasting reform.[37]

South American Ecumenical Witness: Jorgelina Lozada

Jorgelina Lozada was one of the most outstanding graduates of the Women's Training School, Instituto Modelo de Obreras Christianas, established in Buenos Aires, Argentina, in 1922 through cooperation between the Christian Woman's Board of Missions and the Methodist Church. Born on February 18, 1906, the daughter of a Protestant English mother and

Jorgelina Lozada

an Argentinean father, Jorgelina was baptized into the Belgrano Christian Church at age fifteen, entered the training school at age seventeen, and graduated at age nineteen. Her calling to ecumenical work was first nurtured in the Christian Church.

The career which I thus chose has opened many avenues of service and has challenged me to greater endeavor, resulting in an increased interest in the movement for unity and brotherhood which characterizes the communion with which I had my first contact and my first spiritual awakening.[38]

Much of the credit for Jorgelina's spiritual awakening goes to her Sunday school teacher, Señora Elena Colmegra de Azzati, who was the wife of the pastor of the Belgrano Church and an active Disciples churchwoman in Argentina.[39]

In 1930 Pastor Jorgelina was ordained at the Belgrano Christian Church as a home missionary, one of the first women to be ordained in Argentina. She served as pastor of the Villa Mitre Christian Church in Buenos Aires for twenty-four years. There she established a kindergarten and children's medical clinic, and guided the parish in building a new church. As a preacher her goal was to make daily life a pulpit, that is, a means for spreading the good news.

And spread the good news she did, through extensive ecumenical work in South America—including establishing two libraries, serving as president of the Argentine League of Evangelical Women and on the editorial board of its journal *Guia del Hogan*, preparing Christian education materials in Spanish for use in Latin America, serving on boards of two

colleges, working with United Church Women in the United States, and traveling around the world on preaching and administrative assignments. Pastor Jorgelina's facility in Spanish and English, combined with her charisma and ability to speak and write, led to numerous invitations to participate in worldwide ecumenical gatherings.

It was in such gatherings, as well as in church groups, that this young woman shone. Alert, sensitive to the social evils of her day, primed with Evangelical ideals, a facile speaker, she was always ready to stand her ground without compromise, and yet with the courtesy and tact so strong in Latin America.[40]

Ecumenism and United Church Women: Mossie Allman Wyker

As we have seen, missionary societies developed in a number of different denominations about the same time. It is not surprising that women from diverse church backgrounds would realize the possibilities for strengthening their impact by working together in such ways as establishing missionary training centers, preparing study materials, and praying together for mission work. At least three national, interdenominational women's groups formed—Union Missionary Society in New York City in 1861, the Council of Women for Home Missions in 1908, and the Federation of Women's Boards of Foreign Missions in 1911. United Church Women, founded in 1941, arose because of the need for a more broadly defined mission. Initial efforts focused on war relief, and then support for the United Nations, and the development of more positive race relations.[41]

Members of the United Church Women tended to be from the middle or upper-middle class, educated, liberal, Republican, and religiously mainstream—mostly Episcopalians, Congregationalists, Presbyterians, Baptists, Disciples, and Methodists. By and large they were the wives of professional men and usually supported by their husbands. Because of their standing in the community, political power, and acquaintance with government leaders, United Church Women were able to make some changes in local, state, and national policy. Most members were familiar and comfortable with the role of wife and mother.

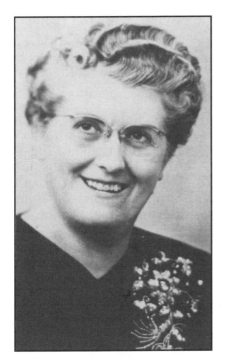

Mossie Wyker

The women regarded their church activities as extensions of their roles as mothers and homemakers, and as demanding the same kind of care, nurture, and management as families except on a larger scale; their public activities, they thought, grew out of private ones.[42]

The third president of United Church Women was Mossie Allman Wyker, an ordained Disciples minister and former member of the Board of Managers of the International Convention of the Disciples of Christ and president of the 1952 International Convention. Mrs. Wyker, while deferential to her husband (she preferred to be addressed as Mrs. James D. Wyker and to do her work in his name), nevertheless participated fully in the life of a pastoral minister. The Wykers served as copastors, and Mrs. Wyker performed marriage ceremonies, funeral services, administered communion, and preached. She says that many times her husband not only supported her but urged her to continue when she was ready to give up.[43]

During Mrs. Wyker's tenure as president of the United Church Women the group was making a difficult transition as one of the organizations that joined together to form the National Council of Churches (in 1950). Her contribution might best be described as acceptance of the traditional roles of women framed by Christian obligation. In her book, Mrs. Wyker provides the following quote.

I do not advocate the neglect of a single duty that will make the atmosphere of home more wholesome, the appearance of the house more inviting; but it is time

for us to know it is a home duty, a command of God, that we neglect not our minds, one of the richest gifts He has bestowed.[44]

Conclusions

In the nineteenth century the sphere of influence for women began to enlarge as they became more aware of conditions in their communities. For the first time, women organized themselves to bring social change to bear on the evils they saw around them. Much of the work of the Christian Woman's Board of Missions and National Benevolent Association was geared toward improving the lot of poor women and children, educating African-Americans, and providing a welcoming home for immigrants. Other groups such as the Woman's Christian Temperance Union and women's suffrage organizations that were not affiliated with a specific church were nevertheless made up of church women, including large numbers of Disciples, and provided other avenues for women to expand their influence in society.

As a group, women have always seen a strong connection between faith and works, realizing that "the advancement of thought and speech and action of social righteousness is an essential and vital part of the Christian message of mankind."[45] The scriptures taught women to witness in the world, and they have been faithful to the call through the years.

The experience women gained in the ecumenical work of the Woman's Christian Temperance Union and suffrage groups undoubtedly paved the way for the large-scale ecumenical movements of the 1940s and 1950s and for peace movements that have been particularly potent during times of war. The first president of the National Council of Federated Church Women, organized in 1928, was Mrs. J. T. Ferguson, member of Independence Christian Church in Kansas City, Missouri. In addition to Mossie Wyker, a number of other Disciples women were officers of United Church Women early on. Among them were Mrs. Emory Ross, Mrs. Fred A. White, Mrs. R. A. Doan, Mrs. Jesse M. Bader, Mrs. Ernest Pearson, Mrs. E. M. Bowman, and Miss Bertha Parks. Mrs. Tamaki Uemura, Disciple from Tokyo, led the communion meditation for the United Church Women at a service one year after the end of World War II.[46]

Prophets who call us to reform had no easier road in the nineteenth century than they did in biblical times. Often reform-minded women were criticized by their contemporaries; some were even rejected by their churches. For committed prophets, the allegiance is to a larger concept of the church than that manifested in congregations. And as today, early reformers often did not live to see the fruition of their work. The Disciples women we remember in this chapter continued to labor, sometimes not knowing if anyone would reap the harvest. We who come after them benefit from and model our work on their tireless efforts and strength of commitment.

An Opportunity to Respond: A Tribute to Present-day Dorcases

This suggestion for a personal, family, or other group devotion is adapted from one suggested by Carol A. Wehrheim.[47] Begin by reading and studying the account of Tabitha (or as we know her, Dorcas) in Acts 9:36–43. Think about women you know from your church, family, community, or the wider world who are faithful to God's call today as Dorcas was in New Testament times. Give thanks to God in prayer by naming aloud women who are devoted to good works and acts of charity, who create possibilities for other people. Finally, write thank you notes to some of the women you named (even if you don't know them), for the role they have played in transforming the faith community.

Notes

[1]Harriet Beecher Stowe, as reported in Carolyn De Swarte Gifford, "Women in Social Reform Movements," in Rosemary Radford Ruether and Rosemary Skinner Keller, (eds.), *Women and Religion in America, Volume I: The Nineteenth Century, a Documentary History* (San Francisco: Harper & Row, 1981), p. 294.

[2]Found in a letter from Angelina Grimke and quoted by Gifford, *Women*, p. 296.

[3]The words are from women's rights reformer Amelia Bloomer and quoted by Gifford, *Women*, p. 298. I am grateful to Gifford for her work in the area of nineteenth-century women's reform movements and for several of the points made in the introduction to this chapter.

[4]Gifford, *Women*, p. 299.

[5]Partially reprinted in Barbara Brown Zikmund, "The Struggle for the Right to Preach," in Ruether and Keller, *Women and Religion*, pp. 219-223.

[6]Zikmund, "The Struggle," p. 223.

[7]Eliza Davies, *The Story of an Earnest Life* (Cincinnati: Central Book Concern, 1881). The book is a powerful account of her life's journey.

[8]*Ibid.*, p. 178.

[9]Marge A. Lester, "Strong Meat for a Life of Courage," *The Disciple* 12 (10) (October, 1985), pp. 18-20, and Hiram J. Lester, "Eliza Davies," in Peter M. Morgan, (ed.), *Disciples Family Album: 200 Years of Christian Church Leaders* (St. Louis: Chalice Press, 1990), p. 54.

[10]Davies, *The Story*, pp. iii-iv.

[11]Information on the facts of Carry Nation's unusual life come primarily from two sources: Louis Filler, "Nation," in *Encyclopedia of World Biography* (New York: McGraw-Hill, 1973), pp. 77-78, and W. Z., "Nation, Carry Amelia Moore," in Alden Whitman, *American Reformers* (New York: H. W. Wilson, 1985), pp. 603-605.

[12]J. Allan Watson, "Carry Nation and Wichita," *Christian Standard* 66 (October 3, 1931), pp. 966, 971. Copyright 1931. The Standard Publishing Company, division of Standex International Corp., Cincinnati, Ohio. Used by permission. This article was written for those attending the International Convention in Wichita in 1931 and details Carry Nation's life in the church and in Kansas.

[13]Various newsnotes and articles on Carry Nation in the January and February editions of the *Christian Standard* 36 (1901), pp. 100, 135, 148, 228, 260, 583. In one article David Nation defended his wife's work (February 14, 1901), p. 212.

[14]Watson, "Carry Nation," p. 971. Copyright 1931. The Standard Publishing Company, a division of Standex International Corp., Cincinnati, Ohio. Used by permission.

[15]*Ibid.*

[16]W. Z., "Nation."

[17]Watson, "Carry Nation," p. 971.

[18]Mrs. P. H. Jameson, "Mrs. Zerelda Wallace," *Christian Standard* 37 (April 27, 1901), p. 547.

[19]Information on the life of Zerelda Wallace comes primarily from two sources: Paul S. Boyer, "Wallace, Zerelda Gray Sanders," in Edward T. James and Janet W. James, (eds.), *Notable American Women, 1607-1950: A Biographical Dictionary. Volume I.* (Cambridge, Massachusetts: Belknap Press of Harvard University, 1971), pp. 535-536 and Mrs. John A. Logan, *The Part Taken by Women in American History* (Wilmington, Deleware: Perry-Nalle, 1912), pp. 575-576.

[20]Frances Willard, *Woman and Temperance* (Hartford: no publisher, 1883), p. 481.

[21]Logan, *The Part*.

[22]"Zerelda Wallace: Death To-day of a Notable Indiana Woman, *Indianapolis News* (March 19, 1901), p. 2.

[23]Boyer, "Wallace."

[24]Ann Braude, *Radical Spirits: Spiritualism and Women's Rights in Nineteenth Century America.* (Boston: Beacon, 1989).

[25]Willard, *Woman*, p. 484.

[26]Boyer, "Wallace."

[27]Frances D. Elliott, "Zerelda Wallace," *The Christian-Evangelist* 38 (April 18, 1901), p. 494.

[28]*Ibid.*

[29]John T. Brown, *Churches of Christ*, p. 617.

[30]Glenn Zuber, "The Gospel of Temperance," pp. 47-60.

[31]"Moxley," *Christian Standard* 54 (August 16, 1919), p. 1145.

[32]"Mrs. L. J. McConnell," *The Christian-Evangelist* 90 (May 21, 1952), p. 523.

[33]Zuber, "The Gospel," and "A West Virginia Mountain Ministry," *The Christian-Evangelist* 64 (September 29, 1927), p. 1313.

[34]"Disciple Named Outstanding Woman," *The Christian-Evangelist* 96 (May 5, 1958), p. 505.

[35]*Ibid.*

[36]*Ibid.*

[37]Mary Midgley, "Practical Solutions," *The Hastings Center Report* (November/December, 1989), pp. 44-45.

[38]Margaret Richards Owen, *The Reverend Jorgelina Lozada: Ecumenical Witness*, (Melbourne Beach, Florida: Margaret R. Owen, 1991), p. 4.

[39]J. Dexter Montgomery, *Disciples of Christ in Argentina: 1906-1956.* (St. Louis: The Bethany Press, 1956), pp. 52-69.

[40]Elizabeth Meredith Lee, *He Wears Orchids and Other Latin American Stories* (New York: Friendship Press, 1951), pp. 78-79.

[41]Brereton, "United and Slighted," pp. 143-167.

[42]*Ibid.*, p. 154.

[43]Mossie Allman Wyker, *Church Women in the Scheme of Things* (St. Louis: The Bethany Press, 1953), p. 37.

[44]*Ibid.*, p. 32.

[45]From Bertha Parks in the October, 1936, edition of *World Call* as reported by Lorraine Lollis, *The Shape of Adam's Rib: A Lively History of Women's Work in the Christian Church* (St. Louis: The Bethany Press, 1970), p. 126.

[46]Lollis, *The Shape*, p. 129.

[47]Carol A. Wehrheim, *The Great Parade: Learning about Women, Justice, and the Church* (New York: Friendship Press, 1992), p. 56.

Shapers of Thought

Authors and Editors

*[Her memory] will live in the hearts of the
hundreds whom she helped to a better life. It
will live in the service of those she inspired to
enter the ministry. It will live in the class that
bears her name and which she taught for over
a generation.[1]*

This chapter pays tribute to women from the Stone-Campbell movement whose pens were guided by the hand of God as they spread the gospel of Christ and the message of restoration through their writing. Authors of religious works ministered to the church in a number of ways. To an often isolated frontier church they brought a sense of community as they shared news of others laboring toward common goals.

Through the work they solicited, editors contributed to the continuing education of church leaders. Long-lasting and compelling debates over critical theological issues were played out in the pages of church papers. Missionary tracts brought the work of overseas and domestic mission fields close to home, dispelling the mystery of faraway places and bringing the reality of those efforts to heartland churches. Hymn writers and poets inspired faithful disciples and brought spiritual enrichment to their lives.

Disciples-related church papers have included contributions by and about women from their first issues. Although women authors were involved in critical theological debates, most often they reported on women's work in the church or wrote inspirational and program material for women's groups. As women's work, especially missionary efforts, came to be seen as church work, women's contributions reached and were appreciated by a wider audience. Early editors remarking in the *Christian Standard* and *The Christian-Evangelist* were genuinely and consistently appreciative of the quality of the work of their women contributors.

Although several of the most prominent Disciples women authors were either unmarried or married later in life and had no children, some women authors successfully combined a career in writing with their home and family responsibilities. In this field as in others, women were not always given the credit they deserved for the work they did, due perhaps both to discrimination and to the women's own sense of modesty. Bess White Cochran, a gifted author and editor, reflected the self-effacement that was so characteristic of women authors when she said, "There is nothing about my career that is not unique about anyone who has followed where the finger of God directed."[2]

Jane Reader Errett *and the Founding of the* Christian Standard

We begin with a woman who, in assisting her father, helped shape the editorial policy and flavor of the *Christian Standard*, one of the preeminent sources of news and inspiration in the Christian Church. Jane Reader Errett (known to those who loved her as "Miss Jennie") was born into a family that became heavily involved in restoring New Testament Christianity through the publishing world. Her father, Isaac Errett, was already establishing himself as a preacher and evangelist when Jennie was born in Pittsburgh on October 10, 1841. Her mother, Harriet Reader, was a cultured English woman whose married life was undoubtedly absorbed by the care of nine children, moving several times via covered wagon, and living in a log cabin while the family was in Michigan, all quite a change from her genteel upbringing.[3]

Jennie's intimacy with and devotion to her father and his work, as well as her ability to articulate principles of the faith,

brings to mind the relationship between Clarinda and Lavinia Campbell and their father, Alexander (discussed in a later chapter).[4] Eulogist E. W. Thornton, literary editor of the *Christian Standard*, said this at her funeral service:

> It truthfully may be said that, through all the years of her mature life, Miss Jennie was dominated by the desire to promote the principles for which her father stood, and unswervingly to contend for the faith that was his.[5]

One may assume that as she matured in the company of such notable church founders as Alexander Campbell, W. K. Pendleton, and Robert Richardson, the faith that was Isaac Errett's became Jennie's as well.

Although Isaac Errett could have spent his days in illustrious company speaking at the large, prestigious churches, for a time he and his family ministered on the Michigan frontier. Because opportunities for the education and cultural enrichment of a young girl were very limited in rural Michigan, Jennie was sent to Pleasant Hill Seminary in Washington County, Pennsylvania. This school, from which Jennie graduated in 1860, was founded by Jane Campbell McKeever (daughter of Thomas Campbell and sister of Alexander), and was for about thirty years the female counterpart of (then) all-male Bethany College.[6]

In 1861 Isaac Errett became coeditor of Campbell's *Millennial Harbinger* and in 1866 was persuaded by church leaders (including T. W. Phillips and James A. Garfield) to establish and edit the *Christian Standard*. Jennie joined her father at his offices in Cleveland and became his constant companion and editorial assistant. (Apparently the rest of the family stayed in Michigan, at least for a while.) For sixty-one years Jennie devoted herself to restoring the doctrine, ordinances, and fruits of primitive Christianity through her work on the *Christian Standard*.[7]

In addition to being her father's assistant editor, Jennie was the circulation manager from 1880-1886, and upon her father's death in 1888, gave up all social activities in order to devote herself to assisting the new editor, her brother Russell Errett. At a time when many Disciples men were not, Isaac Errett was particularly supportive of women's efforts to organize the Christian Woman's Board of Missions. One wonders

if Jennie's talents and dedication helped persuade him of women's untapped potential for church leadership.

Jennie Errett was perhaps the last editor to know well the founders of the Christian Church. She is remembered as a woman with a single-minded devotion to her cause, one possessed of a keen intellect and a missionary zeal, and one who at the same time nurtured employees of the paper. No sacrifice was too great for her to make, and she expected no less from those with whom she worked. On her death, editors of the other major church paper said:

> *The Christian-Evangelist* would be counted in the group next to her relatives and associates in expressions of appreciation of a life worthily lived and an eternal reward well earned.[8]

Through the course of her life, Jennie acquired a one-quarter interest in the *Christian Standard*, but during the last two years of her life she gave away all her money in efforts to further the kingdom. When she died at the age of eighty-five, on March 4, 1927, Jennie Errett "possessed little more than the salary check then due her."[9] By rights, because of her profound understanding of the faith, her single-minded commitment to the *Christian Standard*, and familiarity with its day-to-day operation, Jennie could have become its second editor. She was certainly the logical heir to her father's work, and probably would have been the second editor if her name had been John instead of Jane. There is no record, however, that promoting Jennie to editor was considered.

Christian Standard *Special Contributors*

Persis Lemon Christian

Persis Lemon Christian (married to George Clark Christian), president of the Illinois Christian Woman's Board of Missions and a charter member of the national Christian Woman's Board of Missions, wrote a regular column for the *Christian Standard* called "Of Interest to Women." In 1892 as the question of the ordination of women was being vigorously debated in the pages of the *Christian Standard*, Persis Christian devoted a column to the controversy, pointing out the greater rights guaranteed to women in Sweden, France, and Scotland than in the United States. Furthermore, she said:

When Morning Spreads

While conferences and divines have been trying to decide whether women shall be allowed to preach or not, seven hundred and twenty-two of them in the United States (up to 1890) had settled the matter for themselves and accepted what was then a high and holy call to the service of the Master. Many of these are most successful pastors and preachers. Full freedom is coming to woman as an indication and warrant of a more perfect Christian civilization.[10]

In its first issue of the twentieth century, the *Christian Standard* introduced five people who would be special contributors for the year, "whose works comprise nearly all that is ranked in our best imaginative literature."[11] Four were outstanding women authors—Jessie Brown Pounds, Mattie M. Boteler, Hattie Cooley, and Anna D. Bradley.

Jessie Hunter Brown Pounds

Jessie Hunter Brown (later married to John Edward Pounds) was a name familiar to Disciples for many years. Although chiefly remembered as the author of more than six hundred gospel hymns,[12] Jessie Brown Pounds was also known as the author of poems and books for young people, for editorial

writing (in both the *Christian Standard* and *The Christian-Evangelist*), and as a convention speaker.[13] Of her writing, *Christian Standard* editors said:

> Mrs. Pounds' stories are true in every sense of the word—true to life, true of good taste, true to literary expression, and altogether such works as every parent would rejoice to see in children's hands.[14]

"Welcomed," a poem Jessie Brown Pounds wrote in memory of Archibald McLean, is the most often reprinted of her more than one thousand poems:

Jessie Brown Pounds

Perhaps he now sits with the saints of the ages,
With Carey and Wesley and Wycliffe and Paul,
With Socrates, Plato, and all the high sages—
He had thought their thoughts joyously after
 them all.
They would welcome his coming, their wisdom
 discerning;
He belonged not to part of the race but to the
 whole;
They will surely have joy in him, speedily learning
The whimsical charm of his glorious soul.
But somehow, I can not thus think of him;—
 rather,
I fancy I see him a center of mirth
As, hailing his coming, around him there gather
The children he laughed with and romped with
 on earth;—
The children who slipped from the arms of their
 mothers

And took the long journey with never a fear;
I fancy them calling, each one to the others,
As they called when he came from his journey-
ing here.
And then to the heavenly playground they lead
him,—
This prophet who bore a child's heart in his
breast,—
The children are glad and it may be they need
him
To play with them yonder while taking his rest.[15]

Certainly a prolific inspirational writer herself, Jessie
Brown Pounds also found time to encourage others. At the
national Christian Woman's Board of Missions Convention in
Chattanooga, Tennessee, on October 14, 1898, she spoke elo-
quently on the obligation of women to use both their hearts
and their intellects in church service. About the controversy
surrounding the ordination of women, Jessie Brown said:

On the whole, it is safe to put the wisest head, the
purest soul, the largest sympathies, the most eloquent
mouths together, and let them preach the love of God,
whether they appear in a petticoat or in the *"toga
virilis."*[16]

Upon her death on March 3, 1921, a Chair of Religious
Education and Literature was established in Jessie Brown
Pounds' memory at Hiram College—Hiram, Ohio, being her
home. Contributions for this endowed chair came from the
offerings of Sunday schools and young people's societies in
Ohio, Michigan, and New York. The goal was one dollar a year
for three years from every Sunday school child in the three
states, a sum of fifty thousand dollars.[17] Jessie Brown Pounds'
power to inspire continued long after her death.

Her books and poems and songs will live after her.
And, though dead, she will continue to preach and
inspire reverence in the heart of the public.[18]

Mattie M. Boteler

Mattie M. Boteler is perhaps the woman (among a truly
outstanding company of Christian sisters) who had the most
profound literary impact on shaping early Disciples thought
and on training its leaders.

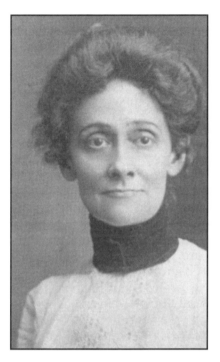

Mattie M. Boteler

No one but Isaac Errett, in all our history, has answered to every demand made upon her, or has left a record of such blameless propriety in her productions; nor has any other pen among us been followed by such a multitude of readers among all classes, with as little occasion for cavil or reproach.[19]

Samuel Lockhart, Mattie's grandfather, was a schoolteacher and member of the Seceder Presbyterian Church in Jamestown, Ohio. After hearing Walter Scott preach, Lockhart became an ardent convert to the Christian Church. Mattie's mother was a lifelong Christian and Bible scholar. "Miss Boteler inherited the religious zeal that dwelt first in her grandfather and also in her mother."[20]

Surely there are many women among us who have spent their lives spreading the gospel message by teaching Sunday school. They bear the legacy of Mattie Boteler, who began teaching Sunday school at age sixteen and continued uninterrupted until her death in 1929. She organized and taught a class for lay evangelists that produced a number of effective church leaders and for thirty-five years taught the adult class that bore her name at the Central Church of Christ in Cincinnati.[21] Mattie Boteler developed innovative methods for Bible teaching, each Sunday memorizing the scripture for the day and developing an epigram, a short, often witty, poem or saying designed to communicate a spiritual truth in a memorable way.[22]

Many of these epigrams were later published and then copied into personal scrapbooks. There are more than 1,815 entries in the *Christian Standard* credited to her. Here is one

example of Mattie Boteler's epigrams that has relevance for us today:

> Now and then the maker of a certain kind of health food displays the portraits of those who have fed upon it as compared with those who have not. It might be interesting if the members of the church could look upon the pictures of those who have fed on the Word as compared to those who have not.[23]

Through the pages of the *Christian Standard* and the *Lookout*, which she edited from 1894-1911 following the tenure of Jessie Brown Pounds, many who never met Mattie Boteler came to know her and to owe their understanding of the faith to her. Particularly noteworthy are her Bible commentaries for midweek and Christian Endeavor prayer-meetings, Sunday school commentaries and books of sermon notes for preachers. "No preacher among us has a surer grasp upon the fundamentals of our message, or is a safer expounder of Scripture than was she."[24]

Hattie Cooley and Anna Bradley

Poet and author Hattie Cooley is known for her contributions to the development of the life of the spirit and to furthering mission work. In particular, her stories deal through fiction but in a straightforward way with the deep perplexities of the Christian life—as in "Earthling"—and with the question of skepticism—as in "Honest Doubter."[25] Anna Bradley also made many contributions to the *Christian Standard*, most memorably a tribute to her mother that resonates a chord in all daughters. A portion is reproduced here.

> We see age and suffering fasten themselves on the dearly loved mother, and we think we realize that she will not be with us long. When the suffering becomes intense, and when love and skill alike fail to bring relief, we think we love so unselfishly that, despite the price we must pay, we want the rest and peace for her. We say we are prepared. We try to say we are resigned. But when we see the empty chair, and know that never again save in spirit, can we hear the loving benediction, we know we have deceived ourselves.[26]

Editors of Missionary Magazines

Marcia Melissa Bassett Goodwin:
Our First Woman Editor (1883)

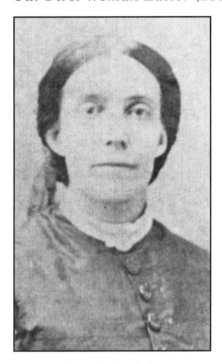

Marcia Goodwin

The first Disciple woman to serve as an editor was probably Marcia Melissa Bassett Goodwin, who, with her husband, Elijah Goodwin, coauthored and edited *The American Housewife* from 1869 until they sold the magazine in 1872. From 1863 to 1888 Mrs. Goodwin also edited and published the *Christian Companion,* which featured news of women's mission work.[27] In a captivating article she wrote for the *Christian Standard* in 1881, Mrs. Goodwin spoke metaphorically of what happens to uppity women who dare to express themselves in public.[28] A portion of this story is reproduced at the end of the chapter. If Mrs. Goodwin was feeling as harassed in her efforts to express her concerns as was the Mrs. Bantam in her story, her Mr. Bantam and sister hens must have come around, as Mrs. Goodwin continued throughout her life to speak the truth no matter the consequences.

Mrs. Goodwin effectively garnered the support of her sister Disciples in establishing their own periodicals and became editor and publisher of *The Christian Monitor*, "the pioneer magazine devoted to the sisterhood of the current reformation."[29] So successful were her efforts (Mrs. Goodwin wrote that "Failure is a word which has never been written upon the banner of the sisters of the Church of Christ."[30]) that she was chosen by the board of the Christian Woman's Board of Missions to edit its monthly magazine, *Missionary Tidings.* Although serious illness forced Marcia Goodwin to resign after

five short months, *Missionary Tidings* was off to a wonderful start. The magazine began as a four-page newsletter in May 1883. The cost of a subscription was 25 cents a year, payable in advance. Although the brethren assured the women of Christian Woman's Board of Missions that their magazine would be a financial loss, *Missionary Tidings* ended its first year with a balance of $52.50 and the paper was always financially sound.[31]

Even though she was criticized during her lifetime for the zeal with which she approached her work, Marcia Goodwin was well respected and remembered fondly at her death by her Christian sisters. When the Women's Auxiliary Missionary Society of the Third Christian Church met in Indianapolis on April 26, 1885, to celebrate her life, Maria Jameson (first president of Christian Woman's Board of Missions) and Zerelda Wallace (temperance and Christian Woman's Board of Missions worker), among many others, paid tribute. They closed with a verse Mrs. Goodwin herself had written, a verse which might well speak to us more than one hundred years later:

> I know that my wreath of pale "Autumn Leaves"
> Is faded and withered and brown,
> But humbly, now, at the foot of the cross
> I lay my offering down;
> Mayhaps the Master, who knoweth all pain,
> Will whisper, "Your toiling is not in vain."[32]

Mrs. S. E. Shortridge (1883-1889) and Lois A. White (1890-1899)

Following Marcia Goodwin's illness and after a year during which a publishing committee was responsible for *Missionary Tidings*, Mrs. S. E. Shortridge assumed that responsibility. As secretary of the Christian Woman's Board of Missions, Mrs. Shortridge received all communication for the *Missionary Tidings* and for the Christian Woman's Board of Missions until her final illness in January 1889. A memorial fund established after her death enabled the building of a church in Butte, Montana.

Lois A. White, assistant editor under Mrs. Shortridge, was the next editor of *Missionary Tidings*, serving until 1899 when she married missionary Neil MacLeod and moved with him to the mission field in Jamaica.[33]

Helen Elizabeth Turney Barney Moses (1899-1905)

The next editor was Helen E. Moses, under whose reign *Missionary Tidings* flourished, adding many more pages per month, regular columns, and program ideas for local church organizations. In her book, *The Shape of Adam's Rib*, Lorraine Lollis calls Helen Moses and Adelaide Frost, missionary to India, the poet laureates of *Missionary Tidings*: Helen Moses for her progressive editing, which resulted in sustained growth in the number of pages, circulation, and financial security of the magazine; and Adelaide Frost for the captivating articles and stories she sent from the mission field.[34]

Helen Moses devoted her life to the church through her work as Sunday school teacher and superintendent and as Kansas state organizer and later national corresponding secretary and president of the Christian Woman's Board of Missions. Helen Moses was steadfast in her service despite significant hardships (her father left the family when she was a child; her first husband died after they had been married only three years, leaving her to support herself and their infant son, who also died at a young age; and she battled constant health problems). Raised an Episcopalian, Helen Moses attended private girls' schools in Columbus, Ohio. She converted to the Disciples of Christ October 9, 1870, at the age of seventeen, shortly after hearing the inspired preaching of O. A. Burgess.[35] Later Mrs. Burgess and Mrs. Moses worked closely together in the Christian Woman's Board of Missions and sustained a long-lasting friendship.

In his biography of his mother, Jasper Moses assures us that she always saw as her first duty the care of her children, and would have gladly given up her public work in the church to assume her place in the home. Nonetheless, he records with pride her work in establishing mission work in Kansas. When doors of Disciples churches were closed in her face because they couldn't accept a "talking woman," Helen Moses delivered her message in churches of other denominations.[36]

She had real sympathy for the isolated women of the Kansas frontier and wrote them encouraging letters. Later as corresponding secretary of the Christian Woman's Board of Missions, "Her letters were dynamos of power. Her pen always dipped into the fluid of hope and wrote great, but possible, things"[37] until her death in 1908.

Anna Atwater (1905-1909) and Effie L. Cunningham (1909-1918)

The other two editors of *Missionary Tidings* were Anna R. Atwater, last president of the Christian Woman's Board of Missions, and Effie L. Cunningham. In January 1919, with a circulation of sixty thousand, the largest circulation of any Disciples publication at that time, *Missionary Tidings* merged with four smaller missionary magazines to form *World Call*. At the merger, Anna Atwater said:

> Many a time have narrow kitchen walls stretched away into zenanas, orphanages, hospitals and homes in distant lands, and love and life have expanded. Many a case of nearsightedness that was well-nigh chronic has been cured and many cases have been prevented by this "ubiquitous missionary."[38]

Bess Robbins White Cochran: World Call *Editor*

Bess Robbins White grew up in her father Walter M. White's Linden Avenue (now Lindenwood) Christian Church in Memphis, Tennessee, one of five sisters. After graduating from West Tennessee State Teachers' College, she was hired by the *Memphis Commercial Appeal*, the largest and most influential newspaper in the South at that time, to write a column for the lovelorn. So captivating was the column (written under the pen name Cynthia Grey) that it grew to a full page and Bess was promoted to society editor. Although we don't know for sure, Bess's commitment to the church was probably the reason she abruptly gave up the "dizzy social world" (as she called it) in 1922 to become the associate editor of the newly established *World Call*, official publication of the United Missionary Society. When editor W. R. Warren left to become president of the Pension Fund, Bess White became the second editor of and only woman ever to edit *World Call,*[39] a position she held from 1929-1932.

Under Bess White's leadership, *World Call* survived two serious threats: the financial crisis brought on by the onset of the Depression and attacks on the United Christian Missionary Society's work leveled by the editors of the *Christian Standard* and other conservatives. Although Bess continued W. R. Warren's policy of avoiding controversy, she later regretted doing so, wishing instead that she had defended more

vigorously the work of the United Christian Missionary Society. In 1969 Bess White spoke of how mission work had changed since her years at the *World Call*.

> Today there are no faraway places and no mystery about anything, unless it is why these once "benighted lands with people sitting in darkness," (now more realistically recognized as underprivileged nations, recipients of our foreign aid program as well as our missionary endeavors) all seem to intensely dislike us. In view of this situation it is much more difficult to stimulate emotional involvement in missionary work than it was formerly; we approach it now with our head more than with our heart; and facts cold and hard and in a way dull have replaced the old fervor of appeal.[40]

Bess White left *World Call* to become publicity director for the National Benevolent Association and editor of its publication, *Family Talk,* when the National Benevolent Association separated from the United Christian Missionary Society in 1932. Her marriage to Louis B. Cochran (an attorney and writer) on June 20, 1937, forced her to resign her position with the National Benevolent Association and move to California. There she wrote several short stories and the book *Without Haloes*. According to Bess, she and her husband together wrote *The Fool of God*.[41] Curiously, the only mention of Bess White Cochran's contribution to the book comes in this paternalistic-sounding paragraph written by Louis Cochran at the end of four pages of acknowledgments, scant credit for one's (almost) collaborator.

> And last, and in the final analysis possibly the most important of all, my enduring gratitude to my wife, Bess White Cochran, whose enthusiasm as a researcher, skill as an editor, persistence as a prodder, and endurance as a typist have resulted in a work that is almost a collaboration.[42]

Bess White Cochran was succeeded as editor of the National Benevolent Association's *Family Talk* by Jesse M. Burke, who was born in Kentucky and educated at the University of Kentucky, Transylvania College, and the College of the Bible. She taught in a public school and at a junior college before

being ordained to the ministry of Christian education at First Christian Church in Jacksonville, Florida. Before assuming her position with the National Benevolent Association, she served First Church as director of religious education and as church secretary.[43]

Rose Stephens Rains

Rose Stephens Rains (married to F. M. Rains) deserves special mention. She served as editorial assistant and office editor of *World Call* from its inception until 1937. Prior to her marriage she had worked for the Foreign Christian Missionary Society.[44] In singing her praises, Bess White said of Rose Rains,

> Mrs. Rains was a woman of pure gold....She was one of the best informed people in the entire United Society family; she had travelled the world over with her husband F. M. Rains, and she knew personally every missionary in the field at that time.[45]

Although she was a quiet, unassuming woman, probably overshadowed by her husband, Rose Rains contributed immeasurably to early mission work in the Christian Church through her competent work and generous nature.

Conclusions

The women whose lives we have glimpsed in this chapter were remarkably strong and persistent. With her father, Jane Reader Errett helped begin and nurture a new church magazine that has grown in prominence for more than 125 years, chronicling and shaping the development of the Christian Church. The *Christian Standard* has always documented the work of women and, along with *The Christian-Evangelist,* is the most accessible source of accurate information on the lives of the early Christian women remembered in this book. Undoubtedly we have Jennie Errett and her father to thank for establishing an editorial policy that encourages contributions by and about women.

Persis Christian and Jessie Brown had the courage to confront discriminatory church practices on theological

grounds, and the strength to survive criticism from both men and women. Marcia Goodwin refused to be dissuaded by the naysayers who thought women would not support a missionary magazine. By the time *Missionary Tidings* ceased publication, its editorial board had enough power to set the course of its successor, *World Call*. Popular columns that were a regular feature of *Missionary Tidings* were continued without question in the new magazine. Bess White Cochran blazed another trail as the only woman editor of *World Call*. Her strong and capable leadership ensured the survival of the fledgling magazine through the lean years of the Depression and the harsh criticism of the United Christian Missionary Society.

The development of church publications does not come without cost. The passion these women felt for their faith is reflected in the devotion they had to their writing and editing. Many of their obituaries describe women who persisted despite physical pain and financial hardship. Jane Reader Errett never married and was said to have given up her social life for the *Christian Standard*. Bess White Cochran and Jessie Brown Pounds married later in life, after they were established as writers, and never had children. Helen Moses edited *Missionary Tidings* early in the morning and late at night so she could also attend to her duties as national corresponding secretary of the Christian Woman's Board of Missions and care for her family.

Writers are loved by many people who never meet them. Mattie Boteler changed people's lives with her clear Bible lessons and theologically sophisticated instruction to pastors. Jessie Brown Pounds' hymns provided comfort and spiritual stimulation to thousands of worshipers. Anna Atwater and Helen Moses and others inspired women around the country to act on Jesus' admonition to spread the gospel around the world. In their forthright analyses of the needs of the family of God and in their calls to service, the editors of missionary magazines acted as modern-day prophets. And in their willingness to unite with smaller missionary magazines and societies, our foremothers showed that they spoke the truth for the whole church—that the contributions of men and women are necessary for the church to witness in completeness.

An Opportunity to Respond:

The following is an excerpt from an article written by Marcia Goodwin. Questions to reflect on or discuss follow the story.

From My Standpoint
Mrs. M. M. B. Goodwin

My mistress is the possessor of some very high-toned fowls, some of whom bear aristocratic and high-sounding titles, and belong to the royal line. You will be astonished when I tell you that one of the most gentle, lady-like and modest-appearing hens of the flock, little Mrs. Bantam, suddenly ascended the piazza steps, and, mounting the topmost round of the railing, began to crow.

Consternation and dismay were visible upon the face of every fowl on the premises. Mrs. Golden Pheasant tossed her plumes and declared that such conduct was "perfectly disgusting!"

"Shameful!" said Madam Bramah. "A crowing hen; she's a disgrace to her sex!" cried the entire crowd of pullets in unison.

"Put her out! put her out!" shouted the big roosters. "Shame; shame!" cried the little ones.

"Hens haven't any right to crow!" "Hens are made to take care of the chickens!" "Their place is in the family circle." "Their eggs will be ruined while they forsake home duties." "Don't listen—she'll put revolutionary notions into the heads of the young pullets, and make them un-henly!" "It's a hen's duty to 'scratch round' and make home pleasant!" "They'll leave us to take care of the chicks, and go 'round disgracing us." "Our mothers didn't want to crow! and our mothers knew what duty was!"

"They are too delicate for public speakers!" "Their voices are too weak!" "Their minds are as weak as their voices!" "They can't comprehend the deep questions of Henology!" "They're the teachers of the young chicks, and must train them for usefulness." "They haven't time and talent for public life!"

"Let one crow, and the next thing we know they'll want to hear the sound of their own voices, and there won't be a stump or a gate post for us to crow from!" cried the roosters in agonized tones.

Poor little Mrs. Bantam was so perfectly overwhelmed and bewildered by these contradictory and commingled cries, that she almost fell off her high perch.

She tried to explain very mildly that she had no idea of "usurping authority," that her crowing was not intended to alarm any one, it was merely an outpouring of her heart's gratitude for the goodness and bounty which surrounded them, and the joys which all hens ought to feel over the higher plane that the sex now occupied. She felt it her duty to impart to her sisters a little needed instruction, and her crowing, she assured them, was not at all dangerous to the morals or the manners of hens. She tried to make them understand that an occasional crow wouldn't take them away from their home duties any more, or for any longer periods of time, than they had formerly used in attending strawberry parties, or in talking scandal at the corner of the garden, when they went there to gather green peas. She for one could not see why standing on a stump was any more immodest than appearing in fancy dresses, a la decollette, at fashionable "hops" in the orchard! She couldn't see why an occasional crow should be any more injurious to a hen's constitution than the wearisome clucking that they had to keep up, from morning to night, to keep their brood together and out of danger.

But, bless your heart, the hens set up such an outcry of "shame! shame! she's out of her sphere! She hasn't any right to crow. We wouldn't crow if we could!" that little Mrs. Bantam's voice was utterly drowned in the confusion.

Questions for Reflection and Discussion

1. In your experience, what are the characteristics of women who are the most effective spokespersons for equality?

2. Describe an experience you have had when other women did not support you. What were your feelings?

3. What are some social changes that need to occur before women can "crow" *and* take care of their families?

4. Why do you think some men are threatened when women become more active in the public world?

5. What is the role of the church in helping women and men discover and use their gifts?

Notes

[1]Charles J. Sebastian, "A Rare Soul," *Christian Standard* 64 (September 28, 1929), p. 917.

[2]Willis R. Jones, "An Interview with Bess White Cochran, Editor of *World Call*, 1929-1932," *Discipliana* 29 (Spring, 1969), p. 32.

[3]E. W. Thornton, "Miss Jane Reader Errett," *Christian Standard* 62 (March 26, 1927), p. 293.

[4]For more about this subject see Debra B. Hull, "Lavinia and Clarinda: The Campbell-Pendleton Bridge," *Discipliana* 50 (Summer, 1990), pp. 25-28.

[5]Thornton, "Miss Jane," p. 293.

[6]*Ibid.*

[7]*Ibid.* Since its founding in 1866, the *Christian Standard* has been "devoted to the restoration of primitive-Christianity, its doctrine, its ordinances, and its fruits."

[8]"Death of Miss Jane Errett," *The Christian-Evangelist* 64 (March 17, 1927), p. 417.

[9]"Jane Reader Errett, 1841-1927," *Christian Standard* 62 (March 12, 1927), p. 248.

[10]Persis L. Christian, "Woman's Interest," *Christian Standard* 28 (April 9, 1892), p. 324.

[11]"Our Special Contributors," *Christian Standard* 37 (January 5, 1901), p. 3.

[12]The most popular of Jessie Brown Pounds' hymns were "Beautiful Isle of Somewhere," "The Way of the Cross Leads Home", "The Touch of His Hand on Mine," and "Calling Me Over the Tide." Six of her hymns can be found in J. E. Sturgis, *Favorite Hymns* (Cincinnati: Standard Publishing, 1933). One is found in *Christian Worship: A Hymnal:* ("I Know That My Redeemer Liveth"); it has also been selected for the forthcoming *Chalice Hymnal.*

[13]"Jessie Brown Pounds," *The Christian-Evangelist* 60 (February 22, 1923), p. 246.

[14]"Our Special Contributors," p. 3.

[15]Jessie Brown Pounds, "Welcomed," *The Christian-Evangelist* 58 (January 27, 1921), p. 101. Reprinted by permission.

[16]Jessie H. Brown, "Woman in the Ministry," *Christian Standard* 29 (August 26, 1893), p. 668.

[17]"Jessie Brown Pounds," *The Christian-Evangelist*, p. 246.

[18]"Jessie Brown Pounds," *Christian Standard* 51 (March 12, 1921) p. 2011.

[19]Russell Errett, "A Record Without Flaw," *Christian Standard* 64 (September 28, 1929), p. 917.

[20]Sebastian, "A Rare Soul," p. 917.

[21]"Mattie Boteler Goes on to Reward," *Christian Standard* 64 (September 7, 1929), p. 847.

[22]"Mattie M. Boteler," *Christian Standard* 60 (August 6, 1925), p. 1094.

[23]Edwin W. Thornton, "Miss Boteler as a Writer," *Christian Standard* 64 (September 28, 1929), p. 917.

[24]"Mattie Boteler Goes on to Reward," p. 847.

[25]"Our Special Contributors," p. 3.

[26]Anna D. Bradley, "My Answered Prayer," *Christian Standard* 42 (May 26, 1906), p. 818.

[27]The Disciples of Christ Historical Society has copies of the first two years of this magazine.

[28]Mrs. M. M. B. Goodwin, "From My Standpoint," *Christian Standard* 41 (April 2, 1881), p. 107.

[29]Mrs. R. T. Brown, "Exercises in Memory of Mrs. M. M. B. Goodwin," *The Christian-Evangelist* 20 (May 16, 1885), p. 155.

[30]Lorraine Lollis, *The Shape of Adam's Rib: A Lively History of Women's Work in the Christian Church* (St. Louis: The Bethany Press, 1970), pp. 65-69.

[31]*Ibid.*, pp. 65-69.

[32]Brown, "Exercises," p. 155.

[33]Lollis, *The Shape*, pp. 65-66.

[34]*Ibid.*, pp. 65-69.

[35]Jasper T. Moses, *Helen E. Moses of the CWBM* (New York: Fleming H. Revell Company, 1909), pp. 19-60.

[36]*Ibid.*, p. 26.

[37]Mrs. M. E. Harlan, "Helen E. Moses," *The Christian-Evangelist* 45 (May 28, 1908), pp. 690, 694.

[38]Lollis, *The Shape*, p. 68. The magazines that merged were: *The Missionary Intelligencer*, published by the Foreign Christian Missionary Society; *The American Home Missionary*, published by the American Christian Missionary Society; *Business in Christianity*, published by the Board of Church Extension; and *The Christian Philanthropist*, published by the National Benevolent Association.

[39]Jones, "An Interview," pp. 28-33. Effie L. Cunningham was associate editor under Warren and White.

[40]*Ibid.*, p. 31.

[41]*Ibid.*, pp. 28-33.

[42]Louis Cochran, *The Fool of God* (New York: Duell, Sloan, and Pearce, 1958), p. 413.

[43]"Jesse M. Burke Joins NBA Staff," *The Christian-Evangelist* 79 (July 17, 1941), p. 843.

[44]"*World Call* Staff Changes Occurring," *The Christian-Evangelist* 75 (June 3, 1937), p. 726.

[45]Jones, "An Interview," p. 30.

Shining Lights of Knowledge

Leaders and Philanthropists in Church-related Colleges

by John H. Hull[1]

> *Hers was a talent for intimacy with the human race....She could appear before a banquet, speak thirty minutes, and leave with $10,000 in pledges....She laughed when Walter Williams, dean of the University of Missouri school of journalism, introduced her as "Luella St. Clair-Moss, a steam-engine in petticoats."*[2]

*E*ducating and the support of education were important works of many women early in the restoration movement. But because of the structure of society and the viewpoints even of many within the restoration movement, women often were kept from positions of leadership within "higher education"— that which now would include high school and college. Indeed, many of the women celebrated in this chapter themselves never received the kind of education they made possible for others. From different backgrounds—widowed Southern aristocrat, Pennsylvania sheep farmer, African-American evangelist, missionary—these women gave of themselves and their

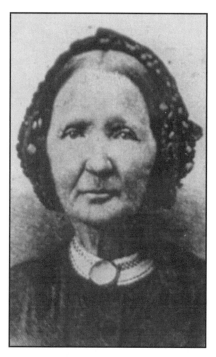

Jane Campbell McKeever

substance that Wisdom might continue to call from the gates, "O simple ones, learn prudence; acquire intelligence, you who lack it. Hear, for I will speak noble things, and from my lips will come what is right; for my mouth will utter truth" (Proverbs 8:5–6).

Jane Campbell McKeever: Founder of Pleasant Hill Seminary

Many of us think we know the story well. This child of Thomas and Jane Campbell was born in Ireland and emigrated to western Pennsylvania at a relatively young age. Recognizing the need for education on what was then the American frontier, this younger Campbell opened a home school and educated local and family children. Eventually, home schooling gave way to higher education, and this Campbell child founded a private, nonsectarian institution to provide college-level education for students from the United States and Canada. This person guided the educational institution for a quarter century, until it was widely recognized as one of the best of its kind in the country. Indeed, the institution was known for providing graduates who helped found and teach in many other institutions. Finally, not long after the Civil War, this person died and was recognized, among other things, as a pivotal person in the development of restoration movement higher education.

This sounds like the familiar story of Alexander Campbell. But in this case, the story is not about Alexander, but about his sister Jane Campbell, whose story is also important in the history of the restoration movement.[3]

Jane Campbell was born on June 25, 1800, in Ahorey, Ireland, the daughter of Jane and Thomas Campbell and the

younger sister of Alexander. Thomas Campbell emigrated to the U.S. in 1807; Jane followed with the rest of her family in 1809. They settled in Washington, Pennsylvania, within twenty miles of Bethany, Virginia (now West Virginia). What little is known about Jane's early education shows she was tutored at home by Alexander.[4]

Between 1809 and 1820, Jane's family moved several times. In 1813, in Cambridge, Ohio, she was a student in her father's mercantile academy.[5] She also may have been a student in a similar academy Thomas ran in Pittsburgh, Pennsylvania in 1815.[6] After her family moved to Kentucky in 1817, Jane began, at the age of eighteen, her long career as an educator. Her reputation as a fine teacher grew rapidly, and helped make the Kentucky school popular, as well as profitable. Because of his opposition to some of Kentucky's proslavery laws, Thomas moved his family back to Pennsylvania in 1819, settling in West Middletown, Pennsylvania, the village in which Jane would live for the next half century. Kentuckians were so impressed with Jane's teaching ability that they argued unsuccessfully for her to stay behind to teach when her family returned North.[7]

In West Middletown, Jane, nineteen, opened a home school for girls and boys.[8] Two years later, Jane married Matthew McKeever. She taught at home during some of the next twenty years, while participating in the family wool business and raising a family that eventually numbered more than twenty natural and adopted children.[9] By 1830 the home school was known as Pleasant Hill Seminary, still educating boys as well as girls.

In 1840, Jane's brother Alexander founded Bethany College in nearby Bethany, (West) Virginia. About two years later, Jane's school outgrew the McKeever home, was moved to a new building, and became Pleasant Hill *Female* Seminary. Jane, the seminary's founder, served as its "principal" for most of the next quarter century.[10]

The seminary was an important educational institution in the restoration movement. The school's three-year curriculum covered some material now taught in a typical high school, although many of its courses and texts were identical to those taught in four-year colleges of the time, including nearby Bethany.[11] Further, some of the courses offered at the seminary—painting and drawing, vocal and instru-

mental music—were not commonly taught at four-year colleges then, but are now part of a standard liberal arts curriculum. There was also at the seminary an emphasis on spiritual values and beliefs. Students were free to attend the church of their choice, although the seminary's *Catalogue* made clear that, "if no special instructions are given they will attend church with the matron, and be under her special care."[12] Both Alexander Campbell and William Pendleton, presidents of Bethany College, attested to the academic excellence of the institution in comparison with other colleges for females or for males.[13]

But more than education happened at Pleasant Hill. Jane and Matthew McKeever were described by a contemporary as "rank abolitionists," and were friends of John Brown of Kansas and Harper's Ferry fame, who was also a wool dealer. Pleasant Hill was an important station on the local "underground railroad," spiriting slaves to freedom in Canada.[14] Apparently, Jane's antislavery sentiments were much stronger—or at least more clearly demonstrated—than those of her nearby brother. In one of the few examples of her writing extant, Jane says, in a letter published in the abolitionist *North-Western Christian Magazine*:

> I truly rejoice to find that ONE of *our brotherhood* has had the fortitude, and independece [sic] of mind, to rise superior to the reproach and opposition of so many of his professed christian brethren, in behalf of the poor, oppressed and degraded slave....I trust that you will be encouraged to persevere, believing that God, who in all generations has been the God of the oppressed...will strengthen you, and bless your efforts in the good cause for which you plead. I intend to exert my influence in this vicinity amongst our brethren in behalf of your magazine.[15]

In 1866, Jane determined to hand over control of the seminary to her son and Bethany College graduate, Thomas Campbell McKeever. Only months into his principalship, Thomas died, and Jane resumed leadership of Pleasant Hill Seminary until 1868, when she finally did retire. Without her strong leadership, the seminary rapidly withered; its last graduating class was in 1869, and it closed some time in the mid-1870s. Hundreds of women from the United States and

Canada attended the seminary during its three decades of existence; 165 graduated, receiving "Mistress of Arts" degrees.[16]

What do we know of those graduates? Despite the societally restricted range of acceptable careers and activities for women in the late 1800s and early 1900s, several went on to make important contributions to the restoration movement, including: Jennie Reader Errett (class of 1860), who, with her father, then her brother, ran the *Christian Standard* from its first publication in 1866 until her death in 1927; Sarah Jane McFarland (1852), who taught at Pleasant Hill for fifteen years, then at a series of restoration movement-related colleges from Kentucky to California; Mary J. Cooney (1869), a public school teacher, generous benefactor of her church, and a life member of the Christian Woman's Board of Missions; Lorinda McKeever Wilkin (1848), daughter of Jane, teacher at Pleasant Hill, and author of many religious articles and pamphlets; Decima Campbell Barclay (1856), daughter of Alexander Campbell and prominent churchwoman throughout her long life; and Rebecca C. Jones (1847), highly respected teacher at Wellsburg (West Virginia) Female Seminary and other institutions.[17]

Jane Campbell McKeever lived with her daughter, Lorinda, in Harrisville, Ohio from the time she left West Middletown and Pleasant Hill Seminary until her death on December 10, 1871.[18] Such was the importance of her work and leadership that her picture was in the middle of the pictures of seventeen women "influential in the Restoration Movement" in a 1916 issue of the *Christian Standard*.[19]

Pleasant Hill Seminary closed its doors, and Jane Campbell McKeever died more than one hundred years ago, but what she accomplished through her educational work is an inspiration to us all. After the Pittsburgh, Pennsylvania, Centennial Convention of 1909, about one hundred former Pleasant Hill Seminary students, including several mentioned in this chapter, gathered in a last great reunion. No more fitting tribute to Jane Campbell McKeever and her seminary could have been written than that penned by Jennie Errett in the *Christian Standard*, as she described the reunion: "Our next great reunion will include those who have gone before among the hosts of the redeemed, to sing with them the song of Jesus, the Lamb of God, whose we are and whom we serve."[20]

Emily Harvie Thomas Tubman:
Benefactor of College and Church

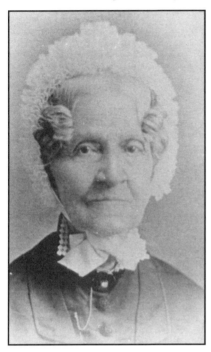

Emily Tubman

Like Jane Campbell McKeever, Emily Thomas Tubman was honored in the *Christian Standard* as a woman influential in the restoration movement.[21] In many ways, however, Jane and Emily, despite their contributions to the movement, were very different individuals. Jane was a seminary leader and teacher, one who lived on a Pennsylvania farm and who was a staunch abolitionist; Emily, one of the foremost philanthropists of the early restoration movement, was an urban Southerner, and a one-time slaveowner who uncompromisingly supported the Confederate cause during the Civil War. Yet across her lifetime, Emily Thomas Tubman's story was that of the one who received many talents, and used them wisely.

Emily Harvie Thomas was born on March 21, 1794, in Ashland, Hanover County, Virginia. Her family was not monetarily wealthy, but was land-rich and well known in the region. When Emily's father died in 1803, Henry Clay was for a time her legal guardian.[22]

In 1818, Emily married Richard C. Tubman, a wealthy exporter from Maryland, and moved with him to Augusta, Georgia, where she lived for most of the rest of her life. Although Richard was Episcopalian, and Emily often attended religious services with him, she did not join his congregation. Interestingly, although she became convinced that believer baptism by immersion was the proper form, and was baptized by a Baptist in 1824 or 1825, she never joined a Baptist congregation either.[23]

Emily and her husband were charter subscribers to Alexander Campbell's *Millennial Harbinger*. Through her reading of issues of that journal, Emily was strongly influenced by Alexander's thinking about the restoration movement. Richard Tubman died in 1836; by 1837, Emily had joined the restoration movement and was one of the founders of the Christian Church in Augusta. In fact, early in its history that congregation often met in her home.[24]

In his will, Richard directed that most of the couple's slaves be offered their freedom. Sixty-nine of their approximately one hundred fifty slaves opted for freedom and were sent by their request and Emily's expense to colonize in Liberia. The others remained as Emily's slaves until after the Civil War.[25]

Her husband's death left Emily a very wealthy widow, one who felt a strong intellectual and emotional commitment to the "primitive Christianity" espoused by Alexander Campbell. Then began almost fifty years of her unstinting contribution of resources and self to the cause of Christ.

Although early in her religious life Emily Tubman was strongly influenced by Alexander Campbell, it is obvious the influence extended both ways. Throughout the decades of their acquaintance, she often entertained him on his trips through the South, particularly in Augusta, and supported Bethany College both with money and by recruiting and financing students. Writing about her relationship with Alexander Campbell, Richard Bennett, an Emily Tubman biographer, notes, "In the age in which Mrs. Tubman lived, it was customary for women 'to be seen and not heard.' Mrs. Tubman deviated from the norm—religion, law, social, and business fields—all these were in her scope of learning."[26]

Emily's monetary contributions to Bethany and other restoration movement colleges began almost as soon as those colleges were established. For example, her contribution of $1000 to Bethany College in 1844, just four years after its chartering, was the largest individual gift the college received that year.[27] In subsequent years, she donated substantial sums of money to Bethany, Hiram, Transylvania, Northwestern Christian University (now Butler University), and Kentucky Female Orphan School (now Midway).[28]

The Civil War destroyed the fortunes of many wealthy Southerners—but not that of Emily Tubman. Her investments

were in areas that, in many cases, increased in value after the war—stock in the Georgia Railroad, land, state and city bonds, and banks. In fact, Emily's benevolence continued during and immediately after the Civil War. Tens of thousands of Confederate former prisoners of war were transported home free on the Georgia Railroad, which she controlled.[29]

After the Civil War, Emily's charitable giving reached new heights, although her desire to avoid publicity makes it impossible ever to know all the causes and organizations she supported. Between the end of the Civil War and her death twenty years later, Emily gave tens of thousands of dollars for new church construction and in support of evangelism; for foreign mission support; to restoration movement colleges, either directly or for support of ministerial students; and for the education of newly freed slaves. Bequests in her will included, among others:

> Female Orphan School of Kentucky (Midway)—$55,000
> Foreign Christian Missionary Society—$30,000
> Christian Church in Augusta—$50,000[30]

Emily Thomas Tubman received much and gave much, during and beyond her life on earth. Like the slave in Matthew's parable, she used her talents wisely, and entered into the joy of her Master on June 9, 1885. In a memorial address in Emily's honor after her death, George Darsie said, in part:

> The good she has done in the world by her direct gifts, great as it is, and as it will be for long years to come, seems to me even less than the good she has done and will do by the unconscious influence of her splendid life and example. What one is is always more than what one does....What an example...for Christian people everywhere to stimulate and cultivate in them the joy-bringing habit of benevolence![31]

Charlotte Fall Fanning: Working in the Shadow[32]

For every woman we are able to name and celebrate, dozens more labored in the shadows, unable to develop fully the gifts that were theirs. Charlotte Fall Fanning was one who worked perpetually in the shadow of her husband, loving helpmate though he apparently was. Yet she was one whose

story is at least partially recorded, and whose independent contributions to the restoration movement were substantial.

Charlotte Fall was born near London, England, on April 10, 1809, and emigrated to America as a child. After the death of Charlotte's mother, her older brother served as a foster parent to her, raising her and giving her both religious and academic education. As a young woman, Charlotte established a good reputation as an educator of young women at the Nashville Female Academy.[33]

Charlotte married widower Tolbert Fanning in 1836. Early in 1837 they moved to Franklin, Tennessee, and almost immediately opened a school. The amount of work Charlotte poured into school and home was tremendous: "Mrs. Fanning was a woman of fine common sense, and fully appreciated her surroundings. She could teach all day, and then attend to the ironing and other domestic duties at night."[34] It is not recorded how Tolbert spent his evenings at this new home and school of theirs.

After running this school for three years, the couple moved to Elm Crag, near Nashville, and ran a female school for two years. Charlotte and Tolbert next embarked on an evangelism tour through the South, a tour that lasted several months. Of course, Charlotte did not preach; that was a man's work. In the words of a biographer:

> Whatever Tolbert Fanning might have been without Charlotte Fall, he was a great man with her....with her to supplement his work in teaching, preaching, farming, and housekeeping, his efforts were crowned with the highest success....She seemed instinctively to know her part, and faithfully she did it. He could preach, she could sing; he could argue, she could persuade.[35]

He could develop his gifts to their fullest; she must labor forever in his shadow.

Apparently, teaching young women was the passion that energized Charlotte's life. Back in Franklin, Tennessee, in 1844, the couple resolved to open a college for males, under Tolbert's direction, and a school for females, under Charlotte's direction. Franklin College and its associated "girls' school" opened in January, 1845; however, at least one former student perceived the two schools as a single entity.[36]

Although the two schools were technically run separately, there were significant points at which they met and over-lapped. Women and men taking the same class in their separate schools often recited together during common sessions. In fact, two of Charlotte's students actually graduated from Franklin College, the only two women in its history to do so.[37] At one point, Alexander Campbell visited Charlotte's school, and commented favorably upon it. (On that occasion, the theme of Campbell's address was "Man as he was, man as he is, and man as he will and must hereafter be; and, more especially, ransomed and renovated man." Even Campbell recognized how peculiar this would sound to an audience composed largely of women, for in a footnote in the *Millennial Harbinger* article summarizing his visit, he says, "Man, in this address, of course represented both sexes."[38])

What type of teacher was Charlotte? Motherly and aggressive are two words J. E. Scobey uses to describe her; Eleanor Hill Fanning, one of her students and a graduate of Franklin College, said:

> Her idea was that education embraced the whole man or woman; that it was the leading out, the developing, of all the faculties of mind, heart, and soul. The physical, as well as the intellectual and moral, powers were to be called forth and trained for usefulness.[39]

Throughout her long career, Charlotte put the needs of her students first, her own needs second (or third, behind those of Tolbert).

Coincident with the duration of the Civil War, Franklin College ceased operations from 1861 to 1865. Charlotte was always a strong supporter of the South, and took pride in the men from Franklin College who served in the Confederate military. In the fall of 1865 the college reopened, but within a month of reopening, the main buildings were destroyed by fire. Not discouraged, Charlotte and Tolbert almost immediately bought nearby Minerva College, renamed it Hope Institute, and opened in the fall of 1866. Charlotte and Tolbert together ran the school until his death in 1874.[40] The level of education in this "school for girls and young ladies" is difficult to establish, since few formal records were preserved. In fact, a former teacher writing about the institute—Tolbert's sister-in-law—

said, "No record having been kept, it is impossible to give a correct list of those who graduated."[41] Within a year or two following Tolbert's death, Hope Institute ceased operation.

Prior to his death, Tolbert and Charlotte agreed eventually to construct an orphan school. Ten years later, Fanning Orphan School opened on the grounds of the former Hope Institute.[42] Ever the teacher, Charlotte delighted in conducting classes at the school until shortly before her death. "Rich and poor, high and low, black and white, were alike the recipients of her favor; and if any discrimination were made, it was in favor of the poor, and especially the sick."[43]

Charlotte died on August 15, 1896, almost eight months after apparently experiencing a severe stroke.[44] No one knows all the names of the girls and young women she educated; no one has recorded the dollars and vitality she poured out for others; no one knows the thoughts of this woman forever in the shadows of men. But we do know that she persevered, that like the writer of 2 Timothy, she fought the good fight, finished the race, kept the faith. How many more like her are there whose names and deeds we will never know?

Mattie Forbes Myers Carr: A Woman with a Dream[45]

Few people ever have pursued a dream across a lifetime like Mattie Myers Carr did. Born Mattie Forbes Myers in Stanford, Kentucky, on September 18, 1846, she was a fragile child, one frequently sick, yet one with the desire someday to establish a college for the education of women. Far from shrinking in the face of physical limitations, Mattie saw her childhood illnesses, and the deaths of two of her siblings, as challenges to be met, as building blocks of character. By the time she was nineteen, she had established a school for girls, soon after completing her own formal education at Daughters College in Harrodsburg, Kentucky. In 1867, at the age of twenty, Mattie purchased Franklin College at Lancaster, Kentucky, and according to a biographer, "She [was] the president, of course."[46] Early in her life, just when Mattie seemed to have reached her dream, events changed her life's course for almost thirty years.

In 1868 she married O. A. Carr and terminated her work at Franklin College. Within six months the young couple had

sailed for Australia to spend the next four years as evangelists and missionaries there. Once again, Mattie opened a home school, this time using income from that venture as an important means of financing their mission work. Her home school seems to have been an extension of her own strong will and purpose; her biographer records:

> Her system of education—indeed, her conception of education—differed materially from that found in Melbourne. If her method seemed radical to the most conservative, it filled with delight those open to impressions of new truth. Mrs. Carr's scheme to educate a girl was not to fill her with facts, but to develop her mind and heart....She took pains to teach them how to preserve their health, how to deport themselves, how to preserve their modesty and integrity, how to become forces in the world....It was her desire to form of each impressionable girl, a noble woman.[47]

To support the couple's ministry in Melbourne, Mattie raised money in a variety of ways. Not only did she run a boarding school for girls, but she also gave music lessons, and even made and sold sailors' caps. Beyond support for her husband's frequent evangelical forays, Mattie also raised money for construction of a chapel, in support of an Australian university, and to underwrite a health-related trip her husband made (alone) to Tasmania.

After more than four years in Australia, their health deteriorating, the couple set sail for the United States, spending several months touring in Asia and the Pacific along the way. After landing in the U.S. late in 1873, Mattie immediately involved herself in female education again, this time as "associate principal" of Hocker (later Hamilton) College in Lexington, Kentucky.

Not content to work at someone else's college, Mattie founded Floral Hill College in Fulton, Missouri, in 1876. She was "head" of that college until 1878, when Floral Hill merged with nearby Christian College in Columbia, Missouri. Mattie remained at Christian College for one unhappy year as "associate principal." Ellis T. Breckenridge relates:

> Floral Hill College was absorbed by Christian College accordingly; but Mrs. Carr's personality was one that

refused to be absorbed by any association, or institution. So definite were her ideas of the management of a school, particularly in regard to its discipline, that her position as associate principal could never have been satisfactory in any school. Mrs. Carr was a woman of intense conviction, and when attempts were made to persuade her from her principles, she felt that she was being persuaded to error.[48]

Over the next fifteen years, Mattie worked for other people in a variety of situations, but always was aiming to establish and run her own college for young women.

For ten years, Mattie served the University of Missouri as a professor of English and Dean of the Young Ladies' Department. Her activities in that position were incredibly varied. Mattie delivered lectures in the university chapel; contributed to the university's magazine; advocated physical education for university students; greatly increased the number of women attending the university and the opportunities those women had available to them; and corresponded with legislators and church leaders. Most people would have been content in that work, but Mattie pursued several other interests with the same type of passion that she brought to all her life's activities.

For one thing, Mattie became actively involved in the Christian Woman's Board of Missions. Perhaps as a result of developing her communication skills over a lifetime of educational endeavor in support of her husband's evangelistic efforts, Mattie was much in demand as a public speaker for the Christian Woman's Board of Missions. From 1884 through 1886 she served as Christian Woman's Board of Missions vice-president for the state of Missouri. In 1885 she delivered an important address detailing the early history of the Christian Woman's Board of Missions at that body's annual convention in Carthage, Missouri. Sadly, others limited the extent to which Mattie was allowed to advocate for the Christian Woman's Board of Missions. Even her husband attempted to limit her advocacy for the Christian Woman's Board of Missions and other causes, saying, "You ought to write much for the Brotherhood. Women can do that work, and not trespass on 1 Cor. 14:34–35."[49] ("Women should be silent in the churches. For they are not permitted to speak, but should be subordinate, as the law also says. If there is anything they desire to

know, let them ask their husbands at home. For it is shameful for a woman to speak in church"[verses 34–35].)

And Mattie found other causes and activities calling for her time. She and her husband coauthored a book, published in 1885, detailing the work of J. K. Rogers and the history of Christian College; Mattie joined the Woman's Christian Temperance Union and in 1884 was the Corresponding Secretary for the Columbia Union branch of that group; and she applied to be president of Midway Orphan School, but was turned down because she was a woman. We will never know all of what Mattie could have achieved, had she not been denied many opportunities simply because of her gender.

In 1886, Mattie's health once again declined, and when her husband accepted a call to a church in Springfield, Missouri, she accompanied him and temporarily withdrew from her educational efforts. During the next three years, as she recovered her health, Mattie planned for what was to be her final grand effort in educating young women. In her own words:

> Like an inspiration the thought came to me: "Build a college for girls, consecrate your life to it, and leave it as a bequest to the Church." I told Mr. Carr of my heart's desire, and, after prayerful consideration, we resolved to devote our united lives to the work.[50] At this significant point in their married life, O. A. finally was following a dream of Mattie's.

Despite concern over her health, Mattie traveled extensively in Missouri, Kentucky, and Tennessee looking for a suitable site for her college. At one point, O. A. went to Sherman, Texas, to conduct some meetings. The citizens of Sherman discovered the Carrs were looking for a college site, and suggested Sherman. From the time of this initial positive contact with the people of Sherman, five frustrating, work-filled years were to pass before Mattie's college finally opened its doors.

Financing her college turned out to be an arduous task for Mattie, her husband, and others. The people of Sherman donated land for the college; it was up to Mattie to finance construction of the college through selling some of the land as lots. At times this work progressed so poorly that Mattie and O. A. were tempted to abandon their effort, in Texas, at least.

Lots were sold, but never paid for; the Carrs lost money personally as they sold possessions and land to finance interest payments they had to make on borrowed money; many people actively resisted their effort to found a college. Finally, in September of 1893, ground was broken for what came to be known as Carr-Burdette College. The college officially opened its doors to students in September 1894.

In the early history of the restoration movement, women often were not fully credited for what they accomplished or the offices they held. A woman in charge of a postsecondary school might be called a "principal" or "superintendent"; a man in a similar position might more often be called a "president." Nevertheless, at least one source unambiguously refers to Mattie as "President [of Carr-Burdette College] until her death."[51] During Mattie's fourteen-year presidency, Carr-Burdette College recovered from its shaky financial start and began to fulfill her dream of a place to provide multifaceted education for women. Although the Carrs essentially owned Carr-Burdette College during their consecutive presidencies— she from 1894 to 1907, he from 1907 to 1913—they stipulated that upon their deaths the college ownership would revert to the Christian Churches of Sherman and of the rest of Texas, and it did. However, none seemed able to run the college as well as Mattie, and it closed its doors in 1929.[52]

Mattie's must have been an interesting presidency. As college president, she regularly taught art classes, constantly worked for and supervised improvements in the college, and raised money, raised money, raised money. According to one writer, "The girls expected the Head Woman to be a little bit odd, and they got what they expected. She was different."[53]

Her health finally destroyed by her chronic overwork, Mattie Forbes Carr died on October 31, 1907, at the age of sixty-one. Throughout her life, she had spent herself extravagantly for the education of young women, and to the glory of her God.

Luella Wilcox St. Clair Moss and Emma Frederick Moore: The Tag-Team Presidency [54]

Woman presidents of institutions of higher education were rare in the early history of the restoration movement. Rare, too, were co-presidents of such institutions. Rarest of all,

perhaps, would be succeeding oneself as president of an institution after someone else had been president for several years—and being a woman. Luella Wilcox St. Clair Moss and Emma Frederick Moore participated in all of the above during their decades of service to the higher education of women.

Luella Wilcox was throughout her lifetime on the leading edge of education and equal rights for women. Born in Virden, Illinois, on June 25, 1865, Luella was the only young woman to be in the high school's first graduating class—and was its valedictorian. After she graduated from Hamilton College in Lexington, Kentucky, she married Franklin Pierce St. Clair, a Bethany College graduate. The couple eventually moved to Colorado, where Luella taught school for three years.[55]

In 1893, Franklin was chosen to be president of Christian College in Columbia, Missouri, and began his tenure that fall. Almost before the couple and their young daughter had a chance to settle in, Franklin died in November 1893. Such was the impression that Luella had made in those few months that the college's board of trustees immediately selected her to take over as the college's president, not as an interim, but on a permanent basis.[56]

One who looked only at paper credentials would have to conclude that Luella was unqualified to be a college president. True, she had graduated from Hamilton College, but had attended it for only a year after high school. By the end of the nineteenth century, it was commonplace for college presidents to have at least a master's degree. In addition, 1893-1894 was a time of economic distress in the United States; certainly this was not a time for a college to select as its president one whose sole involvement in education consisted of teaching for about four years, three of them in rural Colorado. But Christian College *did* call Luella, and for most of the next half century, she answered that call.

At the time Luella began her presidency, Christian College already occupied a prominent place in the restoration movement education of women. From the time of its founding in 1851, the college had counted many prominent restoration movement women among its faculty and alumnae, including faculty members Caroline Neville Pearre (the founder of the Christian Woman's Board of Missions and the one who brought the study of human reproduction to Christian College)[57] and Mattie Myers Carr. If those who selected her thought Luella's

presidency would be a caretaker one, they were badly and fortunately mistaken.

The operative word for Luella's presidency was *change*. Some changes, of course, were minor, others more substantial. College student uniforms changed; the college catalog was updated; *Christian College Chronicle*, a student magazine, began publication; contributions to the college, including $175,000 from John D. Rockefeller, increased. All this and more Mattie accomplished within her first few years as president.[58]

In 1896, she made the acquaintance of Emma Frederick Moore. Emma was born in Auburn, New York, in 1859. After graduating from Wellesley College, she married William T. Moore in 1890.[59] In 1896, the couple moved to Columbia when William assumed the position of dean of the Bible College of Missouri.[60] Although neither knew it at the time, the friendship Luella and Emma began would have important consequences for Christian College and for the history of restoration movement higher education.

While she was bringing needed change to Christian College, tragedy continued to dog Luella and her family. In the second year of her presidency her father, whom Luella had called on often for his sage business advice, suddenly died. In November 1896, Luella herself was stricken with double pneumonia and barely survived. During Luella's time of critical illness, Emma Moore took care of Luella's daughter Annilee and "took over the duties of the president's office."[61]

Slow recovery from her illness led Luella to resign as president of Christian College in mid-1897, contingent upon Emma Frederick Moore succeeding her. Emma was selected by the board of trustees as Christian College's next president, beginning her duties as Luella left. Luella and her sister, Maxine, left for an extended tour in Europe, as Luella's health slowly returned. Luella kept in touch with Emma and with the events at the college, and when the college began to experience enrollment and financial problems, Luella agreed in the fall of 1898 to return to Christian College as "financial secretary."[62] Her major duty was to raise $50,000 to help ease the college's financial burdens and fund some new construction.

Although Luella and Emma poured at least ten thousand of their own dollars into the financial campaign, the campaign otherwise appeared to be going nowhere. Dire circumstances

called for unusual solutions. In April 1899 the board announced that Luella had been elected copresident of Christian College. The very next month, Luella and Emma in effect bought Christian College, assuming its indebtedness and promising to fund at least $15,000 of new building. The board of trustees violated the charter of the college, which specified that the college must be the property of the trustees, but in doing so they saved and ultimately improved Christian College.[63]

New construction began immediately. In real and symbolic ways students aided the construction as they carried building bricks with them on their way from classes. But in the midst of optimism and construction, personal tragedy struck again: Luella's daughter Annilee died of a rheumatic attack in January 1900. The new building on campus was christened St. Clair Hall in honor of her husband, but for Luella, it stood as a monument to Annilee. Luella's response to this most recent tragedy was to throw herself even more totally into the copresidency of the college.[64]

More building and fund-raising ensued. Emma and Luella successfully sought funding from alumnae and others from as far away as England. They established scholarships and sold building bonds. In May 1902, one year behind schedule, they hosted the Golden Jubilee of the college; local papers reported that Luella and Emma had provided $75,000 of the building and improvement funds out of their own pockets. Finally, the copresidents specified that upon their deaths the college would once again become the property of the board of trustees. All in all, their four-year copresidency was a time of relative prosperity and progress for the college.[65]

In the spring of 1903 Luella announced to the board that she had accepted the presidency of Hamilton College in Lexington, Kentucky; Emma would continue as sole president of Christian College. Although the trustees may not have liked being told who would be president of the college, the fact that Emma and Luella owned it left them no voice in the matter. In 1903, then, Emma was president of Christian College while Luella became president of Hamilton College.[66]

The good work that Luella and Emma began continued under Emma's guidance. Many of the improvements she brought to the campus—new laundry equipment, an improved electric generating capacity, an artesian well and water tank, for example—were not educational innovations, but physical

plant improvements. Emma established a reputation with many of the students as a disciplinarian, but one ever sympathetic to their needs. A series of *Christian-Evangelist* articles from 1903-1908 chronicles other changes and improvements at Christian College: a Christian Woman's Board of Missions auxiliary; a new practical course in cooking; new gym equipment; and other improvements, large and small, in the college's buildings and grounds.[67]

Meanwhile, Luella was not idle at Hamilton College. In a June 1904 *Christian-Evangelist* article, restoration movement college presidents were asked to identify, as the article title says, "The Greatest Need in Our Educational Work." Luella's answer was, "financial straw from which may be made educational bricks."[68] (Interestingly, Emma's response in the same article was "Unity," by which she meant, "Our interest should never wane until the permanent efficiency of every school in our brotherhood has been established by an *adequate endowment fund*" [italics hers].[69] And figurative and literal bricks were once again priorities of Luella's. According to *Christian-Evangelist* and *Christian Standard* articles from 1903 to 1908, enrollment at Hamilton College doubled; library holdings increased; a quarterly magazine, *The Hamiltonian*, began publication; tens of thousands of dollars were raised for new building and improvements; and Luella generally infused the college with her vision and energy.[70]

Also during Luella's tenure at Hamilton, the college established a cooperative relationship with nearby Kentucky University. The relationship allowed students from junior-college-level Hamilton to use facilities and meet with professors from Kentucky University, and to transfer to the University as juniors when they had completed the course of study at Hamilton, without formally uniting the two institutions and thus compromising Hamilton's status as a women's college.[71]

And Luella continued to promote the spiritual and intellectual life of students. Articles about Hamilton mention a strong YWCA chapter, a Christian Woman's Board of Missions auxiliary, and as many as four mission study groups. They mention, too, the strengthening of the music program, and the beginning of an "honor roll" to recognize outstanding scholarship.

Obviously, many of the priorities of Emma and Luella were shared priorities, even though they were presidents of

different colleges. Obvious, too, was the fact that, while Hamilton College prospered, Christian College did not. In fact, by 1908 enrollment at Christian College had dropped precipitously, the college was in financial difficulty, and Emma's health took a severe turn for the worse as arthritis began to cripple her. Emma resigned the presidency of Christian College, and in 1909 Luella once again became its president.[72]

Counting her copresidency, this was the third time that Luella had been selected president of Christian College, and, as one writer records it, "Her return, as her first contact with Christian College, brought innovations."[73] For one thing, Christian College officially became a "junior college," although some of its degree programs required more than two years of post-high school work. For another, Luella tackled (once again) the financial solvency of the college. Within the first few months of her return, the college was out of debt, due in large part to Luella relinquishing her part ownership of the college in order to obtain a grant from Andrew Carnegie.

In 1911, the year Christian College celebrated its second Golden Jubilee (sixtieth) Year, Luella married again, this time to the college physician, Dr. Woodson Moss. The marriage seems to have had little effect on the energy Luella brought to her work as president. The building and remodeling that so typified her early presidencies returned; among other projects, the college soon had a new gymnasium, a new academic building, a new gateway entrance to campus, and a natatorium.

Although some thought her out of touch with "modern" women, Luella demonstrated time and again her concern for the education of the whole person. For example, within a few years of her resuming Christian College's presidency, the college was experiencing discontent brought about by the several sororities competing with one another, and excluding some women. Luella's unpopular solution was to disband the sororities, saying that they "weaken the spirit of true democracy... [and] tend to control all student activities and require of the student time and energy disproportionate with the return."[74]

But to think that Luella spent time on nothing besides the welfare of Christian College and its students would be to underestimate her energy and social awareness. Although

Luella had definite, comparatively conservative ideas about what constituted proper female college student decorum, she was long in the forefront of suffrage and other women's rights activities. "Her concept of woman's place was...heretical....For years she told her girls that on the day women got suffrage they could have an all-school holiday."[75]

Ironically, women's suffrage finally was achieved in the U.S. in 1920, a month after Luella retired as president of Christian College, and it is not known whether the students got the day off or not. Now in her mid-fifties and twice widowed, Christian College's first President Emeritus and female member of the board of trustees might have been expected to slip into a quiet retirement, resting on her ample laurels. But of course she did not. In 1922 she received the Democratic Party nomination for a seat from Missouri in the U. S. House of Representatives.[76] Although she was not elected—only two women had been elected to the national House of Representatives up to that time—her platform received the endorsement of *The Christian-Evangelist.*[77]

Later in her life, Luella continued her active service to the college and the wider community. In 1934 she was honored by Christian College for forty years of service, receiving letters of recognition from various graduating classes and delivering the commencement address.[78] Although not as much has been written about Emma's later life, she and William apparently helped establish a church in Clearwater, Florida, after they had retired there.[79]

Emma and Luella died less than two years apart—Emma on December 25, 1945, and Luella on August 18, 1947. Their combined work over a total of about forty years as presidents and copresidents of restoration movement colleges for women is unique; their contributions to the restoration movement in particular and women's rights in general are beyond reckoning.

Early Scholars

Recently a group of women scholars who are Disciples established the Forrest-Moss Institute to nurture and encourage scholarship on women and religion. The institute is named in honor of Luella Wilcox St. Clair Moss and Albertina Allen Forrest.

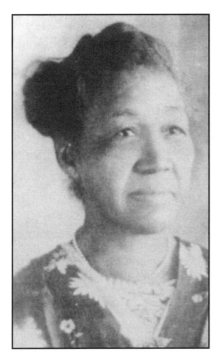

Sarah Lue Bostick

Albertina Forrest studied philosophy, psychology, and English literature as a graduate student at the University of Chicago from 1894-1897. Although she died in 1904, in her few years of life Albertina distinguished herself by becoming the first administrator (in 1894) of what would later become the Division of Higher Education, a charter member (in 1896) of the Campbell Institute, and an author of scholarly articles. Her importance to the history of higher education is as one of the first Disciples women scholars.

In addition to Kathleen MacArthur (mentioned elsewhere), Kristine Culp identifies two other Disciples women who were recipients of Ph.D. degrees in religion from the University of Chicago—Lucy Markley (perhaps the first Disciples woman to earn a Ph.D. degree in religion, in 1925), and Kathryn Rogers (in 1937).[80]

Sarah Lue Bostick and Bertha Mason Fuller: The Founding of Jarvis Christian College.[81]

Despite the fact that African-Americans were among the earliest participants in the American restoration movement—many while they were slaves[82]—relatively little of the higher education focus of the movement centered on African-Americans. The story of Sarah Lue Bostick and Bertha Mason Fuller, and the eventual founding of Jarvis College, provides an inspirational exception to that general rule.

Sarah Lue Howard was born on May 27, 1868, near Glasgow, Kentucky. Of African-, Native-, and European-American heritage, Sarah Lue knew firsthand the bigotry and racial

Bertha Fuller

tensions within the post-Civil War United States. She attended public schools in Kentucky, then married Perry Young in the early 1880s. She had one son from her first marriage, but Perry and their young child died, probably of yellow fever, not many years later.[83]

In 1888, after Perry's death, Sarah Lue moved to Arkansas to live with members of her extended family, and for two years attended Shorter College in North Little Rock. While visiting some relatives in Pea Ridge, Arkansas, Sarah Lue met Mancil Mathis Bostick. They were married in April 1892, on the same day he was ordained as a minister, and shortly after Sarah Lue was baptized into the Christian Church.

At some point in her long career of Christian service, Sarah Lue became an ordained minister, and with Mancil evangelized and preached in African-American and European-American churches throughout the South. Her preaching and her public speaking were well received by African- and European-Americans alike. Sarah Lue was extremely well-read, and apparently retained what she read with unusual clarity, using what she had learned in her speeches and sermons.[84]

Early in her church career, Sarah Lue became involved in higher education, urging young African-Americans to attend Southern Christian Institute in Mississippi. With her active support, Mt. Sinai Church—of which she was a member—of North Little Rock funded educational and other mission efforts, and under her leadership African-American women of Arkansas supported Southern Christian Institute.[85] Sarah Lue herself never had much money—indeed, she died in relative poverty, supported only by payments from the Pension Board

of the Disciples of Christ and by gifts from her many friends—
yet in her will she bequeathed $100 to Southern Christian
Institute, $100 to Jarvis Christian College, and $50 to her
home church.[86]

From at least the 1890s on, African-Americans and others
in Texas had worked to raise money for a college for black
students. (Apparently, there was no serious consideration given
to founding an integrated college.) Mary Alphin, an African-
American organizer of Texas women, was chief among those
working actively for such a college, although progress was
agonizingly slow.[87] In 1903, Bertha Mason, active in the Texas
Christian Woman's Board of Missions and one of the earliest-
ordained restoration movement women, received a promise of
several hundred acres of land for the college from Ida Van Zandt
Jarvis and her husband, Major J. J. Jarvis.[88] This promise led
a decade later to the founding of Jarvis Christian College.

But all did not progress smoothly toward the founding of
that college, even after the land was promised. In 1904 Bertha
invited Sarah Lue, then national president of the Negro Chris-
tian Women's Board of Missions, to come to Texas to coordi-
nate work with the (European-American) Christian Woman's
Board of Missions in the founding of the proposed college.
Despite their work and the work of others like the McAlpines,
an African-American pastor couple, much work remained to
be done. Fund-raising proceeded slowly. African-American
Disciples were understandably reluctant to entrust their mon-
ies to the (European-American) Christian Woman's Board of
Missions; some earlier fund-raising efforts for a college were
nullified when the money was stolen.[89]

Several years later, while Bertha Mason attended the
Paris, Texas, convention of African-American Christian
Churches, the necessary cooperation between European- and
African-American Christians occurred. Bertha was spared se-
rious injury in a horse-drawn carriage accident witnessed by
several of those attending the convention. To many, this was a
message that it was time to sign a cooperative agreement, and
this last formal step assured the college would be built.[90]

Jarvis Christian Institute, as it was initially known, fi-
nally opened its doors in January 1913,[91] but the work on its
behalf continued. For example, Mary Alphin documented con-
tinuing efforts to finance the institute, then to bring the insti-
tute up to full collegiate status, something achieved finally in

1941.[92] We may never know the names of the countless other women and men who gave their cents and dollars for the founding and maintenance of Jarvis.

After Jarvis' founding, Sarah Lue Bostick and Bertha Fuller (in 1907, she married J. J. Fuller) continued their friendship and their work in the ministry and in the service of higher education. Sarah Lue Bostick died on May 1, 1948, having subsisted on her Pension Board income through a long period of declining health caused by cancer.[93] When Bertha sorted through Sarah Lue's papers after Sarah Lue's death, she found that Sarah Lue had kept invaluable files of early journals, mission tracts, and the like. Further, in Bertha's words:

> These [seemingly] worthless scraps of paper were investigated more closely, and found to be stories of Negro achievement or of many atrocities committed against them....In all of our intimate conversations she never mentioned them. As I read them...I knew I had found the secret interest of her heart: the progress of her own race, and the stories of its injustices and oppression....She had gathered the sorrows, tears, laughter, toil, bitterness and suffering of her own race....It was to her, bitter knowledge mixed with the sweet of her Christ like service.[94]

No one will ever know all that Sarah Lue experienced in her work for African-American education within the restoration movement, the joy and the pain that were hers, but we can celebrate her work and her shining example.

The Situation Today

Today, of course, the roles of restoration movement women in higher education and philanthropy are varied and valued. While women are still underrepresented on most faculties of colleges associated with restoration movement churches, and women presidents and higher-level administrators are uncommon, most of us rejoice in women's increasing participation in these forms of service. The debt we owe to our education- and philanthropic-minded foremothers is incalculable; whole generations of women—and men—in and associated with the restoration movement were educated through their efforts.

No one will ever know what motivated these women and others to lead in areas where opposition was common and vehement. But the Bible that they studied and the one whom they followed constantly showed them examples of self-giving, substance-giving, and teaching. Perhaps they more than others felt the power of these lessons, and felt their lives must reflect what they had encountered. It remains for us, in turn, to learn from them, to reapply the timeless lessons in the world in which we live.

An Opportunity to Respond: A Private (or Corporate) Celebration of Women's Wisdom and Philanthropy

(Responsive) Reading: Proverbs 8:1–7a

A. Does not wisdom call, and does not understanding raise her voice?

B. On the heights, beside the way, at the crossroads she takes her stand;

A. beside the gates in front of the town, at the entrance of the portals she cries out:

B. "To you, O people, I call, and my cry is to all that live.

A. O simple ones, learn prudence; acquire intelligence, you who lack it.

B. Hear, for I will speak noble things, and from my lips will come what is right; for my mouth will utter truth...."

Prayer

Eternal God, as wisdom was with you at the creation, as wisdom was then your daily delight, so too, we pray, may we delight in wisdom. Help us to remember and celebrate the lives of those women who found and shared wisdom throughout their lives. May we, like they, in finding wisdom find life. Amen.

Meditation

Suggested readings:

Luke 8:1–3
Luke 21:1–4
Luke 10:38–42

As you think about the first two readings, put the names of women you know in place of those mentioned. Whom do you know who provides for the work of the body of Christ out of her resources? Who travels, proclaiming the good news? Who gives all she has for God's work? As you contemplate the final reading, think about yourself. Are you like Martha, worried overwhelmingly about day-to-day tasks, or are you more like Mary, willing to attend to the teachings of Jesus? What might you do to change?

Prayer

Creator God, you who delight in wisdom, awaken in us a concern for Christian education and intellect. Redeemer God, teach us to give as the widow gave—not of our surplus, but of our very being. Sustainer God, help us, like Mary, to choose the better part, to value learning above the humdrum of our ordinary lives. Amen.

Possible Projects

1. Look at the restoration movement colleges and universities in existence today. Do they value the educational and administrative contributions of women? What are they doing to increase the participation of women on their faculties and staffs?

2. Look at your church. Are the philanthropic and educational efforts of women valued and celebrated? If not, what can you do to change the situation?

3. Look at yourself. What more can you do to develop your talents in the areas of education and philanthropy? What can you do to support the works of others?

Notes

[1]John H. Hull, this chapter's writer, is professor of psychology and department head at Bethany College. He has studied extensively Pleasant Hill Female Seminary and the work of Jane Campbell McKeever. Currently he is researching the stories of Disciples who were active in the underground railroad. He would like to thank several people for their help with this chapter: R. Jeanne Cobb, Bethany College Archives, Bethany, West Virginia; David McWhirter and the staff of the Disciples of Christ Historical Society, Nashville, Tennessee; Jane Fulcher, local historian, West Middletown, Pennsylvania; and the archival staff of the Brooke County, West Virginia, Public Library.

[2]Allean Lemmon Hale, *Petticoat Pioneer* (St. Paul, Minnesota: North Central Publishing Company, 1968), p. 148.

[3]John H. Hull, "Jane Campbell McKeever," *Discipliana*, 52 (spring, 1992), p. 7.

[4]Robert Richardson, *Memoirs of Alexander Campbell, Volume I* (Philadelphia: J. B. Lippincott & Co., 1871), pp. 40-46, 78-79, 204, 279.

[5]Alexander Campbell, *Memoirs of Elder Thomas Campbell* (Cincinnati: H. S. Bosworth, 1861), p. 123.

[6]Lester G. McAllister, *Thomas Campbell: Man of the Book* (St. Louis: Bethany Press, 1954), p. 175.

[7]Richardson, *Memoirs*, pp. 494-496.

[8]Phoebe A. Murdock, *Pleasant Hill Seminary* (unpublished manuscript, no date), p. 1, in the Pleasant Hill Seminary Collection of Jane Fulcher, West Middletown, Pennsylvania.

[9]Letter from Lorinda McKeever Wilkin to William T. Lindsey (March 15, 1910), Pleasant Hill Seminary Collection, Bethany College Library Archives.

[10]See for example the following *Millennial Harbinger* articles: "Pleasant Hill Seminary," series 3, volume 4, (September, 1847), p. 537; A.C., "Pleasant Hill Seminary," series 3, volume 5, (August, 1848) p. 479; A.C., "Pleasant Hill Female Seminary," series 3, volume 7 (August, 1850), pp. 474-475; Isaac Errett, "Meeting at West Middletown, Pa., and Pleasant Hill Seminary," series 4, volume 6, (March, 1856), p. 177; A.C., "Pleasant Hill Female Seminary," series 4, volume 6, (September, 1856) p. 539; R.M., "Pleasant Hill Female Seminary," series 4, volume 7, (November, 1857) p. 658; and *Twenty-first Annual Catalogue of Pleasant Hill Female Seminary 1866-1867* (Washington, Pennsylvania: Reporter Steam Book and Job Office, 1867), p. 4.

[11]For example, *Twenty-third Annual Catalogue of Pleasant Hill Female Seminary 1868-1869* (Wilmington, Ohio: Garvin & Lowry, 1869), pp. 4, 5, 12, 13; *Catalogue of Bethany College, 1870* (Wheeling: Frew, Hagans, & Hall, 1870), pp. 13-20.

[12]For example, *Sixteenth Annual Catalogue of Pleasant Hill Female Seminary, 1861-1862* (Washington, Pennsylvania: Reporter and Tribune Book and Job Office, 1862), p. 18.

[13]For example, A.C., "Pleasant Hill Seminary, Washington County, Pennsylvania," *Millennial Harbinger*, series 5, volume 1, (August, 1858) p. 480; W.K.P., "Pleasant Hill Female Academy," *Millennial Harbinger*, 36, (August, 1865) p. 381.

[14]Ernest F. Acheson, "Editorial Correspondence. The Pleasant Hill Seminary—A Noted Educational Institution of the Past," *The Washington* [Pa.] *Observer* (no volume listed on the copy available), (September 6, 1888) (no page number listed on the copy available), Pleasant Hill Seminary Collection of Jane Fulcher, West Middletown, Pennsylvania.

[15]Jane C. McKeever, "Interesting Letter," *North-Western Christian Magazine*, 1, (November, 1854) pp. 153-154.

[16]For example, *Sixteenth Annual Catalogue of Pleasant Hill Female Seminary 1861-1862*, p. 18.

[17]I have collected data on these and about thirty other Pleasant Hill Seminary graduates from *Christian Standard* and *Christian-Evangelist* articles, the Brooke County (Wellsburg, West Virginia) Public Library Archives, and from Jane Fulcher of West Middletown, Pennsylvania.

[18]"Died," *Christian Standard*, 7, (January 6, 1872) p. 5.

[19]"Women Influential in the Restoration Movement," *Christian Standard*, 51, (April 8, 1916) p. 1011.

[20]J. R. E., "Pleasant Hill Seminary," *Christian Standard*, 46, (August 13, 1910) p. 1397.

[21]"Women Influential in the Restoration Movement," p. 1011. Unless otherwise noted, all other references in the Emily Thomas Tubman section are from Joseph Richard Bennett, *A Study of the Life and Contributions of Emily H. Tubman* (Butler University, Indianapolis, unpublished B.D. thesis, 1958).

[22]*Ibid.*, pp. 7-8.

[23]*Ibid.*, pp. 10-13; see also, George Darsie, "Mrs. Emily H. Tubman," *Christian Standard*, 20, (July 11, 1885), p. 220.

[24]Bennett, *A Study*, p. 14.

[25]*Ibid.*, pp. 41-45.

[26]*Ibid.*, p. 17.

[27]"Bethany College," *Millennial Harbinger* series 3, vol. 2 (July, 1845), pp. 329-332.

[28]"The Tubman Chair," *Millennial Harbinger* series 4, vol. 7 (June, 1857), p. 355 and Bennett, *A Study*, pp. 59-67.

[29]Bennett, *A Study*, pp. 26, 53.

[30]*Ibid.*, p. 30.

[31]Darsie, "Tubman," p. 220.

[32]All references but one in the section on Charlotte Fall Fanning are taken from James E. Scobey, (ed.), *Franklin College and Its Influences* (Nashville: Gospel Advocate Co., 1954).

[33]Scobey, *Franklin College*, pp. 147-148.

[34]*Ibid.*, p. 149.

[35]*Ibid.*, p. 151.

[36]*Ibid.*, p. 153; see also Anthony Joyner, "Letter," in Scobey, *Franklin College*, p. 241.

[37]Scobey, *Franklin College*, p. 153, 328.

[38]Alexander Campbell, "Our Visit to Nashville," *Millennial Harbinger* series 4, vol. 5 (February, 1855), p. 105.

[39]Eleanor R. Fanning, "Mrs. Fanning's School," in Scobey, *Franklin College*,

p. 171.

[40]Scobey, *Franklin College*, pp. 160-161.

[41]*Fanning*, "Mrs. Fanning's," p. 177.

[42]Scobey, *Franklin College*, pp.161-162.

[43]*Ibid.*, p. 165.

[44]*Ibid.*, p. 166.

[45]Most of the biographical information in the section on Mattie Myers Carr is taken from J. Breckenridge Ellis, *The Story of a Life* (Sherman, Texas: Reynolds-Parker Co., 1910).

[46]*Ibid.*, p. 119.

[47]*Ibid.*, pp. 195-196.

[48]*Ibid.*, p. 321.

[49]*Ibid.*, p. 361.

[50]Mrs. O. A. Carr, "Carr-Burdette Christian College," *Christian Standard*, 30 (July 21, 1894), p. 731.

[51]Colby D. Hall, *History of Texas Christian University* (Fort Worth, Texas: Texas Christian University Press, 1947), p. 318.

[52]*Ibid.*, p. 320.

[53]*Ibid.*, p. 318.

[54]Most of the biographical information about Luella Wilcox St. Clair Moss in this section is taken from Hale, *Petticoat Pioneer*.

[55]*Ibid.*, pp. 115-116.

[56]*Ibid.*, p. 115.

[57]*Ibid.*, pp. 94-95.

[58]*Ibid.*, pp. 117-118.

[59]"Mrs. W. T. Moore Dies," *Christian Standard*, 82 (March 2, 1946), p. 135.

[60]Hale, *Petticoat*, p. 121.

[61]*Ibid.*, p. 124.

[62]*Ibid.*, p. 125.

[63]*Ibid.*, pp. 126-127.

[64]*Ibid.*, pp. 128-129.

[65]*Ibid.*, p. 129.

[66]*Ibid.*, p. 132.

[67]Mrs. W. T. Moore, "Christian College," *The Christian-Evangelist*, 40 (July 2, 1903), p. 14; Mrs. W. T. Moore, "Christian College, Columbia, Missouri," *The Christian-Evangelist*, 41 (July 7, 1904), p. 870; Mrs. W. T. Moore, "Christian College," *The Christian-Evangelist*, 42 (July 6, 1905), pp. 867-868; Mrs. W. T. Moore, "Christian College," *The Christian-Evangelist*, 43 (July 5, 1906), p. 854; Mrs. W. T. Moore, "Christian College," *The Christian-Evangelist*, 44 (July 4, 1907), pp. 859-860; and "Christian College," *The Christian-Evangelist*, 45 (July 2, 1908), p. 847.

[68]Luella Wilcox St. Clair, "Straw for the Bricks," *The Christian-Evangelist*, 41 (July 7, 1904), p. 864.

[69]Mrs. W. T. Moore, "Unity," *The Christian-Evangelist*, 41 (July 7, 1904), p. 865.

[70]"Hamilton College," *The Christian-Evangelist*, 40 (July 2, 1903), p. 16; Luella Wilcox St. Clair, "Hamilton College, Lexington, Kentucky," *The Christian-Evangelist*, 41 (July 7, 1904), p. 873; Luella Wilcox St. Clair,

"Hamilton College," *The Christian-Evangelist*, 42 (July 6, 1905), p. 869; Luella Wilcox St. Clair, "Hamilton College," *The Christian-Evangelist*, 43 (July 5, 1906), p. 855; Mark Collis, "Hamilton College Commencement," *Christian Standard*, 42 (June 9, 1906), p. 906; "Hamilton College Commencement," *Christian Standard*, 43 (June 22, 1907), p. 1064; Luella St. Clair, "Hamilton College," *The Christian-Evangelist*, 44 (July 4, 1907), p. 860; "Hamilton College," *The Christian-Evangelist*, 45 (July 2, 1908), p. 849; and Luella Wilcox Sinclair [sic], "Hamilton College, Lexington, Kentucky," *Christian Standard*, 44 (July 18, 1908), p. 1234.

[71]"Hamilton College," *The Christian-Evangelist*, 40 (July 2, 1903), p. 16.

[72]Hale, *Petticoat*, p. 140.

[73]*Ibid.*, p. 141.

[74]Mrs. L. W. St. Clair-Moss, "Social Sororities Abolished at Christian College," *Christian Standard*, 50 (February 27, 1915), p. 739.

[75]Hale, *Petticoat*, p. 123.

[76]"Mrs. Luella St. Clair-Moss Nominated," *The Christian-Evangelist*, 59 (August 10, 1922), p. 1009.

[77]"Mrs. St. Clair Moss' Platform," *The Christian-Evangelist*, 59 (August 10, 1922), p. 1024.

[78]"Christian College Honors Mrs. Moss," *The Christian-Evangelist*, (May 31, 1934), p. 719.

[79]"Mrs. W. T. Moore," *The Christian-Evangelist*, (March 13, 1946), p. 278.

[80]Kristine A. Culp, "Disciples Women Scholars," *The Disciple* 131 (5) (May, 1993), pp. 16-17.

[81]Most of the biographical information about Sarah Lue Bostick in the section is taken from Bertha Mason Fuller, *The Life Story of Sarah Lue Bostick* (Little Rock [no publisher listed], 1949).

[82]Colby D. Hall, *Texas Disciples* (Fort Worth, Texas: Texas Christian University Press, 1953), p. 329.

[83]Fuller, *Life Story*, p. 10.

[84]*Ibid.*, pp. 31, 33-34.

[85]*Ibid.*, p. 14.

[86]*Ibid.*, p. 30.

[87]Hall, *History*, p. 330.

[88]Hall, *Texas Disciples*, p. 335-336 and Hall, *History*, p. 331.

[89]Fuller, *Life Story*, pp. 19-21.

[90]*Ibid.*, pp. 23-27.

[91]Hall, *Texas Disciples*, p. 336.

[92]Mrs. William Alphin, "Needed—A College," *The Christian-Evangelist*, 63 (November 18, 1926), p. 1447; Hall, *Texas Disciples*, p. 338.

[93]Fuller, *Life Story*, p. 29.

[94]*Ibid.*, p. 36.

\mathcal{A}cts of Mercy

The Christian Woman's Board of Missions and the National Benevolent Association

Oh yes, to each one will come memories of the one woman who first touched her heart, awoke within her that sleeping angel, the missionary spirit, and taught her God's way.[1]

Mary Rebecca Williams was almost certainly the first woman missionary who came out of the Stone-Campbell movement. And although embraced by the church especially after her death, Mary Williams was not financially supported through church agencies. Instead she spent her own money or raised the money she needed from church members, mainly women. One of Mary Williams' notable supporters was Selina Campbell (second wife of Alexander), who assisted Mary by appealing for funds through the pages of the *Millennial Harbinger*.

Mary Williams was born in 1780 in England and raised as an Episcopalian. She emigrated to the United States as a well-educated, highly cultured middle-aged woman in 1835, became acquainted with Alexander Campbell, and converted from the Anglican Church to the Disciples. She was baptized in the Ohio River near Cincinnati by D. S. Burnet. Miss Williams "loved truth with the simplicity of a child and the

117

devotion of a martyr."[2] Her faith journey took her to Palestine where she worked for a time with the Barclays (daughter and son-in-law of Alexander and Selina Campbell), then set up a private school for girls in Jaffa. There she died on December 17, 1858. Her funeral service brought together many of her students and other missionaries as well as Arabs, Moslems, Greeks, and Roman Catholics.[3]

The Christian Woman's Board of Missions

The first nationally organized missionary activity for Disciples women was the Christian Woman's Board of Missions. Christian Woman's Board of Missions was the "grand passion" in the lives of countless women who devoted their spiritual, intellectual, and financial resources to its work, often at great personal sacrifice. That its history is well recorded testifies to the profound impact the Christian Woman's Board of Missions had on the development of the Christian Church and women's leadership in it. A tribute paid to founder Caroline Neville Pearre at her funeral service applies equally well to the Christian Woman's Board of Missions as a whole.

> And all about the group waiting on the hillside was a larger group—seventy-five thousand daughters, sisters, comrades, the world around—watching with hushed voices for the last glimpse of her who was leaving to them the heritage of service.[4]

Today we are the daughters, sisters, and comrades watching with hushed voices for a glimpse of those women of the Christian Woman's Board of Missions who left us such a rich heritage of service.

Caroline Neville Pearre: The Mother of the Christian Woman's Board of Missions

Caroline (Carrie) Neville was born on April 15, 1831, near Clarksville, Tennessee, the daughter of a pastor. She was trained as a teacher and taught at several of the leading seminaries for young women, including Christian College in Columbia, Missouri; Daughters College in Harrodsburg, Kentucky; the School for Young Ladies in Versailles, Kentucky; Mt. Vernon (Ohio) Seminary; the Sayre Institute in Lexington, Kentucky; a school in Richmond, Kentucky; and Madison

Female Institute in Kentucky.[5] In 1869 Caroline Neville married S. E. (Sterling Elwood) Pearre, a Disciples pastor.

Throughout her life, Mrs. Pearre had a number of experiences that gradually led her to a vision of the Christian Woman's Board of Missions. Through correspondence with her friends, she became aware of domestic and foreign missionary needs and became increasingly frustrated by the lack of response from the leadership of the Christian Church.

After the Civil War, the American Christian Missionary Society, organized in 1849, had a plan that had been on paper for five years but had resulted in little effective, cooperative missionary work.[6] Prior to 1874, the American Christian Missionary Society had attempted three missions, each of which failed.[7]

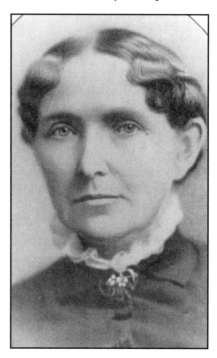

Carolyn Neville Pearre

Other denominations had overcome opposition to women assuming leadership roles in the church; already there were women's missionary societies in the Congregational (1868), Methodist Episcopal (1869), Presbyterian (1870), Episcopal (1871), Baptist (1873), and African Methodist Episcopal (1874) churches.[8]

Christian Woman's Board of Missions historian Imogene Mullins Reddel says that Mrs. Pearre, like Mary, kept all these things, pondering them in her heart.[9] Finally, Mrs. Pearre's call to special service came from God as she was on her knees in daily prayer. In a story known well to Christian Church women, Mrs. Pearre said:

> Surely we could be led, if we had a leader. This matter
> pressed upon my heart and would not down. Finally,

upon the 10th day of April, 1874, about ten o'clock in the morning, just after I had finished my private devotions, the question came home to my heart almost like a voice—"Why can not you do it?" With a great throb of joy, I said: "I will," and the turning point had come.[10]

And:

As when, on her knees, she pleaded for the nations that sit in darkness, there came to her a vision of an unawakened sisterhood, who must be aroused to a sense of the world's need. She rose from her knees and set herself earnestly to the task.[11]

In May 1874, she organized a missionary society for the women of her church in Iowa City, then corresponded with other women who set up similar societies in their churches. (The first local woman's missionary society predated Mrs. Pearre's by a couple of months, having been organized at Central Christian Church in Des Moines, Iowa, on February 28, 1874.[12]) Next she wrote to Thomas Munnell, secretary of the American Christian Missionary Society, asking that women from local missionary societies be allowed to meet together to discuss the formation of a churchwide board at the American Christian Missionary Society meeting in October. Munnell replied, "This is a flame of the Lord's kindling, and no man can extinguish it."[13]

In the meantime, Isaac Errett, editor of the *Christian Standard*, visited the Pearres and heard of Caroline's plan. His editorial ("Help Those Women," published on July 11, 1874) in support of the work gave a great boost to the fledgling organization.

We are fully in sympathy with this movement on the part of the sisterhood in our churches. We see in it the dawn of a new era of activity and spiritual growth for Christian women—a bright promise of the development of an immense wealth of resources hitherto largely neglected, and a great increase of power in the church for high and grand achievement.[14]

Such editorial support was vitally important in the early development of the Christian Woman's Board of Missions. J. H. Garrison, editor of *The Christian-Evangelist,* also favored the idea of women organizing for missionary work and an-

nounced the October meeting in his paper. Marcia Melissa Bassett Goodwin, editor of *The Christian Monitor*, a magazine for women, was especially instrumental in promoting the organizational work of what was to become the Christian Woman's Board of Missions, saying, "Dear sisters, while the brethren are talking about women's work in the church, show them that you know what it is by doing it while the lords of creation are discussing the matter."[15]

Although it was not planned with this in mind, the number of women who gathered to charter the Christian Woman's Board of Missions brings to mind the number Jesus sent out as disciples and missionaries. Seventy or seventy-five women (sources differ) met in the basement of the Richmond Street Christian Church in Cincinnati on October 21, 1874, and drew up a constitution. "Long afterward they learned that theirs was the first women's organization in the country to carry on both home and foreign work, to employ both men and women, and to be managed entirely by women."[16] The next day Mrs. M. M. B. Goodwin and Mrs. Pearre addressed the regular session of the convention, following which Isaac Errett, newly elected president of American Christian Missionary Society, offered a resolution in support of the Christian Woman's Board of Missions. The motion was approved unanimously.[17] Among the first officers and state organizers were:

Officers

President	Maria Jameson
Treasurer	Nannie Ledgerwood Burgess
Recording Secretary	Sarah Wallace
Corresponding Secretary	Caroline Neville Pearre

State Organizers

Illinois	Elmira Dickinson
Kansas	Rosetta Butler Hastings and Ellie K. Payne
Arkansas and other states	Persis Christian
Arkansas, Mississippi, and Texas	Sarah Lue Bostick
California	Reba B. Smith
West Virginia	Selina Campbell
Kentucky and Colorado	Susie Sublette[18]

Maria Butler Jameson: First Christian Woman's Board of Missions President

Maria Butler Jameson of Indianapolis was elected the first president of the Christian Woman's Board of Missions at the Cincinnati meeting and served with distinction from 1874-1890. Butler University is named in honor of her father, Ovid Butler, from whom she learned that "women had brains capable of high thinking and executive doing, that though the home was her first sphere of service, there were other fields that should claim a share of her best life."[19]

Maria Jameson (married to Patrick Henry Jameson) is remembered as a "virile leader" who as Christian Woman's Board of Missions president immediately turned her attention to three tasks—establishing local mission chapters, raising money to send a missionary overseas, and developing missionary literature.

Because Christian Woman's Board of Missions work was supported by many small contributions over and above the regular offerings women gave to their churches, raising money was slow going. It took two years before the women of the Christian Woman's Board of Missions were able to send their first missionaries, Dr. and Mrs. W. H. Williams and their young child, to Jamaica (an old American Christian Missionary Society post). Feeling that an organization supported by women should be represented by women, the Christian Woman's Board of Missions was eager to send its first single woman missionary into the field. That woman was Jennie Laughlin, who was sent to Jamaica in 1878.

Initially Christian Woman's Board of Missions reports, letters from missionaries, and financial appeals were published in established church papers. Later, the Christian Woman's Board of Missions published its own magazine, *Missionary Tidings*, which first appeared in 1883. Through all the difficulties associated with the beginnings of such an ambitious undertaking as the Christian Woman's Board of Missions, Mrs. Jameson urged, "Let prayerful anxiety stimulate our ingenuity."[20]

Children's Work: Nancy E. Burns Atkinson and Charlotte S. McGrew King

At the second annual convention, the Christian Woman's Board of Missions discussed actively involving children in

mission work. A resolution in support of that goal was adopted officially in 1876. "Man may start out alone in his quest of the Celestial City...but when woman goes the long journey...she takes the children with her."[21] Children were encouraged to engage in systematic self-denial not only as a means of training them in the practice of Christian stewardship, but also in order to increase their ownership of mission efforts.[22]

Nancy Atkinson (married to Alonzo Melville Atkinson) is credited with beginning the first children's auxiliary of the Christian Woman's Board of Missions in Wabash, Indiana, in 1874. This and other children's missionary societies were the precursors of Christian education and missionary education for children. Children progressed from Little Light Bearers (a society for babies who were given life memberships in the Christian Woman's Board of Missions), through the Willing Workers, into Triangle Clubs, and then into Mission Circles (for young women). In the last year of the Christian Woman's Board of Missions' existence, there were thirty thousand child members in more than one hundred twenty societies who had raised half a million dollars for mission work.

The money they raised, literally from saving pennies, went to build a church in Japan and to support orphanages in India.[23] There was also a special missionary magazine for children called *Little Builders at Work* (later *Junior Builders* and *King's Builders*).

Interestingly, Nancy and her first husband, Philip Burns, were involved in the "Bethany riots" of 1855 while he was a student at the college. It seems that Philip gave an antislavery address as his sermon in Sunday chapel. Slavery was a contentious issue in the college and Christian Church at this time, and the largely Southern student body grew restless. Protests on both sides ensued and Philip, along with three to eight other students, either was expelled from or left Bethany College (sources differ). Philip and Nancy subsequently attended North-Western Christian University (now Butler University), graduating in the first class, Nancy with both a bachelor's and a master's degree.[24]

Charlotte S. McGrew was born on the north side of Pittsburgh on July 15, 1835. She began attending church at the age of six weeks and continued uninterrupted until her death at age eighty-six. For a time she was a student in Walter Scott's Bible class. In 1864 she married pastor Joseph King

and devoted herself to local congregational concerns.[25] Later
she became a charter member of the Christian Woman's Board
of Missions and followed in Nancy Atkinson's footsteps, be-
coming the first secretary of the Young People's Department
of the Christian Woman's Board of Missions. Mrs. King is
responsible for the collection of funds for the building of the
church in Akita, Japan. Other women particularly involved in
children's work were Mattie Pounds and Ellie K. Payne. Mrs.
Payne's husband held the Christian Woman's Board of Mis-
sions Bible Chair at the University of Kansas while she was
state President of the Kansas Christian Woman's Board of
Missions.[26]

Fund-Raising: Nannie Ledgerwood Burgess, Elmira J. Dickinson, and Rosetta Butler Hastings

Nannie Ledgerwood, granddaughter of Henry Palmer, a
Disciples pastor, was born in Washburn, Illinois, on July 12,
1836. After spending a year as a student at Eureka College
she married Otis Asa Burgess (a young man brought into the
church by her grandfather) and moved with him to Indianapo-
lis. Mrs. Burgess served as the first treasurer of the Christian
Woman's Board of Missions, and after the deaths of her hus-
band and parents, as the vice-president and then president of
the organization until her death in 1902.

> She was timid before the public, and little dreamed
> that she would be called upon to bear the official burdens
> and responsibilities which came upon her during the
> last decade of her life. In those last years she retained
> all her womanly gentleness and sweetness, but added
> to them a breadth of vision, a wisdom in management
> and administration, and a clear grasp of the problems
> which confront any great missionary organization.[27]

Caroline Neville Pearre, Nannie Ledgerwood Burgess, and
Elmira J. Dickinson were childhood friends. Their relation-
ship sustained them as together they led the Christian
Woman's Board of Missions through its early years. Respond-
ing to correspondence from Caroline Pearre, Elmira (some-
times spelled Almira) Dickinson organized a local woman's
missionary society in Eureka, Illinois, in July 1874 and the

Illinois Woman's Missionary Society in September of the same year. In October she became a charter member of the national Christian Woman's Board of Missions.

Miss Dickinson graduated from Eureka College with an M.A. in 1869 and went on to become a faculty member and the first woman trustee of the college, but her lifelong dream was to become a missionary.[28] Although she was unable to fulfill her dream, she did make it possible for countless other women missionaries to minister in her name. In 1878 Illinois raised one-third of the Christian Woman's Board of Missions budget.[29]

Elmira probably recruited another notable Illi-

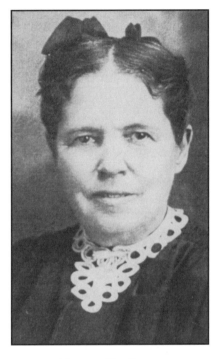

Rosetta Hastings

nois Christian Woman's Board of Missions worker, Persis Lemon Christian. Following Elmira as president of the Illinois Christian Woman's Board of Missions, Persis, also a charter member of the Christian Woman's Board of Missions, went on to become a national Christian Woman's Board of Missions organizer in twenty-nine states and a popular convention speaker. Persis Lemon Christian (married to George Clark Christian) was frequently introduced as "Persis the Beloved," and earned praise for her work from J. H. Garrison in the pages of *The Christian-Evangelist*.[30] Persis Christian is the author of a hymn reproduced on page 70.[31] She died July 1, 1918, in Eureka Springs, Illinois.

Rosetta Butler Hastings was a Christian Woman's Board of Missions organizer and fund-raiser of a different sort. Whereas Elmira Dickinson represented highly educated, affluent, career-oriented, single women, Rosetta Hastings represented isolated, rural, poor, but dedicated farm wives and mothers.

While the conditions under which these pioneer State workers labored were quite different—Miss Dickinson from a little settler's farm, and with the cares of motherhood and household work pressing hard on her— both had the vision of the new call to service of the womanhood of the church, and both gave themselves without reserve to rousing them to their high calling.[32]

Rosetta, daughter of Pardee Butler, state evangelist for Kansas, was also married to an evangelist who spent much of his time away from home. Beginning in 1875, while tending to the garden, farm, and children, Rosetta wrote essays and letters urging rural Kansas women to support the Christian Woman's Board of Missions, laying the groundwork for the formation of the Kansas Christian Woman's Board of Missions in 1879—all this with four children under the age of five and a fifth baby on her lap.[33]

Rosetta wrote with understanding but conviction to her Christian sisters, asking for a pledge of 15 cents per month per member, 5 cents for the state and 10 cents for the national organization:

> I know how many of our sisters live in small and inconvenient homes and wear nothing finer to meeting than calico dresses and sunbonnets. I know how drouth and grasshoppers have several times reduced the more needy of us to beggary, and the rest of us to such close economy as we had never before thought possible. Yet, in the face of these facts, I ask you to assist in missionary work.[34]

The depth of commitment to the Christian Woman's Board of Missions apparent in the dedication of these three women was critical to providing the solid financial foundation necessary for the ministry of the Christian Woman's Board of Missions to go forward.

Chronicler of the Christian Woman's Board of Missions: Ida Withers Harrison

Several women, recognizing the centrality of the work of the Christian Woman's Board of Missions in the history of the church, have chronicled its history, among them Imogene Mullins Reddel (in *The Christian-Evangelist* in 1934) and

Lorraine Lollis (in *The Shape of Adam's Rib,* published in 1970). The first to record the history of the Christian Woman's Board of Missions in a systematic way was Ida Withers Harrison (in *Forty Years of Service,* published in 1915, and *The Christian Woman's Board of Missions, 1974-1919,* published in 1920).

Ida was the daughter of Williams Temple Withers, a Civil War general from Kentucky and Mississippi, and Martha Sharkey. Because she was born in 1850, Ida's early life was marked by the horrors or war and the disruption of Reconstruction. She was, however, well educated and for most of her life, affluent. In 1879 Ida Withers was married to Albert Harrison and lived the rest of her life with him in Lexington, Kentucky. Ida spent her adult life in church service as a member of Central Christian Church (moving there from Broadway Church after that congregation became independent) and in service to her community (with leadership roles in the Women's Clubs of Kentucky, the Democratic Party, the Red Cross, the YWCA, and the Garden Club).[35]

Ida was the vice-president of the Christian Woman's Board of Missions for twelve years (1908-1920), centennial secretary (in 1909), and was a speaker on missionary concerns much in demand at colleges and conventions.[36] She was the first woman to receive an honorary degree from Transylvania University, awarded in appreciation for her work in education. In her later years she devoted herself largely to peace efforts.[37]

In speaking of the involvement of women in nineteenth-century reform movements, of which she herself was such a good model, Ida Withers Harrison, charter member of the Christian Woman's Board of Missions and National Benevolent Association, said, "The women in the church heard the call of the poor and needy, and felt that same impulse to organize that found expression in the Women's Rights movement."[38]

Christian Woman's Board of Missions Among African-Americans

Sarah Lue Howard Bostick

Sarah Lue Howard, born in 1868 in Glasgow, Kentucky, was one of ten children, and is the most prominent of the Christian Woman's Board of Missions organizers among

African-Americans. Sarah Lue, largely a self-taught woman, married a physician and minister named Mancil M. Bostick in 1892, organized the first African-American Christian Woman's Board of Missions auxiliary (at Pea Ridge Church, Arkansas, in 1896) and served as its president.[39] She went on to organize five more societies before being appointed by the "white sisters in Little Rock" specifically for the task of organizing African-Americans in the Christian Woman's Board of Missions.[40]

At the turn of the century black and white auxiliaries of the Christian Woman's Board of Missions held simultaneous and segregated conventions. In 1914 African-American auxiliaries asked the Christian Woman's Board of Missions to provide a full-time organizer for them. Sarah Lue Bostick was their choice. Subsequently she was sent by the Christian Woman's Board of Missions to do field work in Mississippi and Texas as well as in Arkansas.

Sarah Lue's particular interests were in supporting the Bible Chair at the University of Michigan and in Jacob Kenoly's mission school in Liberia. Before her death in 1948, Sarah Lue served as president of the woman's department of the National Christian Missionary Convention and as president of the Conference for Black Women Leaders held for several years beginning in 1908 at the Southern Christian Institute. (In 1900 the American Christian Missionary Society asked the Christian Woman's Board of Missions to manage the Southern Christian Institute, begun as part of American Christian Missionary Society's domestic mission work, in an attempt to help educate African-American Disciples.)

Sarah Lue was faithful in the use of her scant resources, always trying to earn her own money for the church.[41] She helped the white founders of the Christian Woman's Board of Missions and those who came later to realize "that much of their devoted work for Negroes could be more effective and creative as work with Negroes."[42]

Rosa Brown Bracy

Rosa Brown (later Rosa Brown Bracy), a graduate of the Southern Christian Institute, was appointed the first field secretary for "Negro work" in the Christian Woman's Board of Missions. She began to organize women's missionary societies in African-American churches in 1916, only four years before the Christian Woman's Board of Missions merged with other

missionary organizations. But Rosa continued in the United Christian Missionary Society and as an officer in the National Christian Missionary Convention.

She was active in helping to establish Jarvis Christian College (originally established through the efforts of the Christian Woman's Board of Missions as Jarvis Christian Institute).[43] Mrs. Bracy was succeeded in her work of organizing African-American church women by Carnella Jamison Barnes, now at Avalon Christian Church in Los Angeles.

Oletha Brown Blayton

Born on April 29, 1897, in Monroe, Louisiana, Oletha Brown was raised by her

Rosa Brown Bracy

grandmother in Duckport, Mississippi. Her grandmother taught her to read the Bible, to pray, and to live a Christian life. The strong foundation in the faith given to Oletha led to her own confession of faith and baptism in the Mississippi River at age eleven. After graduating from the Southern Christian Institute, where she picked and preserved fruit and made quilts to pay part of her tuition, Oletha left the South to work in Washington, D.C. There she met and married Benjamin Blayton, Sr., raised her family, joined what became 12th Street Christian Church, and helped establish the National Missionary Society, precursor to the Christian Women's Fellowship.

As it was illegal before the 1950s for black and white people to share sleeping quarters except as servant and patron, the women of 12th Street Church pretended to be servants to the women of National City Christian Church when the two groups met for retreats. Together these two women's organizations circumvented the law so they could minister to the significant needs of the poor in the nation's capital.[44]

The contributions of African-American Disciples women are not well recorded. If in general the work of women is anonymous, the work of African-American women is even harder to access. Although not often recorded in traditional sources, the stories of African-American women are beginning to be preserved. In addition to the women discussed in this section, information on other more contemporary African-American women Disciples is contained in two sources, Melvia Fields' book *Women on a Mission* and a Christian Women's Fellowship resource titled *Christian Women Share Their Faith*. A prayer included in Melvia Fields' book stands as a tribute to the few named and many unnamed African-American women whose memories continue to call the church to its mission:

> Our souls magnify the Lord and our spirits rejoice in God our savior...that we recall those women who came to this land not on the deck of a ship, but in the dark hold of the slave ship; who preserved an African heritage and understood the liberating message of the Christian gospel; who know the double jeopardy of being black and female....That we are heirs of those women who call the church to accept new forms of leadership even today; that we are all of these women and more who seek to serve you, our Lord, we offer this prayer of thanksgiving and gratitude. We are many, and yet we are one. We are bound together as women. We are a part of the family of God. We are empowered for mission because of these women. Thank you God. In the name of Jesus we pray. Amen.[45]

Christian Woman's Board of Missions in Canada

Canadian participation in the Christian Woman's Board of Missions began as early as 1884 when a woman's missionary society organized by Mrs. Carrie Angle in Wainfleet, Ontario, began to send contributions to the Christian Woman's Board of Missions. In 1885 a second woman's society began at the Coburg Street Church in New Brunswick. The first mission project in Canada was the founding of a church in Manitoba.

Mrs. M. V. Romig was the longest-serving traveling secretary in Canada, but many Christian Woman's Board of Missions officers and missionaries from the United States visited

Canadian societies. The Canadian and United States Christian Woman's Board of Missions groups were merged in 1913. Canadians contributed greatly to the development of the Christian Woman's Board of Missions—particularly through the international missionaries they provided. A partial list of Christian Woman's Board of Missions missionaries from Canada follows.

Emma Ennis	India
Mrs W. C. McDougall and daughters	
Dr. Dorthea and Wilhelmina	India
Dorothy Menzies (Bicks)	India
Louise Cory (Kilgour)	China
Margaret Stainton (Hutcheson)	Paraguay
Mrs. James P. McLeod	India
Ethel Smith Monroe	India
Dr. Martha Smith	India[46]

Susie Rijnhart

Dr. Susie Carson Rijnhart-Moyes (married to Petrus Moyes), the first Canadian woman to earn first-class honors in medicine, served with her husband as a medical missionary in Tibet. The harsh conditions of her service led to her early death on February 7, 1908, and left her husband and infant son alone.[47]

Other Notable Missionaries

Christian Woman's Board of Missions' first missionary endeavor was in Kingston, Jamaica, in 1876, at a church originally established by the American Christian Missionary Society. But the major foreign

missions efforts were in India. In 1881, the Christian Woman's Board of Missions sent four women missionaries to India, their first mission effort in a non-Christian country. The four women, who among them eventually had 101 years of missionary service, were Maria Graybiel, Ada Boyd, Mary Kingsbury, and Laura Kinsey. In the central provinces of India they established schools, orphanages, hospitals, and churches, and spread the gospel message in zenanas (the small part of the household, to which women and children were restricted; no men except the master were allowed inside).

Mattie Burgess (fifty-three years of service) followed in 1883, as did a number of women physicians in 1889.[48] Ida Withers Harrison lists the sixty mostly women missionaries who served in ten different locations in India during the existence of the Christian Woman's Board of Missions. She also lists missionaries from the other foreign and domestic fields of Christian Woman's Board of Missions including:

1. thirty-six who opened schools, mission stations, a church, and auxiliary Christian Woman's Board of Missions organizations, and published a church magazine in Mexico;

2. five plus three native Mexican helpers who established the Mexican Institute in San Antonio, Texas;

3. twenty who established orphanages in Puerto Rico;

4. eight who organized schools and churches in Argentina;

5. six who worked in Liberia;

6. three who worked among the Cree and Salteaus Indians in Canada;

7. numerous others who worked in the United States to serve the mountain schools of Appalachia, to establish Bible Chairs in five universities, to develop outreach programs for Asian persons living in California, to build educational opportunities for African-Americans, to do settlement work in Indianapolis, and to establish the college of Missions in the Deterding Building in 1910. (The building is named for Sarah Davis Deterding, loyal and active member of the Christian Church in Taylorsville, Illinois, who died at age thirty-seven, leaving a husband and daughter as well as her parents and siblings.[49])[50]

Christian Woman's Board of Missions: Conclusions

Five years of study involving members of the Christian Woman's Board of Missions, the American Christian Missionary Society, the Foreign Christian Missionary Society, and the National Benevolent Association resulted in the merging of these groups and several other smaller groups on October 20, 1919. The newly formed organization was called the United Christian Missionary Society. (Later the National Benevolent Association again became a separate organization.) The Christian Woman's Board of Missions brought the bulk of the financial resources and membership into the new organization. Christian Woman's Board of Missions leadership insisted that the United Christian Missionary Society have equal numbers of men and women on its committees and that every office be open to either a man or a woman.

> In its 45 year history, the CWBM grew from local societies in 9 states to local societies in 43 states, from 75 members to more than 100,000 members, from contributions of 430 dollars to contributions over 7 million dollars, from one mission post in Jamaica to mission fields in 10 countries, with 974 missionaries serving 68 churches, 284 schools, and 9 hospitals.[51]

The story of the Christian Woman's Board of Missions is remarkable. What today has evolved into at least four major organizations—Christian Women's Fellowship, Division of Homeland Ministries, Division of Overseas Ministries, and the United Christian Missionary Society—began thanks to the efforts of Caroline Neville Pearre, Nannie Burgess, Elmira Dickinson, and others who worked on the grassroots level to build an organization in service to others. All of us owe a large debt of gratitude to our foremothers in the Christian Woman's Board of Missions, none of whom had prayed in public until they did so before their Christian Woman's Board of Missions sisters.

The Next Step: Jessie Trout and the Founding of the Christian Women's Fellowship

In what was called the "most important meeting of Disciple women since 1874,"[52] seventy-five state presidents and secretaries of Disciples women's groups met at Turkey Run

State Park in Indiana from January 8-17, 1949, and founded the Christian Women's Fellowship. The need was for a national organization and structure to support the work of Disciples women on the local level in three areas—worship, study, and service.

Although there were many women who were instrumental in the founding of the Christian Women's Fellowship, Jessie Trout's name stands out. Jessie Trout was a Canadian citizen who was educated for mission service at the college of Missions (founded by the Christian Woman's Board of Missions) and served as a missionary in Japan for twenty years. From 1935-1940 she worked with Japanese people in establishing a wholly indigenous effort, a real turning point in the way Disciples thought about missionary work.[53]

Recognizing the need for cooperative work, Jessie Trout conceived the Turkey Run Conference and set it in motion. She asked that women who were not at Turkey Run pray daily and intentionally for God's will to guide the assembly. Prior to the meeting, delegates studied questions sure to arise.

All their efforts were framed by careful Bible study led by Dr. Kathleen MacArthur, member of Park Avenue Christian Church in New York City and a YWCA executive. Dr. MacArthur earned her Ph.D. in religion from the University of Chicago in 1936, making her perhaps the second Disciple woman to do so.[54]

Jessie Trout went on to become executive secretary of the Department of Christian Women's Fellowship from 1952-1962.[55] Her vision for the women of the church lives on today in the work of the Christian Women's Fellowship and its off-shoots, World Christian Women's Fellowship established in 1952, International Christian Women's Fellowship established in 1953, and Quadrennial, first held in 1957. Christian Women's Fellowship is a model for any organization that is contemplating change because Jessie Trout and her coworkers recognized the principles embodied in this statement.

> Take time for study....We want to create fellowship, not to break it. The organization is made for women— not women for the organization.[56]

A complete history of the Christian Women's Fellowship is being written and should be ready for the celebration of their fiftieth anniversary.

What We Do Best Is Care: The Founding of the National Benevolent Association

The foundings of the Christian Woman's Board of Missions and National Benevolent Association are similar in many ways. The same sensitivity to the plight of the less fortunate here and abroad that opened Caroline Neville Pearre to the call to found the Christian Woman's Board of Missions in Illinois directed the work of Sarah Matilda Hart Younkins in St. Louis. Empowered by the Holy Spirit, both women were able to enlist other women in the long, oftentimes lonely, and sometimes unsuccessful efforts to gain recognition for their work from the men who controlled access to established church structures.

Mattie Younkin

Sarah Matilda Hart, born in 1843 in Illinois, was unusually aware of the needs of orphans and the homeless because of her own father's early death. Married at fifteen to physician Edwin Younkins and subsequently the mother of two daughters, Mattie and her family moved to St. Louis in 1875 and became members of Central Christian Church. In rural areas, churches or families took care of their own unfortunate members, but in urban areas resources and responsibilities were more diffuse. The combination of the overwhelming need Mattie saw around her, the failure of the church to address that need fully, and a profound spiritual experience she had on a return visit to her alma mater Abingdon College (now merged with Eureka College) prompted Mattie to gather six of her friends in the basement of the church to pray in February 1886.

After almost a year of prayer and discussion, on January 10, 1887, the women formed a permanent organization, The

Benevolent Association of the Christian Church, "to restore to the church that brotherly love and benevolence taught by Christ and practiced by the disciples in the early days of the church.[57] It was another twelve years before this organization was recognized by the general convention of the church. In contrast to the Christian Woman's Board of Missions, which was from the beginning established by and for women, the women of the National Benevolent Association conceived a churchwide benevolent association.

Mattie Younkins, the first ordained Disciples woman in Missouri, became the chief evangelist and fund-raiser for the benevolent work. Initially she was allowed 10 dollars per month to cover her expenses and 10 dollars to help the needy. In the words of Donie Hansborough, longtime recording secretary of the National Benevolent Association:

> Mattie Younkins took to the field, went from one to another, inspiring hope and arousing energy when reverses and discouragements came. By her enthusiasm, we were led to believe in her prophecies of success. It was she who came forward now, with a willingness to endure the hardship of a solicitor's fate....Through her good work, many friends to the cause were made and our list of life members increased.[58]

Mrs. Younkins died of breast cancer in 1908, six days before the general convention adopted the National Benevolent Association as the first denominationwide benevolent association in the United States.

Other Women of the Early National Benevolent Association

In addition to Mattie Younkins, Marjorie and Hiram Lester (in their book, *Inasmuch...The Saga of the NBA*) identify Donie Hansborough, Sophia Anna Kerns, Fannie Shedd, Rowena Mason, Emily Ivers Meier, Elizabeth Hodgen, Judith Garrison, Mrs. E. M. Bowman, Ida Withers Harrison, and others as early leaders of the National Benevolent Association.

Laddonia Waters was born in 1845 near Clarksville, Missouri, and married attorney J. K. Hansborough. Donie Hansborough was elected recording secretary of the National

Benevolent Association at its founding and continued until her death on September 3, 1938, at the age of ninety-three. For a time she also edited an early National Benevolent Association newspaper, called the *Christian Philanthropist*, which was published by Rowena Dozier Mason. Boys from the Christian Orphans' Home of St. Louis, the first National Benevolent Association facility, delivered Mrs. Hansborough's handwritten newspaper to the editor, then picked up flour sacks full of copies of the paper for her to fold and stamp (most of the time at her own expense). Mrs. Hansborough spent her later years living on the grounds of the Christian Orphans' Home.[59]

Rowena Dozier was born in St. Charles, Missouri, in April 1842 and died on October 21, 1918. She married Captain J. C. Mason and gave birth to one child who died in infancy. Her husband died after they had been married only five years. Mrs. Mason devoted her considerable energy to the care of others' children as the president for sixteen years of the Christian Orphans' Home. On her death she contributed 10,000 dollars to the building fund of her church, Union Avenue, and 100,000 dollars to the National Benevolent Association.[60]

Emily Ivers Meier was born in 1860, raised by her grandparents after the deaths of her parents, educated in Memphis, and was married to Henry M. Meier of St. Louis in 1881. In 1893 she brought her only child, Duncan, to the Orphans' Home so he could share his birthday cake and ice cream with the children. Later she served as president of the National Benevolent Association from 1896-1906, and is remembered as a clear and convincing speaker and able administrator under whose leadership several homes for the elderly and for children were established.[61]

Judith Elizabeth Garrison was born in 1846. She attended Abingdon College where she met James Harvey (J. H.) Garrison. They were married in 1868 and he went on to edit *The Christian-Evangelist* for forty years. Mrs. Garrison was not only one of the founders of the National Benevolent Association, but also a later president. She died at the age of ninety-three in 1939.[62]

The Legacy

The founding of the Christian Woman's Board of Missions represents a turning point in the recognition of women in the

Christian Church. Caroline Neville Pearre listened prayerfully to the voice of God, shared her vision with her friends, and despite their very real misgivings, organized women widely separated by life experiences and geography. What was it that caused Caroline Neville Pearre to be open to her call? In addition to her life of daily contemplative prayer, Caroline Neville Pearre was influenced by conditions of her time. The nineteenth-century reform movement was growing in a number of areas—temperance, abolition of slavery, suffrage, and the world peace movement. It is not surprising that church women would be particularly responsive to efforts to address the needs they saw around them.

The founders of the Christian Woman's Board of Missions and National Benevolent Association were sensitive to the horrible conditions of their sisters and the children in other countries—particularly in the Far East—and in urban centers of the United States. Because of cultural traditions, it was not acceptable for men to minister directly to these less fortunate women. The task fell to American women. At its founding most of the leaders of the Christian Woman's Board of Missions were privileged women not excessively burdened by the tasks of wife, homemaker, and mother, and had access to financial resources and power (through their husbands or fathers). Yet they recognized their need to unite with all women in order to uncover the vast resources of talent not being tapped by the church.

Because educational opportunities for women were severely restricted, early Christian Woman's Board of Missions leaders recognized the importance of home and church study—hence the development of missionary magazines. The missionary school established in the Deterding Building in Indianapolis gave women missionaries (in the absence of access to seminaries) the practical and theological training they needed to carry effectively the gospel message.

Becoming a missionary gave women who were not accepted as ordained pastors/evangelists, physicians, or other professionals opportunities to serve in ways faithful to their call. The leadership skills in organization, financial management, and public speaking that women on the local and national levels gained served them well into the twentieth century as their participation in traditional church bodies grew.

Those of us who serve as leaders in our local churches, who have cut our teeth and honed our skills in women's groups, who serve on boards and divisions of the general church, and those who still ache for acceptance find our inspiration in the work of our foremothers in the Christian Woman's Board of Missions and National Benevolent Association.[63]

An Opportunity to Respond:

Perhaps you would be interested in writing the story of the Christian Woman's Board of Missions, National Benevolent Association, or Christian Women's Fellowship in your church or region. These suggestions will help you get started.

Writing Her Story[64]

1. Begin by collecting all available records and other informational materials. Obituaries are particularly good sources for life facts.

2. Talk with different people who may have mementos, letters, programs, notes, pictures, and knowledge of past events and activities. Don't forget family members and friends.

3. Inform members of the church about the project and ask for materials and information.

4. Pictures make delightful illustrations and are often enjoyed more than lengthy written accounts of a particular event or activity. Ask members and former leaders to share pictures too.

5. Old minutes are excellent sources of information.

6. Select a writer who is interested in research, well organized, and skilled in writing.

7. Call upon the services of the Disciples of Christ Historical Society and local archives.

8. Use desktop publishing to produce a pamphlet or booklet that you can share with church members, your region, and local libraries.

9. Enjoy mahogany cake at one of your meetings. This family recipe dates from the mid-nineteenth century and was served at missionary society meetings.

Mahogany Cake

1 ½ cups sugar ½ cup butter
½ cup milk 3 eggs
1 ½ cups flour 1 teaspoon soda
1 teaspoon vanilla

Mix the above ingredients together. Melt 2 squares of unsweetened chocolate in 1/2 cup milk. Add to the mixture. Bake 40 minutes in an 8 x 8 inch cake pan in a 350 degree oven. Frost or serve with ice cream.

Notes

[1]Helen E. Moses, "Prominent Women at the Jubilee Convention," *Christian Standard* 36 (July 20, 1899), p. 910.

[2]D. S. Burnet, "Obituary Notices," *Millennial Harbinger* series 5, vol. 2 (March, 1859), pp. 298-299.

[3]See also in the same issue of the *Millennial Harbinger* articles by Sarah B. Johnson, "Death of Sister Williams," pp. 198-199; Thurston Crane, "Missions," pp. 196-197; J. T. Barclay, "Letter from Jerusalem," pp. 195-197; and Selina H. Campbell, "Death of Sister Williams," p. 172.

[4]Ada M. Mosher, "Mother of CWBM," *World Call* (January 30, 1948), p. 39 as reported by Lorraine Lollis, *The Shape of Adam's Rib: A Lively History of Women's Work in the Christian Church* (St. Louis: Bethany Press, 1970), p. 39.

[5]"Hearthstone Homilies," *The Christian-Evangelist* 47 (October 27, 1910), p. 1557.

[6]Lollis, *The Shape*, p. 30.

[7]Lester G. McAllister, "Women's Missionary Society," in Peter M. Morgan, (ed.), *Disciples Family Album: 200 Years of Christian Church Leaders* (St. Louis: Chalice Press, 1990), p. 65.

[8]Virginia Lieson Brereton and Christa Ressmeyer Klein, "American Women in Ministry: A History of Protestant Beginning Points," in Janet Wilson James, *Women in American Religion* (Philadelphia: University of Pennsylvania Press, 1980), pp. 171-190.

[9]Imogene Mullins Reddel, "The Story of 60 Years: The Origin and Development of Women's Missionary Work," *The Christian-Evangelist* 71 (August 23, 1934), p. 1092.

[10]Caroline Neville Pearre, "Our Beginning," *Missionary Tidings* 17 (August, 1899), pp. 102-103 as reported in Lollis, *The Shape*.

[11]"Hearthstone Homilies," p. 1557.

[12]Claude E. Spencer, "Women Have Not Been Idle," *Discipliana* 22 (6) (1963), pp. 83-84.

[13]Reddel, "The Story," p. 1092.

[14]Isaac Errett, "Help Those Women," *Christian Standard Supplement* (April 8, 1916), p. 1011.

[15]Lollis, *The Shape*, p. 31.

[16]Reddel, "The Story," p. 1092.

[17]Lollis, *The Shape*, p. 33.

[18]*Ibid.*, pp. 41, 53-63.

[19]Mrs. M. E. Harlan, "The First President of the Christian Woman's Board of Missions," *The Christian-Evangelist* 68 (August 10, 1911), p. 1147.

[20]Reddel, "The Story," p. 1093.

[21]Ida Withers Harrison, *The Christian Woman's Board of Missions, 1874-1919* (no city: Mayfield, no date), p. 58.

[22]Reddel, "The Story," p. 1093.

[23]Lollis, *The Shape*, pp. 50-52.

[24]*Ibid.*, pp. 50-51. See also Alexander Campbell, "Disturbances at Bethany College," *Millennial Harbinger* 6 (January, 1856), pp. 55, 59.

[25]George Darsie, "Mrs. Charlotte S. King," *Christian Standard* 57 (April 16, 1921), p. 2466.

[26]Lollis, *The Shape*, pp. 62-63.

[27]J. H. Garrison, "A Fallen Leader," *The Christian-Evangelist* 39 (May 29, 1902), p. 376.

[28]Lollis, *The Shape,* pp. 53-54.

[29]Harrison, *The CWBM*, p. 52.

[30]Lollis, *The Shape,* p. 55.

[31]Persis L. Christian, "When Morning Spreads," *Christian Standard* 31 (January 1, 1895), p. 75.

[32]Harrison, *The CWBM*, p. 52.

[33]Lollis, *The Shape*, pp. 55-56.

[34]Harrison, *The CWBM*, p. 50.

[35]Lollis, *The Shape*, pp. 46-49.

[36]*Ibid.*

[37]A. W. Fortune, "Appreciation of Mrs. Ida Withers Harrison," *The Christian-Evangelist* 64 (December 15, 1927), p. 1670.

[38]Harrison, *The CWBM*, p. 21.

[39]Melvia Fields, *Women on a Mission* (Paris, Kentucky: Bourbon Graphics, 1990), pp. 15-16.

[40]Lollis, *The Shape,* p. 59.

[41]*Ibid.*, pp. 60-61. She carefully recorded her work and expenses. The Disciples of Christ Historical Society is in possession of many of her materials.

[42]*Ibid.*, p. 90.

[43]*Ibid.*, p. 61. See also Fields, *Women*, p. 17.

[44]Carole Coffey, *Christian Women Share Their Faith* (Published by the Department of Church Women, Division of Homeland Ministries, Christian Church [Disciples of Christ]), pp. 68-69.

[45]Fields, *Women*, p. 31.

[46]Lollis, *The Shape*, pp. 93-97.

[47]"Death of Dr. Rijnhart-Moyes," *The Christian-Evangelist* 45 (February 20, 1908), p. 240.

[48]Lollis, *The Shape*, pp. 73-74.

[49]W. W. Weedon, "Deterding," *The Christian-Evangelist* 27 (December 11, 1890), p. 799.

[50]Ida Withers Harrison, *Forty Years of Service: A History of the CWBM, 1874-1914* (no city: no publishing company, no date), pp. 120-132.

[51]Debra Hull, "CWBM: A Flame of the Lord's Kindling," *Discipliana* 48 (3) (Fall, 1988), p. 42.

[52]Lollis, *The Shape*, p. 137.

[53]*Ibid.*, pp. 133-135.

[54]Kristine A. Culp, "Disciples Women Scholars: Inventing a Religious Vocation with Daring Leaps," *The Disciple* 131 (5) (May, 1993), pp. 16-17.

[55]Janice Newborn and Martha Faw, "Forty Years of Choice and Changes," *Discipliana* 51 (1) (Spring, 1991), pp. 3-6.

[56]Lollis, *The Shape*, p. 146.

[57]For a comprehensive history of the National Benevolent Association see Hiram J. Lester and Marjorie Lee Lester, *Inasmuch...The Saga of the NBA* (St. Louis: National Benevolent Association, 1987), p. 21.

[58]*Ibid.*, p. 29.

[59]"One of the NBA Founders Dies," *The Christian-Evangelist* 76 (September 9, 1938), p. 1028.

[60]"Mrs. Rowena Mason," *Christian Standard* 54 (November 30, 1918), p. 222.

[61]Mrs J. K. Hansborough, "Mrs. Henry M. Meier," *The Christian-Evangelist* 72 (August 29, 1935), p. 1146.

[62]"Mrs. J. H. Garrison Dies at the Age of 93," *The Christian-Evangelist* 77 (December 21, 1939), p. 1385.

[63]Many of these ideas are articulated in Brereton and Klein, "American Women," pp. 171-190.

[64]Adapted from "Writing Your Christian Women's Fellowship History" in the fortieth anniversary packet of Christian Women's Fellowship materials. Additional information on preserving historical materials is available from the Disciples of Christ Historical Society, 1101 19th Avenue, South, Nashville, Tennessee 37212-2196.

*L*ooking to the *F*uture

*P*roviding Inspiration for *Y*oung and Old

The young people of today realize that the guides of humanity are those who give devoted service, not those who rule by might from a golden throne.[1]

*A*lthough there have been lively debates about whether the reasons are rooted in biology or experience, there is no disagreement about the fact that women have always been the primary nurturers of children, both within and outside the church. So it is not surprising to find that early Disciples women ministered to children and youth.

Some women expressed their commitment to children and to the future of the church by teaching—in Sunday school, in youth meetings, or in Disciples-related colleges and seminaries. Others gave faithfully of their financial resources for the education of young people, particularly those preparing for Christian ministry. Still others wrote the inspirational prose and poetry or the missionary papers and Sunday school materials that laid the foundations of Christianity for generations of young people. A great number of women expressed their commitment to helping the youth of the church and of the

world through service in the Christian Woman's Board of Missions and National Benevolent Association.

The women whose stories are a part of this chapter join others whose devotion has been to blessing the young and old of the church and of the world. The work of women in these diverse areas continues to serve us today. Some of them laid down the structure through which others could serve—setting up the means for collecting and distributing contributions, developing camp and conference structures, and writing study curricula. Many of them helped to establish the Disciples as a movement committed to the development of a strong biblical and spiritual foundation among its children and youth and continuing inspiration among its older members.

The Campbell Daughters:
Lavinia, Clarinda, and Decima

Lavinia and Clarinda Campbell were Alexander and Margaret Brown (Alexander's first wife) Campbell's last two children and Decima was Alexander Campbell's tenth child and last daughter. (Her mother was Campbell's second wife, Selina Huntington Campbell.) As fate would have it, Lavinia and Clarinda were the first and second wives of William K. Pendleton, second president of Bethany College, one of its first five professors, and an editor of the *Millennial Harbinger*.[2]

As the bridge between Campbell and Pendleton and between the church and the college, Lavinia and Clarinda were instrumental in helping to establish Bethany College according to the vision and philosophy of their father. Decima was born in 1840, the same year Bethany College was founded and Lavinia and William were married. From another generation, she knew her father in his maturity and spent her last years in the role of caretaker and preserver, as the only resident of Campbell Mansion.

Although separated by about twenty years (Lavinia was born in 1818 and Clarinda in 1822), Decima shared with her sisters an upbringing firmly rooted in a profound faith and committed to the value of education. William K. Pendleton wrote about Clarinda:

> Her religion was older than mine. She never knew the time when she did not feel herself a child of her father's and her mother's God....From a child she knew the

scriptures; she knew not only the words, but the things they symbolized, by a faith which actualized every precept and substantialized every hope.[3]

When Clarinda was just five years old and Lavinia nine, in 1827, their mother died of consumption, an illness which plagued the Campbell family, eventually killing five of the daughters (including Lavinia and Clarinda) born to Margaret and Alexander. About a year after Margaret's death, Alexander married Selina Huntington, Margaret's chosen successor. In her memoirs, Selina spoke affectionately of her stepchildren. However, she apparently destroyed all pictures and references to Margaret in the home, behavior that was undoubtedly difficult for young children to understand.

It was the custom in the Campbell home for everyone (including guests) to participate in daily devotions—to read the Bible, answer questions, and memorize scripture (which each person recited at evening devotions). As the daughters grew in their ability to understand the faith, each became well able to present the doctrinal positions of her father. During their lives, all three daughters accompanied Alexander on fund-raising, debating, and evangelizing trips. On these trips the Campbell daughters witnessed to a faith that was by that time not just the faith of their father, but a faith shaped by their life experiences as well.

It was on one of these trips to Charlottesville, Virginia, in 1838 that Lavinia met William K. Pendleton, a student at the University of Virginia.

At the time of her [Lavinia's] visit to Charlottesville, Mr. Pendleton had been ill, and was, as yet, unable to leave the house. His friends among the students, dropping in to see him from time to time, brought glowing accounts of the beautiful Miss Campbell, and condoled with him on his enforced absence from the places where they had the privilege of meeting her. "Never mind," was his reply, "I shall soon be well, and I will cut you all out yet," which he did as soon as he entered the field.[4]

Two years later Lavinia and William were married. Although William intended to practice law in Charlottesville, Alexander persuaded him to help establish Bethany College.

A year later, in 1841, Lavinia and William's only child, Campbellina, was born. (Miss Cammie, as she was affectionately known, became a much loved professor of modern languages at Bethany College.)

Lavinia and her family lived at Mount Lavinium (now known as Pendleton Heights, the Victorian residence of Bethany College presidents). Lavinia devoted herself to her husband and father and to their work at the college. William admired Lavinia for her intellectual and spiritual graces, and looked to her for direction. The young men who were students at Bethany called on her for advice, as in this instance.

> One of the first class recalls a habit of the young men at that time of carrying very slender canes which they handled most delicately, and she was asked what she thought of the practice. "I always think the cane indicates weakness, either of the body or the head," was her answer, and from that hour the canes disappeared.[5]

Alexander Campbell was devoted to his daughters as well and clearly looked on them as his spiritual heirs. His relationship to Clarinda must have been particularly close as she bore the name that tied him to Margaret, his first love. When Margaret Brown and Alexander were courting, Alexander was writing a column for a Washington, Pennsylvania, paper which he signed with the pseudonym Clarinda. Margaret accurately guessed that Alexander was the author. Margaret and Alexander commemorated this pleasant time in their lives by naming their fifth daughter Clarinda.

Alexander also had a special place in his heart for Lavinia. In early 1846, he declined an invitation to visit Great Britain because of Lavinia's illness from the dreaded consumption. When she died a few months later, her husband William Pendleton became deeply despondent. Because of the early death of his beloved Margaret, Alexander was certainly well able to understand William's despair and responded by encouraging him to take a trip to Europe in the company of Clarinda and other young people.

William came back from this trip much more at peace, and in love with Clarinda. Clarinda and William were married in 1848. Although there was some controversy about the appropriateness of two sisters marrying the same man, Alexander

and Selina did not oppose the marriage, finding no biblical injunction against it. Clarinda became a devoted and loving mother to Cammie and bore two children herself—William and Lavinia. Clarinda died in 1851, when Lavinia was six weeks old. Baby Lavinia died twelve days later. On Clarinda's gravestone in God's Acre, the Campbell burial grounds in Bethany, West Virginia, these words are inscribed,

> We need not engrave her praise here: in the gratitude of the poor whom she blessed; in memory of the Christian friends—to whom she was a model; in the cherished affection of those whom in the more intimate relation of sister, daughter, mother, wife, she cheered by her work and encouraged by her example,—in these is her memorial written and the treasure of her worth preserved.[6]

Decima Campbell, born late in her father's life, enjoyed some of the benefits a well-established and prominent family has to offer. At her funeral in 1920, then president of Bethany College Cloyd Goodnight said, "To have an intellectually inclined father and a spiritually strong mother is a rare asset to the life of any child."[7]

The Campbell family valued education, even for its daughters. As a young child Decima was tutored privately at home. Later she attended Pleasant Hill Seminary, founded and operated by her aunt Jane Campbell McKeever, and graduated with honors from Canandaigua College for Women in New York.[8]

Decima was a great favorite of her father's and accompanied him on evangelistic tours throughout the country. By the time she came along, the restoration movement was clearly established and credible. Through Alexander she was exposed to powerful people and the important ideas of the time in politics, commerce, education, government, and religion.

Decima was married to John Judson Barclay, governmental minister to Cyprus and later to Morocco. They were the parents of three sons and a daughter. After the death of their daughter at age sixteen, Decima said, "The sweetness has gone out of life for me."[9] Although never fully recovering from her pain at the death of her only daughter, Decima became an author, historian, and painter, saying in old age that she regretted not becoming a writer of history. Mrs. Barclay spent much of her later life in residence at Campbell Mansion and is

largely responsible for taking the initial steps in assuring the preservation of both Campbell Mansion and the Old Meeting House.[10]

The Campbell daughters were instrumental in helping to shape the direction of the church and in helping to found and provide direction for the first Disciples-related college. Together they courageously set forth and preserved church principles and church-related education in this country. But Lavinia, Clarinda, and Decima represent countless women whose influence on the development of the church was mostly felt not in direct ways, but through the influence they brought to bear on their powerful husbands and fathers. All three women were able to speak articulately about theological matters. In spite of the fact that to speak with conviction one must hold strongly the position one espouses, most audience members undoubtedly heard the Campbell daughters as spokespersons for their father rather than as independent theologians.

It is also likely that the contributions these Campbell daughters made in shaping the thought and action of their husbands and father is lost to us. Many men first ask their wives for feedback on their ideas before they present them to a wider audience. But it is uncommon even today for the contributions wives and daughters make in shaping these ideas to be identified, much less credited.

Mother of Many: Elizabeth Williams Ross

Elizabeth Williams (known to her friends as Lizzie W.) was born in 1852, called Eureka, Illinois, home, and married a Disciples pastor, Allison Troy Ross. Together they were the parents of one son, Emory. Because of some financial difficulties, Mrs. Ross was forced to write to the Southern Christian Institute to ask for work for her husband and herself in 1896. The next year she and her husband and the ten-year-old Emory left for Edwards, Mississippi.

This move proved to be the gateway to Africa for their son. While at the Southern Christian Institute, Emory became friends with Jacob Kenoly, an African-American man educated at the institute. Kenoly went on to become a missionary to Africa, literally giving his life in service to the mission field in Liberia. Because of his devotion to his friend Jacob and his deeply held faith, Emory too became a missionary, spending his

life ministering to the people of equatorial Africa. Mrs. Ross rejoiced in her son's decision, but Mr. Ross never fully reconciled himself to losing his son's company and died in 1913.[11]

Rather than become despondent over the loss of both husband and son as some of her friends had feared, Mrs. Ross devoted herself to the young people of the church. She closed her home in Eureka and became a missionary evangelist, speaking in almost all the states of the union, in Canada, and before nearly all the Disciples colleges[12] on behalf of the United Christian Missionary Society.[13] More than sixty years of age and much loved by young people, she became

Elizabeth Ross

known as Mother Ross, "a homeless woman with hundreds of homes throughout the country."[14] In addition to her church work, Mother Ross spoke to YWCA-YMCA groups and other civic organizations and to thousands of recruits in army camps during World War I. "Always well received, she emphasized the need for devotional living and a strong Christian faith."[15]

She wrote several inspirational books, specifically directed to young people. In the foreword to *The Golden Room*, Gustine Courson Weaver wrote, "How can rational words be joined together to make intelligible the magic of perpetual youth that was hers?"[16] Mother Ross was a friend to old and young alike. Walter White, pastor of Linden Avenue Christian Church in Memphis and father of Bess White Cochran, said at Mrs. Ross's funeral that she "probably knew by name more people in our brotherhood than any other individual."[17] In tribute to Mother Ross, Gustine Courson Weaver wrote that "of the over one and one half million Disciples of Christ fully half have been personally uplifted by her life and her cheer and her courage."[18]

Mrs. Ross's friend Gustine Courson Weaver was herself a noted author with works published regularly by *The Christian-Evangelist* and Bethany Press. Her books were compared favorably to the works of Robert Louis Stevenson and Shakespeare. In addition to the vibrancy of her writing, Gustine was also known for habitually dressing in the color orchid and for using an orchid typewriter ribbon and stationery.[19]

Elizabeth Ross died at the home of the president of the Southern Christian Institute and his wife, her good friend Mrs. J. H. Lehman, on September 12, 1926. At her funeral service she was remembered by Walter White for her knowledge of the scriptures, her abiding faith and unselfish service to others, her powerful personality, and her work as a missionary proponent.[20]

Continuing the Education of Youth: Joyce Montgomery Foulkes

Elizabeth Ross was particularly interested in the education of African-American youth for church service, both here and abroad. She labored in the South during the difficult period after the Civil War and into the turn of the century. She supported her son in his call to follow his friend Jacob Kenoly to missionary service in Africa. Joyce Montgomery Foulkes continued the heritage of Mother Ross and others who believed in the importance of Christian education for minorities.

Joyce Montgomery, an African-American born in 1942, was nurtured in a white church, Tabernacle Christian Church in Franklin, Indiana, which she joined as a young girl. Not only in her church, but in a number of other situations, Joyce found herself the only black person. Her patience and openness helped those with whom she came in contact to accept all people as children of God. Through her work in the Christian Women's Fellowship Joyce helped other women learn

> ...not only of the needs of our neighbors near and far, but also of their cultures and customs. We learned of the difficulties of our sisters with whom we had so much in common, yet were so very different.[21]

As an adult, Joyce Montgomery Foulkes was a member of Light of the World Christian Church in Indianapolis and active

in her region (as the moderator of the Indiana region) and general church, all the while caring for her children. Joyce credited her church family with recognizing her gifts and giving her the skills necessary to serve effectively. At her untimely death in 1987, Joyce was preparing for professional ministry. In her honor, a fund to educate minority students at the Christian Theological Seminary was established after her death. Joyce Coalson writes:

> Joyce Montgomery Foulkes…was a woman who hated evil but not the evildoer, loved good, and worked to establish justice. Her commitments to justice live on…as we move toward a more inclusive church.[22]

Shaper of Character: Cynthia Pearl Maus

It has often been said that Christianity is always only one generation away from extinction. So it is critical for us to develop a deeply held faith in our young people and to equip them for future church leadership positions. No one knew this better nor worked harder to bring it to pass than Cynthia Pearl Maus.

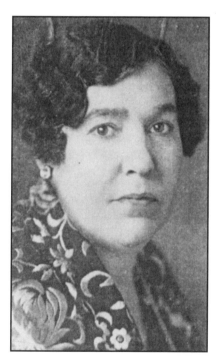

Cynthia Pearl Maus

Cynthia was born on a farm in Iowa in 1880 and grew up in Iowa, Colorado, and Kansas. Her poor but industrious parents gave her the faith and confidence that would sustain her throughout life. Educated at the State Normal School at Emporia and at Northwestern University, Cynthia worked as a high school teacher and as an office worker. She gained experience and a fine reputation as a youth worker in the Hamilton Avenue

Christian Church in St. Louis, beginning in 1907.[23] In 1910 she was hired by Marion Stevenson, editor-in-chief of the Christian Board of Publication, to serve in the department of church school literature. In this position she was an articulate proponent of the importance of religious education.[24]

In 1914 Cynthia Maus became superintendent of the Young People's Department of the American Christian Missionary Society (later the United Christian Missionary Society). From this position she became nationally known for her work with young people—in helping to establish vacation church school, weekday church school, and summer camps and conferences. She began the first Young People's Summer Conference in the Disciples church in 1919. A series of International Youth Conventions followed, beginning in Memphis in 1926. Cynthia Maus's goal in all her youth work was to promote spiritual development and leadership training in young adults.[25]

During the Depression, in 1931, Cynthia Maus resigned from her position with the United Christian Missionary Society to begin independent work. Her chief reason for resigning was to spare others less senior than she from being laid off in a time of financial cutbacks in the United Christian Missionary Society offices. Cynthia Maus was honored by the children of Bolenge, Belgian Congo, with a program of native dances and costumes in 1956[26] and recognized for her work with young people in the granting of an honorary degree from Chapman College in 1958.[27] She died in 1970.

Missionary to Children: Eva Nichols Dye

The children of Bolenge learned their faith in part from Eva Nichols Dye who was the first Caucasian Disciples woman missionary to serve in Africa. When Eva and her husband Royal Dye went to the Belgian Congo (now Zaire) shortly after their marriage, they found a primitive people with no written language who were practicing polygamy. In the interior of the country cannibalism still occurred.

Mrs. Dye, who was a registered nurse, learned the Lonkundo language, developed a written form of it, and began to translate the Bible and hymns for the native peoples. Later she established a school for girls and wrote a captivating book on African missions. Two of the Dye's three daughters were born in Africa. After returning to the United States because of

ill health, Mrs. Dye was active in the Hollywood-Beverly Christian Church in Los Angeles, continued to support Filipino mission efforts in California, and inaugurated the tradition of a prayer room at state, national, and international conventions. She died on March 9, 1951.[28]

There are many people who have had a profound impact on the lives of Disciples young people. Almost all active Christians can name someone from their youth who was instrumental in their faith development. However, there are few who, like Cynthia Maus, had the vision to conceive of national youth work and to press for its recognition. Cynthia Maus set in motion the structure that would allow for extensive and meaningful opportunities for Christian education for children and for the training for leaders.

Her legacy to us is found in the Disciples whose lives have been touched and whose commitment to the faith has been shaped by their experiences in Christian education and youth work. We continue her legacy when we support financially and with our best resources programs for the young people of the church.

The Gardener: Mae Yoho Ward

If people could be likened to flowers, Mae Yoho Ward would be a rose. Not some hothouse variety, bred for its show or effect, but a sturdy, bright red, fragrant flower that would bring lasting beauty to all who passed by.[29]

Mae Yoho was born in 1900 to a well-educated Disciples pastor (Jeff Yoho) and his wife, on a prosperous farm in West Virginia. Mae's father, who served his last pastorate at the Madison Avenue Christian Church in Huntington, West Virginia, was well known as a convincing preacher in and out of the pulpit. Mae's son, Don, writes:

Indelibly etched in Mae's memory was a picture of her father standing on the porch of the parsonage before a lynch mob, a torch in one hand and an open Bible in the other, giving no ground on the subject of prohibition. The conviction and power of his position that night sent the crowd away, and it never threatened his family or church again.[30]

Mae's father had progressive attitudes on the capabilities of women and their need for education. For instance, at age nineteen, Mae became the only woman in her town to learn to drive when her father insisted that the modern woman needed to be able to move around independently. And realizing the difficulties Mae would face as a college woman in the early twenties, Mae's father wrote letters of encouragement to her every day during her college years.

After her graduation from Bethany College in 1923, Mae became the director of religious education for the Christian Churches in West Virginia and Ohio. Later Mae entered Yale University, her father's alma mater, to study at the divinity school. Unfortunately the encouragement she had come to expect based on the support she received from her father was not to be found among the professors at Yale. Because she was a woman she was denied admission to the divinity school, and had to study instead in the school of education and merely take courses as a nondegree candidate in the divinity school. She earned her master's degree from Yale in 1928.[31]

Mae was married to Norm Ward, also a Yale graduate student, on September 25, 1926, and they served the Christian Church as missionaries to Buenos Aires, Argentina, for six years. During that period, their first child, a daughter named for Mae's beloved sister Dee, died in a diphtheria epidemic. Mae and Norm returned to minister in Wadsworth, Ohio. In the second great tragedy of her life, Mae's husband Norm left her, cutting her off not only from her husband but also from her relationship with the Wadsworth church and leaving her financially destitute.[32]

With a young son to support and no position commensurate with her education and experience to be found, Mae began a series of jobs as a chambermaid, baker, and grocery store worker. Mae's son, Don, says this was a time of humiliation, hopelessness, and near poverty for his mother.[33]

In 1941 Mae's prayers for church work were answered as she was offered the position of secretary for Latin American affairs by the president of the United Christian Missionary Society. She and Don moved to Indianapolis and became active members of the Downey Avenue Christian Church. During this period of her life she was a much-sought speaker for church events and an active spokesperson for the civil rights movement, the farm workers strike in California, and for

Christian unity. Visitors to the Ward home were invariably treated not only to stimulating conversation, but to pot roast, potatoes, green beans, and after-dinner table games (which Mae liked to win).[34]

The prayer journal of Mae Yoho Ward, edited by her son, Don, is the personal and inspirational record of a woman seeking to live her life as a child of God and inspire others to do the same. It is difficult to choose a representative sample of her work, as the topics on which she wrote are varied. However, this excerpt illustrates Mae's concern with all of life and her ability to find the sacred in everyday life:

> I would give a sacred meaning to the commercial phrase, "Reach out and touch someone." It causes me to see my fingers in a way not seen before, and sets my mind wandering. How often have they been used aright? How often have they been used, to touch a hand, to prepare a dish, to play the typewriter keys and bring a song to a lonely heart, to hold a cup of wine and a piece of bread, to fold in quiet supplication?[35]

Following her work with the United Christian Missionary Society, Mae joined the staff of the Division of Higher Education and then, upon her second retirement, became the self-appointed groundskeeper of the Missions Building in Indianapolis. Legend has it that a part of her prayer life each day included praying intentionally for each person who entered the building, whether or not she knew them. She received honorary degrees from Bethany, Culver-Stockton, and Drake. Mae Yoho Ward died in 1983. In an entry in her journal shortly before she died, Mae encourages women:

> Why is it so hard for men today to have an interest in the spiritual life and yet most of the "saints" are men? Doesn't it go back again to education, opportunity and biological freedom? Raise up great women, Oh God, so that there will be equality among the saints in the coming generations.[36]

A Challenge to Us: An Intentional Prayer Life

Mae Ward's journal is remarkable in the number of people for whom she prayed. Her son writes:

We found lists of hundreds and hundreds of names, people for whom Mae petitioned each day. Lists changed and names were dropped, added, or repeated as her "prayer partners'" needs for healing, support, or reconciliation were resolved. It appears that, on the average, eight or ten people per day were thus remembered, but it is not unusual to find twenty, thirty, or more names. There is a deep sense of assurance in finding one's name here.[37]

In addition to names of individuals, Mae also prayed for the work of organizations and groups of people—for instance, all Sunday school teachers, those preparing for Quadrennial, the editors of church publications, the work of the United Nations, those who recently attended a workshop she led, and regional and general work of the church, as well as the more common topics of prayer petitions. Despite great hardship, Mae Ward bloomed wherever she was transplanted. Her life continues to provide inspiration for us for she recognized the centrality of prayer in Christian life.

Mae Yoho Ward's life calls us to renew our prayer life. The challenge to us is to develop intentional ways to pray that fit with our personalities and needs. Prayer is powerful, both for the one praying and for the one for whom the prayer is offered. Mae Yoho Ward "was one of those rare persons who strove to pray without ceasing and whose life thus became a prayer....To that end, and to her life, we can only add 'Amen.'"[38]

An Opportunity to Respond:

Suggestions for beginning or renewing an intentional prayer life are endless. Perhaps you can adapt some of these ideas for yourself.

1. Mae made lists of people for whom she wished to pray and of their particular needs.

2. I have a friend who has daily and weekly lists of prayer concerns that she updates by asking the people on her list or their families what their specific and current needs are.

3. The church provides us with a calendar of prayer suggestions.

4. Local church bulletins often contain lists of needful persons and other areas of community concern.

5. I have another friend who is a member of the diaconate. As she serves communion, she prays for each person sitting in the pew.

6. A former youth leader prayed each day during summer conference for every participant, by name.

7. I have found it personally helpful to pray for those with whom I am angry or in conflict.

8. Another friend prays as she walks, another as she drives to and from work.

9. Our Christian Women's Fellowship and church membership class both have a "prayer partner" program.

10. We have a group of women who pray for each other. One of us who recently had a mastectomy said that she felt very clearly the power of our prayers for her and that they were instrumental in her recovery.

Notes

[1]Gustine Courson Weaver, "Foreword," in Elizabeth W. Ross, *The Golden Room* (Cincinnati: Powell and White, 1927), p. ii.

[2]For further information on Lavinia and Clarinda Campbell Pendleton see Debra Hull, "Lavinia and Clarinda: The Campbell-Pendleton Bridge," *Discipliana* 50, (2) (Summer, 1990), pp. 25-28 and associated references.

[3]William K. Pendleton, "In Memory of Clarinda," *The Millennial Harbinger* series 1, vol. 7 (February, 1851) p. 415.

[4]F. D. Powers, *The Life of W. K. Pendleton* (no city; no publisher, 1902), p. 68.

[5]*Ibid.*, p. 74.

[6]*Ibid.*, p. 125.

[7]Cloyd Goodnight, "Address Delivered at Funeral of Mrs. Barclay," *Christian Standard* 60 (June 5, 1920), p. 885.

[8]"Mrs. Decima Campbell Barclay," *The Christian-Evangelist* 57 (May 27, 1920), p. 543.

[9]Jane Campbell Dawson, "In Memoriam Decima Campbell Barclay," *Christian Standard* 60 (June 5, 1920), p. 885.

[10]*Ibid.*

[11]For further information on the life of Elizabeth Ross see "End of the Road for Mother Ross," *The Christian Evangelist* 63 (September 23, 1926), p. 1215.

[12]*Ibid.*

[13]"The Passing of Mother Ross," *The Christian Evangelist* 62 (September 16, 1926), p. 1175.

[14]"End of the Road," p. 1215.

[15]Lester G. McAllister, "Mother Elizabeth Ross," in Peter Morgan, (ed.), *Disciples Family Album: 200 Years of Christian Church Leaders* (St. Louis: Chalice Press, 1990), p. 72.

[16]Weaver, "Foreword," p. i.

[17]"End of the Road," p. 1215.

[18]Gustine Courson Weaver, "Tribute from Mrs. Gustine Courson Weaver," *The Christian-Evangelist* 63 (September 23, 1926), p. 1215.

[19]Frederick D. Kershner, "As I Think on These Things," *The Christian-Evangelist* 68 (January 8, 1931), p. 41.

[20]"End of the Road," p. 1215.

[21]Joyce Montgomery-Foulkes, "Mother of Six and Future Minister," in Carole Coffey, (ed.), *Christian Women Share Their Faith.* (Department of Church Women, Division of Homeland Ministries, Christian Church [Disciples of Christ]), p. 16.

[22]Joyce B. Coalson, "Joyce Montgomery Foulkes," in Morgan, *Disciples Family*, p. 94.

[23]For information on the work and life of Cynthia Pearl Maus see "Cynthia Pearl Maus," *The Christian-Evangelist* 70 (February 23, 1933), p. 252, and News Editor, "Cynthia Pearl Maus to Close Work," *The Christian-Evangelist* 68 (October 1, 1931), p. 1305.

[24]"Cynthia Pearl Maus," *The Christian-Evangelist* , p. 252.

[25]See Lester G. McAllister, "Cynthia Pearl Maus," in Morgan, *Disciples Family*, p. 82, and News Editor, "Cynthia Pearl Maus," p. 1305.

[26]"Author Honored," *The Christian-Evangelist* 94 (May 16, 1956), p. 506.

[27]"Two Receive Doctors' Degrees," *The Christian-Evangelist* 98 (April 21, 1958), p. 447.

[28]"Memorial Services Are Held for Pioneer Missionary Eva Nichols Dye," *The Christian-Evangelist* 89 (May 2, 1951), pp. 433, 440, and Evelyn Utter Pearson, "An Appreciation of Eva N. Dye," *The Christian-Evangelist* 80 (August 13, 1942), pp. 882-883.

[29]Hiram J. Lester, "Mae Yoho Ward," in Morgan, *Disciples Family*, p. 88.

[30]Don Ward, (ed.), *The Seeking Heart: The Prayer Journal of Mae Yoho Ward.* (St. Louis: CBP Press, 1985), p. 9.

[31]*Ibid.*, pp. 9-13.

[32]*Ibid.*

[33]*Ibid.*

[34]*Ibid.*

[35]*Ibid.*, p. 127.

[36]*Ibid.*

[37]*Ibid.*, p. 25.

[38]*Ibid.*, p. 13.

The Circle of Women in the Church

Conclusions

*She was simply incapable of accepting someone
else's version of reality until she had measured
it against her own experience...."the delicate
vibrations of [her] soul."*[1]

*I*n 1848, the first Woman's Rights Convention in the United
States was held in Seneca, New York. The Declaration of
Sentiments produced there, modeled after the Declaration of
Independence, highlighted the various ways in which women
suffered discrimination. Specifically identified in the Declara-
tion of Sentiments were disenfranchisement and the lack of
political power, legal inequities, lack of occupational and edu-
cational opportunities, and interestingly, subordination in
church government.[2] The Declaration called for:

> ...the zealous and untiring efforts of both men and
> women for the overthrow of the monopoly of the pulpit
> and for the securing to women an equal participation
> with men in the various trades, professions, and
> commerce.[3]

The Declaration did not by itself bring an end to discrimi-
nation. After finding that appealing to those who held power

over them (through the Declaration) was not successful, women acted in more direct ways, circumventing traditional avenues of influence. Sophonisba Breckinridge contends that the action of women in forming women's organizations led directly to better opportunities for employment, to suffrage, and thus to greater political power. By extension, it was the development of church women's organizations and female seminaries that led to greater participation by women in church leadership roles, in decision-making positions, and ultimately in shaping the direction of the church.

In the middle of the nineteenth century, women were faced with a number of obstacles that prevented their full participation in the public world. Ironically, by establishing their own successful organizations and institutions, independent from male-dominated church structure, women eventually gained at least partial access to that very structure, and helped to control its evolution.

Impetus for Change

Others express the simple, but for the time unfulfilled, desire to share the life of the community directly and yet completely, not partially on the one hand as celibates nor vicariously on the other as shut off by marriage from full participation in the productive work of the community.[4]

One might legitimately wonder why some women insisted on full participation in the life of the church. Why were they not satisfied with their traditional roles in caring for families and homes?

For the typical woman, participation in church life meant a passive receptivity, at least in corporate activities. Most of the time women did not see their lives and experiences reflected in the liturgy and worship practices of the church. The voice of the traditional male preacher did not speak naturally to the spiritual life of the woman. And the voices of those women who were called to be preachers and evangelists were often muted by others who urged them into silence.

The unique approach of faithful women touches not only the souls of other women, but deepens the understanding of all people. Many authors have tried to write about the differ-

ences between the ways men and women approach their faith. The following quote written by a man about seventy years ago suggests some of those differences:

> Man tries to know God through his logic; woman knows him better through emotion and service....Man constructed the cross, and hung the world's Redeemer upon it; woman waited, and wept while He died. If woman had been admitted to her rightful place in the councils of the early church we would have had more of Christ's religion, and fewer man-made creeds barnacled on the "Ship of Zion."[5]

In 1810, another male writer made a related point in speaking of the essential feminine nature of Christianity in this excerpt from a sermon:

> I believe that if Christianity should be compelled to flee from the mansions of the great, the academies of the philosophers, the halls of legislators, or the throng of busy men, we should find her last and purest retreat with women at the fireside; her last altar would be the female heart; her last audience would be the children gathered around the knees of a mother; her last sacrifice, the secret prayer, escaping in silence from her lips, and heard perhaps only at the throne of God.[6]

Or, expressed in a lighter vein, in a joke repeated by Mossie Wyker in her book:

> Woman weeps o'er the sins she's done, and makes them seem like double; man straightway forgives himself, and saves the Lord the trouble.[7]

Surely not all men nor all women can be expected to respond in the same way. Some women provide aggressive leadership; some men provide gentle care. Still, the lack of participation by women in the public life of the church created a twofold problem. On the one hand, women whose style and personality allowed them to fit easily and comfortably into the male-defined roles of pastor, elder, deacon, theologian, and church executive were unusual, somewhat suspect and threatening, and unlikely to be tapped for such positions. On the other hand, the characteristic feminine voice, whether it be provided by women or men, was largely absent from the church.

"Sermon illustrations, biblical stories, religious language, and religious images were oriented around the worlds, values, and experiences of men."[8]

Courageous Pioneers

With courage born of a deeply felt faith commitment, then, women began to assert themselves, affirm their gifts, and seek legitimate power in the church.[9] Despite opposition, a few women began to preach. As they converted their listeners and established thriving churches, they captured the attention of official churchdom and some were ordained (usually rather reluctantly). Women preachers were most easily received not solely on their own merits, but when they either followed their husbands into pastorates or had the strong support of their husbands.

Lois Banner reports the percent of clergy (in all denominations) who were women in the decades between 1900 and 1980. These statistics do not indicate that women enjoyed wide acceptance as pastors.

1900—4.4%	1940—2.2%
1910—1%	1950—8.5%
1920—2.6%	1960—5.6%
1930—4.3%	1979—4.6%[10]

It is difficult for us to grasp the degree of commitment and fortitude it took to persist in the face of such incredible odds. A woman who felt a genuine call to preach the gospel, a call that infused her whole being, risked being verbally assaulted by other Christians who preached that her biblical obligation was to keep quiet. And she had very few women colleagues with whom she could share her experiences and from whom she could receive support.

A New Way of Experiencing God

The most prophetic women among the early Disciples, however, recognized that through the development and valuing of the self comes a new experience of God. And the oppression of one individual created in the image of God robs all of us of a fuller, more complete experience of God. The twelfth chapter of 1 Corinthians teaches us to value the contributions

of all those whose gifts are of the one spirit. Just as the body would not be complete if it were just an eye or just an ear, so the church would not be complete if it were only male in its public leadership. And just as the body parts that seem to be weaker are indispensable, so the seemingly weaker (female) members of the early church were indispensable in its development. The body of the church is built up when it is formed by the gifts of all those who drink of the one Spirit. The realization that they embodied these scriptural truths about the value of women and women's work in our shared experience of God gave early Disciples women the courage to persist in their determination to be full participants in the body of Christ.[11]

Women and Higher Education

Recognizing that access to higher education was critical in both the development and the valuing of women, early Disciples women also sought to broaden educational opportunities for women. Because women were subtly and directly discouraged from enrolling in college in the nineteenth century, industrious Disciples women established all-female seminaries and coeducational missions schools. These new alternatives were a godsend to the middle- and upper-class women whose families could afford to send them.

Education increased women's participation in the public world in a number of ways. Women who had received the education necessary for them to enter professions gained organizational and management experience in their jobs—experience that helped immeasurably in their church work, particularly in the later years of the Christian Woman's Board of Missions and in the United Church Women. Women who were well educated but not employed applied the same resolve to their church work that they had to their studies.

Initially some saw the education of women in female seminaries as a way to equip them better for their traditional duties—that is, education was seen as a way to make women better wives and mothers.[12] But women's achievements kept pace with the changing curricula and many graduated with degrees earned through completing the same course of study as their male counterparts. Additionally, some women met and married men who had the same aspirations as they did.

Having a husband who shares and supports one's career aspirations not only makes life easier for the woman, but leads to greater acceptance of her by those outside the family.

Even with the support of husbands, though, full and enthusiastic acceptance of women preachers was uncommon. For example, when previously all-male seminaries were finally opened to women, they were allowed to matriculate and were awarded degrees, but were discouraged from entering pastorates. And in coeducational seminaries, women students lost the sisterhood of emotional and financial support that had been available to them in the mission schools established by women.

The Anger Motive

In addition to justification by faith, the impetus for women to establish separate organizations also came from anger and impatience with men. For example, the Woman's Christian Temperance Union was largely established and its protests led by women who were angry—angry with husbands and fathers who placed their desire for the bottle above the welfare of their families, angry at saloon owners and barkeepers who took advantage of those who had difficulty controlling their drinking, and angry at the male government leaders who saw what was happening to women and children and didn't do anything to stop it. Women's missionary organizations developed in part because women became impatient with men. In the opinion of early church women, the official male-run church missions organizations were ineffectively managed, failing to minister effectively to the pressing needs of women and children, especially in other countries.

A Morality of Mutuality

For women, the work they did in foreign and home mission societies was a natural outgrowth of the truths they learned at home—nurturance, care for the vulnerable, and attention to the spiritual needs of others. These women understood in a very personal and concrete way the twenty-fifth chapter of Matthew. They lived the ancient truth that in feeding the hungry, giving drink to the thirsty, welcoming the stranger, clothing the naked, healing the sick, and visiting the impris-

oned—in ministering to the least of the members of the family of God—they were joined in intimate relationship with God. These women also knew that when they failed to respond to the needs of the least among them, they failed to respond to God as well.

The early women of the Christian Church discovered new truths as well. The work they did justified the role of self-affirmation in one's mature faith journey toward knowing God. As one comes to understand oneself and one's talents as spirit-filled, the obligation to use one's talents for the public good is inescapable. And through service one comes to know God more directly. Self-affirmation, service, and knowing God, then, are intertwined, each leading to greater depths of understanding and levels of expression of the others.

The work of early Disciples women pioneers also established a new morality for the church, one based on connection with others rather than on power over others, a moral orientation that carries with it a greater possibility for the development of all people. The mutuality inherent in connection

> signifies a relation marked by equivalence between persons, a concomitant valuing of each other, a common regard marked by trust, respect, and affection in contrast to competition, domination, or assertions of superiority.[13]

Ultimately a morality based on mutuality rather than power may lead to a more profound relationship with God.

> If, however, moral autonomy is grounded on relationship, if mutuality is a moral excellence, then language emerges that sees holy mystery as at once essentially free and richly related, the two being not opposites but correlatives. God's activity is discerned in divine, free, mutual relation rather than in divine distance, rule, and search for submission.[14]

Responses to the Efforts of Women

Several prominent men (as well, undoubtedly, as many unnamed men) did recognize the gifts of women and publicly encouraged them in their missionary, educational, and social

reform efforts. Perhaps the presence of strong women in the lives of these men encouraged them in their support of women. Among these men were Isaac Errett, his own daughter a strong and capable journalist and churchwoman, and J. H. Garrison, whose wife was one of the founders of the National Benevolent Association.

But at the same time, a significant number of men opposed women's efforts and urged them to return to the private sphere of their homes. Ida Withers Harrison believed that opposition from American church men to women speaking in church delayed the establishment of women's church missionary organizations in Disciples-related churches in North America for at least twenty-five years.[15]

Women also were prohibited from competing for missions funds through the already-established church structure. Instead they had to raise substantial sums of money from many small, grassroots gifts. Fortunately our foremothers were particularly good at financial planning and management, publicity, recognizing the centrality of the local church, and corralling enthusiasm into commitments of time and money. When the missionary education for women was inadequate, Disciples women established their own mission school, emphasizing the practical education necessary to succeed in another country as well as the theological basis for missionary work.

The Results of Mergers

Not surprisingly, as the women's separate efforts began to succeed and to be recognized by men, there was pressure to bring these organizations into the official church structure. Christian Woman's Board of Missions brought the lion's share of money, experience, and resources into the United Christian Missionary Society. In other denominations where this same phenomenon occurred, women lost their positions on missionary boards when they came under the general church structure. In the Disciples church, by design, the United Christian Missionary Society Board was required to have equal representation by men and women. This tradition continues in the Division of Homeland Ministries today.

United Church Women, flourishing as an independent organization, was one of the most prominent participants in

the organization of the National Council of Churches. After the efforts at uniting, when women attempted to take their rightful place alongside men in merged church organizations— even when the intention was to include women—they often faced less than wholehearted acceptance. Mossie Wyker records an incident that occurred when she was with a group planning a state convention. As the group was planning for inspirational evening speakers, one woman suggested that they might ask a woman to fill one of the spots. The men present were concerned with three questions:

Will her voice carry in a large auditorium?
Is she an excellent speaker?
Is she attractive?

Fortunately the women found one among them who qualified in all three areas.

The woman who introduced the speaker at the state convention described the planning committee's discussion, then turned to her male colleagues on the stage behind her.

A few were slightly bald and a bit heavier than they had been in college. She commented: "Some day we are going to demand those requirements for our men speakers," and then she stepped aside for the "attractive" speaker, who could be heard—and who had something to say![16]

When separate women's organizations and colleges became parts of established church structures, women both made some gains and took some losses. As with those whose influence comes through powerful husbands and fathers:

They were often stymied, however, in the full exercise of authority by the strictures that the male establishment imposed, and by their own culturally derived self-doubts and internal inhibitions.[17]

Inclusivity Versus Diversity

Efforts at including women in church leadership and decision-making roles, well-intentioned as they often were, sometimes ended up looking as if the dominant male group was letting the women participate, but only on their terms and not by adapting to the real presence of women in the

public life of the church. It's one thing for male-run groups to have merged with female-run groups and to have allowed some women to serve on the boards. It's quite another for male-run groups to work in mutual relationship with women to change their structures or programs in order to be more responsive to the particular life experiences and needs of women. The degree to which women are genuinely valued is reflected in the extent to which the organization or institution seeks to change in response to their presence.

The difference may be reflected in the different ways we understand inclusivity and diversity. An inclusive church lets everyone participate in the established structure, modifying the "rules" only as much as is absolutely necessary. A diverse church recognizes different ways of coming to the truth and welcomes new approaches to structuring itself and conducting its business in order to value the contributions of all persons.

Trying to Find a Middle Ground

As women's organizations and institutions were merged with male-led organizations or in other ways came under the general church structure, significant numbers of women did attempt to find a middle ground—somewhere between the independent and autonomous organizations they had been used to, and losing their separate identity entirely in the newly formed organizations. The experiences of United Church Women serve as an example of a woman's organization intentional in its efforts to be loyal to the established churches of which it was a part while agitating for greater participation in shaping the direction of the National Council of Churches:

> Although they sought loyally to serve church and society, at the same time [they] worked zealously to effect women's acceptance (as more than undersecretaries and assistants) in the boardrooms of the establishment.[18]

In 1969, though, after a reorganization of the National Council of Churches in which United Church Women (as well as some other groups) lost their status as a general department, the group withdrew from the National Council and resumed its autonomous existence (now as Church Women United).

The participation of the United Church Women in the National Council of Churches was made more difficult for several reasons. Perhaps United Church Women were not as theologically sophisticated (having been denied access to seminaries and the informal network of church scholars) as their male counterparts. Perhaps they were naive about the use of power and influence in accomplishing their goals. Surely they were marginalized in the structure of the National Council itself. But in many ways, the merger was sound and could have succeeded. The men and women involved were of the same religious traditions and faith orientations. Their goals in the church and in the world were not terribly different. Instead, they differed primarily in what they thought were the appropriate means to reach their goals, particularly regarding issues of power and authority within the organization.[19]

A Personal Balancing Act

A number of the individual women whose lives are described in this volume tried to do personally what United Church Women tried to do corporately—function effectively as part insider, part outsider. In their daily lives, women lived out their ambiguous feelings—the joy of their calling to Christian witness and the pain of their rejection as leaders.

But no matter how strong the personal calling, ministry can never be entirely effective unless the call to the one is affirmed by a responsive community. Early Disciples women continually struggled with faithfulness to speaking the truth as they knew it, and not being so bold as to alienate their hearers and negate the good work they had been able to do. Often they were able to control the frustration they felt while in public, corresponding privately with each other about it instead.

In order to be accepted, early Disciples women had to be highly competent in their work. What might be tolerated as mediocre performance by male colleagues would cause a woman in the same situation to be harshly criticized. And at the same time, women had to make sure their domestic houses were in order. Although there are certainly important examples of single women leaders in the church, Virginia Brereton says that, as late as the 1950s:

Nearly every married woman leader in the church at this time, no matter how far-flung and prominent her public activities, insisted that she was first and foremost a homemaker.[20]

Perhaps acceptance came easier to those women who followed traditional expectations at least in part by nurturing children and caring for a home. It is easier to find a receptive ear when one is saying radical things and questioning traditional church authority if one has a traditional family background and acts like a lady. But many of these women also probably felt real ambivalence in their lives. It is never easy to balance one's commitment to the public world and one's commitment to the family.

In Solidarity with Our Foremothers

In part because of their trials and because of their need for support from one another, there was a solidarity that developed among the early women who extended themselves into public church work. When the support from men and from other women was weak or when the response was antagonistic, women leaders turned to each other for comfort and affirmation. Passionate friendships developed and were nurtured. Childhood friends used their different talents in support of one another's efforts.

Sisterhood transcended the boundaries of genetic relationship, personality, and leadership style. Women who were very different on the surface became soul sisters, establishing relationships that sustained for a lifetime. No matter what divided women, they were and still are united by their common experiences. Then, as now, our hearts go out to women experiencing unfortunate marriages, pregnancies, the death of children and spouses, illnesses, and oppression.

Disciples women today join our foremothers in an unbroken circle of Christian witness and service. Like them, we are a diverse group. While the biblical basis for our work and our ultimate goals are the same, we express our personalities and our faith in different ways. As they did, some of us prefer to work inside established church structure, sometimes subtly influencing those in power. Others take a more activist approach, challenging and questioning structures and organiza-

tional patterns that overlook or exclude women's special needs and talents. Some of us work most effectively in structures that are still rather parallel to mostly male-led parts of the church. But as with our foremothers, there is remarkable solidarity in our diversity. We are less threatened than strengthened and broadened by our differences.

While women of today are the grateful recipients of the gifts our foremothers passed down to us, we still have work to do before women can participate as the genuine partners of the men in our church. As one small but telling example of the road still ahead of us, my computer spell-checker does not recognize the word "foremother." Instead it suggests "forefather." Even the language we use to speak of our history is still evolving.

In other areas, too, much remains for us to address. Particularly striking still is the lack of women pastors, especially of large churches, the relatively low proportion of women teaching in seminaries, especially in particular subject areas, and the lack of women on the general cabinet (general minister, deputy general ministers, and presidents of the divisions). Too often we still forget to include women in positions of influence, or mistakenly believe that men can represent the unique needs and gifts of women (although we would never assume that an all-female group would adequately represent men). Perhaps the true test of inclusiveness will come when we feel as comfortable describing our whole church (men and women together) as a sisterhood as we do speaking of the brotherhood.

A Final Word

All of us, women and men alike, continue to reap the benefits of a faith broadened and deepened by the genuine and full participation of women. When we hear women preachers, we encounter the word in a different way, a way that adds to its significance for our lives. When we read the prose and poetry, and sing the hymns of women writers, we see the world and the impact of faithful people upon it with new eyes and new hearts. As we learn from women teachers and scholars, we gain important insights into the meaning of scripture in the lives of all people. When we consider portions of the scripture sometimes overlooked, we see Christian symbolism

reflected in the day-to-day experiences of women. As we work to alleviate the needs of those oppressed and in poverty, we experience firsthand the morality of mutuality. And in so doing, we come into closer communion with each other and with God, our mother and father.

May the legacy that our foremothers in the Disciples tradition left to us continue in our lives and in the inheritance in the faith we leave to our children. Let books of the next century record the words of our mouths, the activity of our hands, and the meditations of our hearts as acceptable not only to the God whom we worship, but also to the church whom we serve.

An Opportunity to Respond: Moving Toward a Diverse Worldview

It is difficult for all of us to understand the world from another's point of view, even under the best of circumstances. Particularly on matters of faith, spirituality, worship practices, and organizational structure, those of us who are members of the European-American culture need to better understand and to become more sensitive to the practices of members of nondominant cultures. Even when we are well motivated to open ourselves to other ways of knowing God and expressing our faith, lack of opportunity for interacting with persons from a different background makes the process harder.

Those who truly want to commit themselves to an openness to diversity can take several concrete steps.

1. Develop an awareness of your own cultural background and its influence on your beliefs and practices, so you are not like the fish who didn't know its environment was wet because it had never experienced anything else.

2. Immerse yourself in another culture through church-related travel and service, through attending worship services planned by another group, through learning the language of another group of people. Christian Women's Fellowship programs, regional conferences, General Assemblies, and Quadrennial often provide excellent opportunities for closer interaction

with people of varied cultures. Make intentional efforts to avail yourself of these opportunities.

3. Read the words of faithful women from other cultures. Books that are personal favorites of mine, and that I would recommend highly, include *Cries of the Spirit: A Celebration of Women's Spirituality* edited by Marilyn Sewell (especially strong in African-American and Native American writers); *Women's Consciousness, Women's Conscience*, edited by Barbara Hilkert Andolsen, Christine E. Gudorf, and Mary D. Pellauer (with chapters on Hispanic and African-American women's experiences and ethics); *Womanspirit Rising: A Feminist Reader in Religion* and *Weaving the Visions: New Patterns in Feminist Spirituality*, both coedited by Judith Plaskow and Carol P. Christ; *More than Words: Prayer and Ritual for Inclusive Communities*, by Janet Schaffran and Pat Kozak; and *We Will Not Hang Our Harps on the Willows: Global Sisterhood and God's Song*, by Barbel von Wartenberg-Potter (from a European perspective).

4. There is an organization of Disciples women scholars called the Forrest-Moss Institute. They are preparing a book, scheduled for publication in 1995, on:

> the nature of the human experience through women's lives, feminist interpretation of the Bible, doctrines of God and Christ, women's spirituality, the Eucharist, the woman pastor's authority and preaching, the history of the various ethnic women in the church and what women's experiences offer to models of the church.[21]

This book will be another important resource for all of us.

5. Finally, keep a journal in which you reflect on your reading and other experiences. Try writing in the journal in various forms—letters, prose, poetry, free association, observations. Incorporate artwork if you want.

6. Share your experiences with others.

Notes

[1]From psychoanalyst Karen Horney's diaries as recorded by Susan Quinn, *A Mind of Her Own: The Life of Karen Horney*. (New York: Summit, 1988), p. 15.

[2]Sophonisba P. Breckinridge, *Women in the 20th Century: A Study of Their Political, Social, and Economic Activities*. (New York: Ayer Press, 1972), pp. 1–7.

[3]*Ibid.*, p. 2.

[4]*Ibid.*, p. 4.

[5]J. F. Burnett, *Early Women of the Christian Church: Heroines All*. (Dayton, Ohio: Christian Publishing Association, 1921), pp. 17-18.

[6]Quoted by Nancy F. Cott, "Religion and the Bonds of Womanhood." In Jean E. Friedman and William G. Shade, *Our American Sisters: Women in American Life and Thought*. (Lexington, Massachusetts: D. C. Heath, 1982), p. 198.

[7]Mossie Allman Wyker, *Church Women in the Scheme of Things*. (St. Louis: Bethany Press, 1953), p. 8.

[8]Rita Nakashima Brock, "What Is a Feminist Anyway?" *The Disciple* 130 (12) (December, 1992), p. 19.

[9]Elizabeth A. Johnson, *She Who Is: The Mystery of God in a Feminist Theological Perspective*. (New York: Crossroad, 1992), pp. 61-75.

[10]Adapted from Lois W. Banner, *Women in Modern America: A Brief History*. (San Diego: Harcourt Brace Jovanovich, 1984), pp. 279, 278.

[11]Johnson, *She Who Is*, pp. 61–75.

[12]Banner, *Women*, pp. 37–39.

[13]Johnson, *She Who Is*, p. 68.

[14]*Ibid.*, p. 69.

[15]See Debra Hull, "CWBM: A Flame of the Lord's Kindling," *Discipliana* 48 (3) (Fall, 1988), pp. 39-42.

[16]Wyker, *Church Women*, p. 28.

[17]Virginia Lieson Brereton, "United and Slighted: Women as Subordinated Insiders." In William R. Hutchison (ed.), *Between the Times: The Travail of the Protestant Establishment in America, 1900-1960*. (New York: Cambridge University Press, 1989), p. 148.

[18]Hutchison, *Between*, p. 142.

[19]Brereton, "United," pp. 143–164.

[20]*Ibid.*, p. 145.

[21]"Women Scholars Organize, Plan to Publish Book," *The Disciple* 130 (12) (December, 1992), p. 42.

Index